The Additional _____ing Architecture

The Additional Element in Architecture
On Kazimir Malevich's Arkhitektons and Planits

Pedro Ignacio Alonso and Paulina Bitrán

THE MIT PRESS
Cambridge, Massachusetts · London, England

Glossary

Arkhitektons A series of changing configurations of fully independent extruded squares and rectangles. Made out of plaster, wood, or glass, they are temporarily joined by means of gravity and weight, becoming painterly sensations through photography.

Base planes Horizontal bases on which both arkhitektons and planits rest. In most of the planits these are delineated to frame the position of the drawing. In the case of arkhitektons, these are black tables or white platforms. Some are curvilinear, and in one case the base plane is a mirror.

Cruciform Having two structural elements, compounded with medium elements, that form a cross as the formal base of an arkhitekton.

Dissolution of prismatic elements Drawing effects conceived to render architectural objects unattainable.

Eaves Cantilevered elements, of almost no thickness, usually black, made out of painted glass and horizontally attached to an arkhitekton.

Equilibrium The balance established between elements in such a way that they articulate the arkhitekton's form by means of weight and gravity only.

Flat planes Flat elements with a certain thickness (3 mm to 5 mm), standing midway between eaves and regular prismatic volumes.

Form The stabilization of a recognizable configuration of prismatic elements, independent of its appearance through different techniques, its variation in diverse states, and its positioning in various media and formats.

Groupings Assemblages of medium and ornamental elements, becoming independent compounds (like minute arkhitektons in scalar correspondence), resting adjacent to or on top of the structural element or the cross-shaped form of an arkhitekton.

Medium elements Prismatic elements that are smaller than the structural elements but larger than the ornaments. Their size varies between 10 mm and 65 mm.

Ornaments The smallest elements on a given form. Unessential to the structural configuration of an object, but fundamental

to the arkhitekton's texture, grain, porosity, and overall appearance in relationship to light and shadow. Their size varies between 2 mm and 10 mm.

Planits A series of changing configurations of fully independent extruded squares and rectangles, realized by means of reverse perspectival drawing techniques.

Point of departure The transformation threshold of a given form at which it becomes a different form altogether.

Porosity The quality of having space between elements, especially in arkhitektons composed of a larger number of medium-sized and ornamental elements.

Positioning Placement, for example an arkhitekton placed in an exhibition, a planit in a hanging tapestry, or a photomontage within a preexisting image.

Reconstruction The reassembling of physical arkhitektons following information provided by photography, using elements from Malevich's original plaster models.

Reproduction The remaking of physical arkhitektons following information provided by photography, without having any elements from Malevich's original plaster models.

Satellite A type of grouping that is not directly attached to an arkhitekton but stays in close proximity to it.

State A different, provisional version of a given form.

Structural elements Large prismatic elements that constitute the main body of the arkhitekton. Their size varies between 65 mm and 200 mm.

Technique The mode of realizing forms, whether as physical plaster models (arkhitektons), drawings (planits), photographs, or photomontages.

Tonal planes Basic geometric figures made in painted glass, mainly circles, embedded in specific elements, and present in very few arkhitektons (such as arkhitekton A10). They can also be flat cardboard pieces, painted in various colors and attached to the volumes.

1 *Arkhitektons*

We have written this book knowing that Kazimir Malevich would have hated it. This is largely because we have sought to recover precisely what he took great efforts to annihilate. To make matters worse, metaphorically we make use of the term "archaeology," which he despised. Malevich's attitude toward the dissolution of his own work partially explains why the exact number of his arkhitektons—assemblages of extruded squares and rectangles made out of plaster, wood, or glass that he worked on in the 1920s—is unknown, and why physical traces of the original plaster models are almost all lost. Very few survive, mostly in museums and collections in Russia, France, and the Netherlands. But even these are not really originals but reconstructions that have been assembled using a handful of remaining elements. A rough estimate made through a survey of the existing literature would tell us that Malevich made about twenty-five physical models (the arkhitektons), twelve drawings of such assemblages (called planits), and one photomontage.[1] Counting is elusive, however. It is known that four of the six planits exhibited by Malevich in the Venice Biennale of 1924 went missing, namely, the Supremo planit, the Chino planit, the Sanatorium planit, and the Architecture and Suprematism planit.[2] It is also known, for instance, that the Dynamic Suprematist arkhitekton exhibited in Warsaw in 1927 disappeared from the apartment of Malevich's friends Szymon and

Helena Syrkus when German troops pillaged the city following the Warsaw uprising in 1944.[3]

All of which helps to explain why existing reconstructions were largely assembled by following published photographic records. Even the more thorough of these reenactments, like the one conducted by Poul Pedersen and team for the Centre Pompidou in the late 1970s, only remade five of the arkhitektons, namely Alpha, Beta, Gota, Gota 2-a, and Zeta.[4] Closer scrutiny of Malevich's original photographs, however, especially those showing general views of the different exhibitions in which the arkhitektons were displayed, reveals that at least seven others existed, for which no individual photographs were ever published. Consequently, to date, most of the arkhitektons are entirely lost in physical form.

This book aims to unveil those missing arkhitektons through digital modeling, while simultaneously reconstructing all the others in order to assemble a comprehensive set of twenty-seven forms (including the planits). The argument set forth is that both arkhitektons and planits can only be properly grasped when considered together, as a single cohesive series. Instead of physically reconstructing some (assessing them individually), we set ourselves the task of digitally reconstructing all (assessing them collectively). By "all" we mean all the forms that can be deduced from carefully observing the photographs Malevich published. Similar to Pedersen's work, the digital modeling from photographic records allows for the examination of Malevich's investigations of spatial form. We call this method a visual archaeology.

And yet, in spite of the seeming clarity of our intent, an initial methodological problem soon arises about how to really differentiate one arkhitekton from another, because arkhitektons and planits are not individual, discrete objects. They are neither fixed nor unchanging drawings or models. Rather, they are agglomerations of loose elements temporarily joined—quite literally—by means of gravity and weight, from a minimum of eighteen elements in arkhitekton A10 up to 252 in arkhitekton Gota. Malevich is clear in explaining this condition, understanding that an object

> immediately disintegrates into a large number of component
> parts which are fully independent; further investigation
> will prove that the thing did not exist, that only the sum
> of things existed. . . . One begins the investigation of the
> disintegrated things and under the pressure of investigation

The Additional Element in Architecture

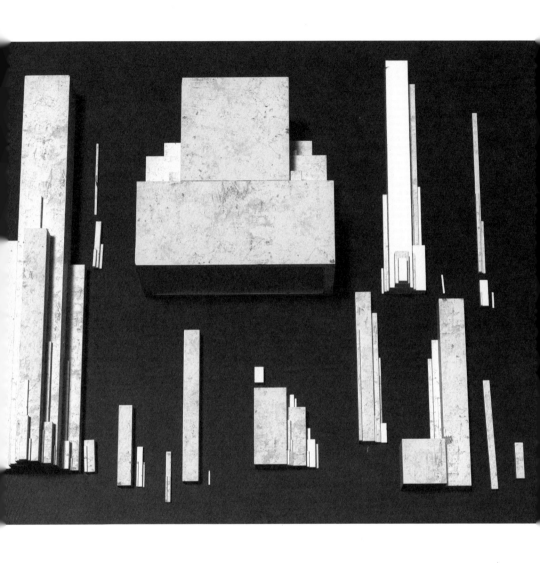

Scattered and fragmented plaster elements of arkhitektons. © Paulina Bitrán.

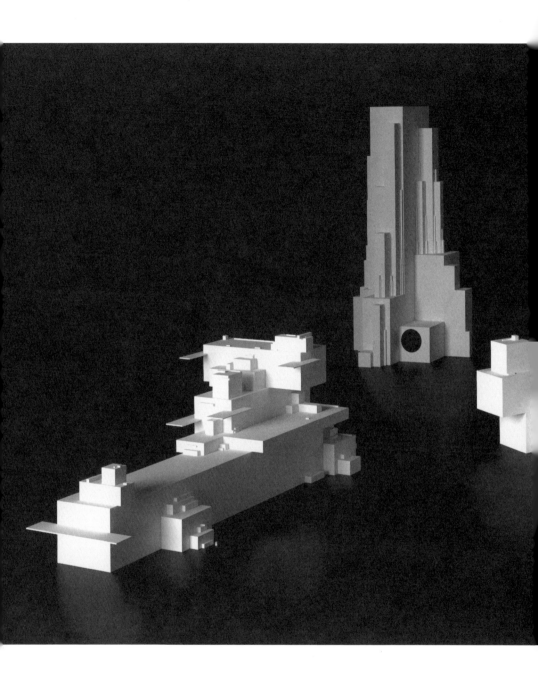

Left to right: arkhitektons Alpha, Gota, Beta, Zeta, and Gota 2-a. © Paulina Bitrán.

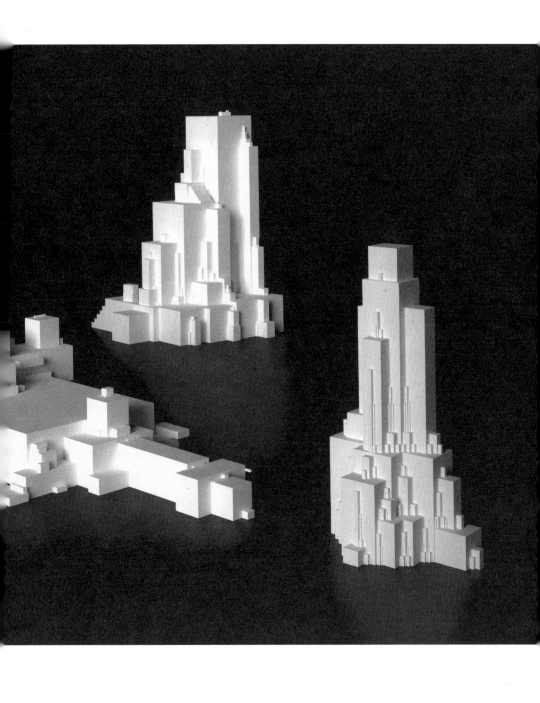

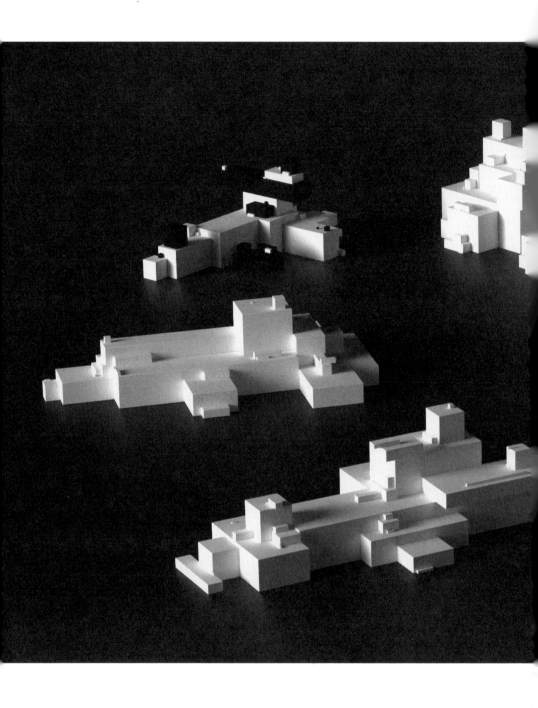

Clockwise from top left: newly identified arkhitektons A24, A25, A26, A23, A21, A22, and A20. © Paulina Bitrán.

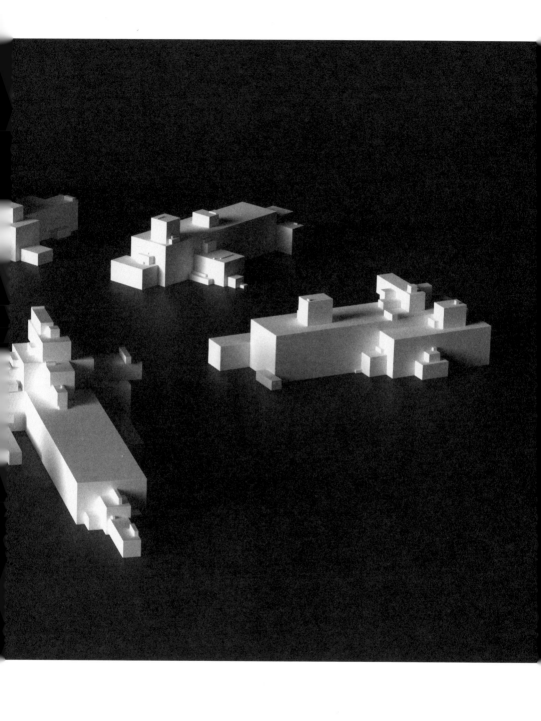

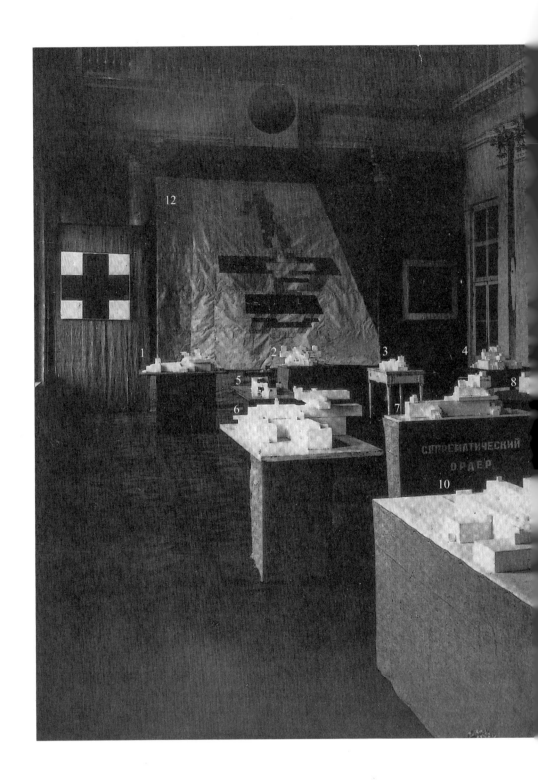

Kazimir Malevich's arkhitektons displayed in the GINKHUK exhibition, Leningrad, June 1926. Source: Andréi Nakov, *Malevich: Painting the Absolute*, vol. 3 (London: Lund Humphries, 2010). Key: **1**, A22; **2**, Beta; **3**, A26; **4**, A25; **5**, A24; **6**, A7; **7**, Alpha; **8**, A23; **9**, A21; **10**, A20; **11**, A6; **12**, Future Planit for Leningrad: The Pilot's House; **13**, A11; **14**, A10; **15**, Spokoj.

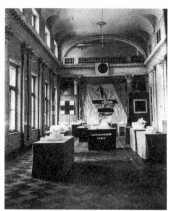

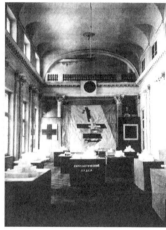

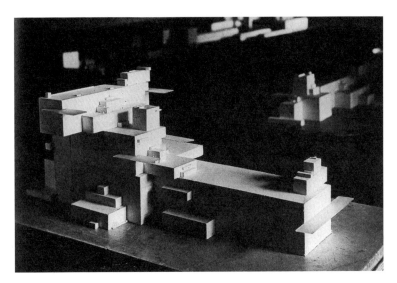

Kazimir Malevich, arkhitekton Alpha (1922–1923).

the things again disintegrate into a multitude of things, whose investigation will prove that these disintegrated things also in their turn disintegrated into independent things and bore a mass of new links and relations with new things, and so on ad infinitum. The investigation will prove that things do not exist, that at the same time there exists their infinity, "nothing" and at the same time "something."[5]

The term "arkhitekton" is thus a conceptual category that refers to this ongoing tension between "nothing" and "something," which leads, in fact, toward Malevich's "nonobjectivity." Rather than fixed objects, the arkhitektons refer to a whole series of changing configurations of transiting volumes. This in turn introduces the problem of time, and more specifically the intervals through which one arkhitekton changes. And it does so in two ways: while retaining some stable features, a given arkhitekton gradually becomes dissimilar to itself, but in such a way that it is still recognizable as itself. It is multiplied, as it were, into different states (variations). Or else at some point these states become so unrelated to each other that they reach a distinct form altogether (difference). There is a threshold, or "point of departure," dividing variation from difference. Malevich arrived at different forms as the result of these processes, in the modulation of form through

The Additional Element in Architecture

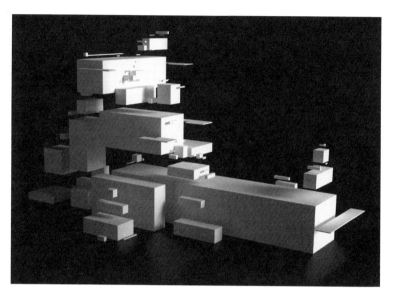

Arkhitekton Alpha, exploded digital model. © Paulina Bitrán.

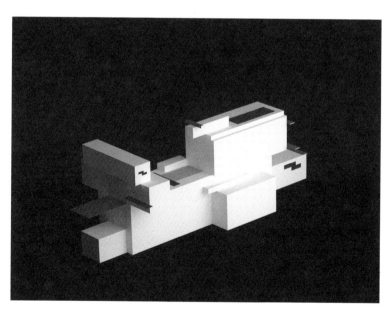

Arkhitekton 10 (A10). © Paulina Bitrán.

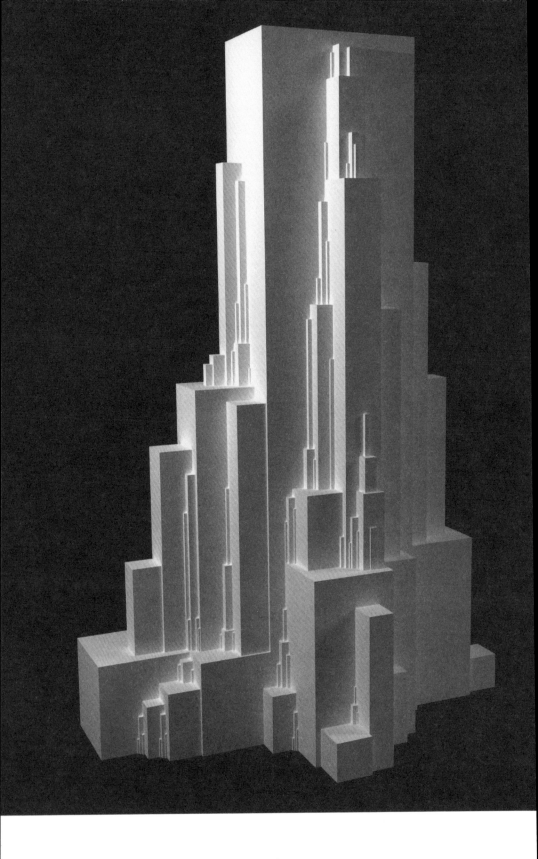

Arkhitekton Gota. © Paulina Bitrán.

time, yet not for the sake of form, but for the sake of exploring difference as such.

It is in this context that one should not fail to recognize Malevich's signature forms of the square and its extension into cubic prisms as "no-things" aspiring toward a kind of neutrality, where the volumes are the result of the (dynamic) extrusion—at different lengths—of the square. The Suprematist surface plane is turned into a volume by the dynamic displacement of these neutral figures. El Lissitzky—in reference to Malevich—insisted that the square was the zero of all form and all painting. Or as he said in 1922, "Malevich exhibited a black square painted on a white canvas. Here, a form was displayed which was opposed to everything that was understood as 'pictures,' or 'painting,' or 'art.' Its creator wanted to reduce all forms, all painting to zero."[6] Consequently, for Suprematism, the no-thing of the square becomes the foundation stone for the new spatial construction of reality, the square extolled as the very source of all creative expression. Through the square, form is thought to be suppressed, neutralized, absent, reduced to zero, the basic unit of art and architecture. According to Lissitzky, therefore, what is formed is nothing but a relationship between abstract, nonobjective individual parts.

Such a reading was perfectly clear to the architect Zaha Hadid, whose own studies of Malevich, more than half a century later, allowed her to explore concepts of explosion, fragmentation, distortion, and grouping, as well as ideas of lightness, buoyancy, and fluidity. That is to say, what matters is a type of relationship between elements, not the elements themselves. If something is contained by the abstract elements of an arkhitekton, then, it is not form but its absence. The final, provisional form of the overall composition is nothing but a set of relationships that can only be grasped when form itself is silenced through the agency of the nothingness of squares.

We have to acknowledge, however, that the square—as a visual sign—should not be considered a figurative label that comes to be attached to things and qualities already established in advance, by God or by nature, such as that of the neutral. Rather, Malevich's square recalls Ferdinand de Saussure's renowned understanding that the sign is arbitrary, so that there is no internal connection between the idea of the "no-thing" or "neutral" and the "geometrical construct" of the square which acts as its signal. Saussure explains that there is a phase in the creation of signs (which he

following pages:
Twenty-one arkhitektons. Top row, left to right: Zeta, Gota, Gota 2-a, A14 (Lukos); second row: A25, Beta, Alpha, A22, A19; third row: A15, A20, A18, A21, A6 (Dynamic Suprematist Arkhitekton), A7 (Form A); fourth row: A8, A26, A23, A11, A24; fifth row: A10. © Paulina Bitrán.

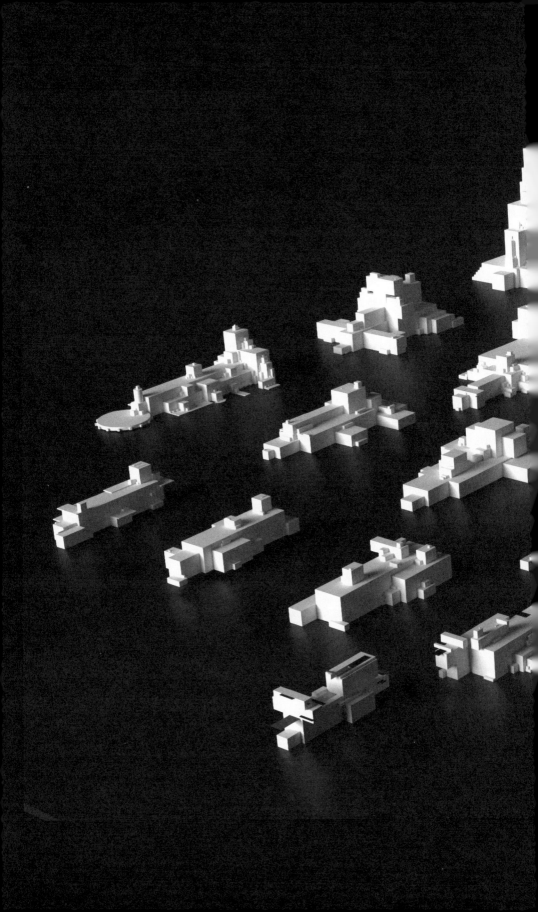

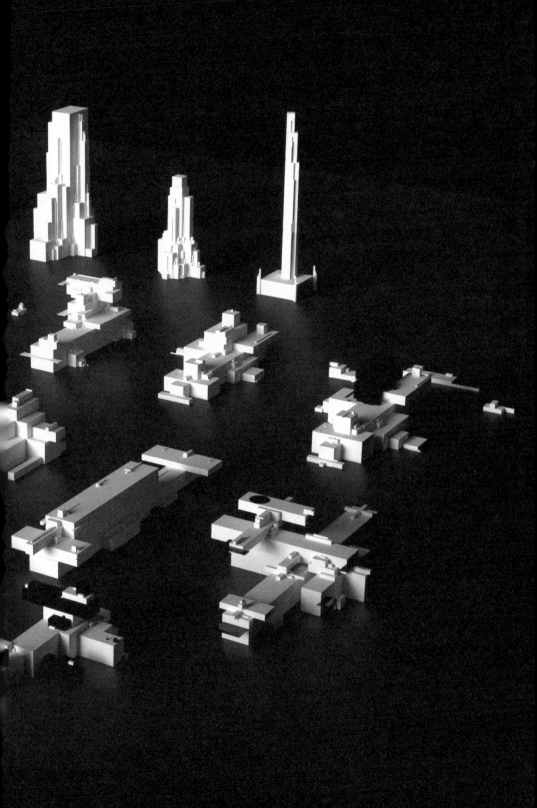

calls "secondary") in their adoption by the community, in this case the modernist adoption of the square as signifying neutrality. The absence of form is not attached to the square by an internal connection given in advance to that geometrical figure; but, on the contrary, this attachment is a matter of modernist convention, in which Malevich had thus played a fundamental role.

This book presents our attempts to explore these often-elliptical dynamics as well as this apparent convention. In order to grasp the problem, we digitally modeled as many arkhitektons and planits as possible, which in turn opened up the essentially unknown boundaries of what we took to be a larger, often fuzzy object, composed of several such prismatic agglomerations and "points of departure," both vertical and horizontal. For Malevich, such an operation was quite conscious and straightforward. As part of this work, we have animated Malevich's "artistic-scientific film" on "the emergence of a new plastic system of architecture"[7]—a project that he only left drafted as a script,[8] but that reveals in full the role of transition and transformation in his search for a new architecture. This is also clear in his writings:

> This displacement of the model meant the revelation on the plane of various forms of time. At this moment a new harmony and system of construction was achieved: new links between straight and curved lines, volume, relief, contre-relief, colour, planes, texture and materials as such, and from the possibilities . . . in the construction two features arose: the visible static quality, and movement as the dynamic growth of forms.[9]

To Malevich, form is conceived in its more simplified terms as the equilibrium of gravity and weight, over time, in the agglomeration of hundreds of nonobjective prisms, which suddenly—and because of the introduction of what he enigmatically termed an "additional element," either a bacterium or a bacillus, something capable of producing "effective changes in an organism"[10]—would stumble and dissolve until a new point of equilibrium is found: an entangled array of forces that are dependent not on the shape but on the size, weight, and quantity of the neutral elements at play.

We may suggest that architecture is seldom seen as a state of form-suspended-in-equilibrium in this deepest sense. And these precarious and volatile states of stability are precisely what

The Additional Element in Architecture

Malevich was intent on exploring. In his thorough research on Malevich's arkhitektons, Tarcisio Cardoso notes this in saying that "the Suprematist non-objective 'blurring' snatches the fixedness of entities away into their inherent 'spatial chaos.'"[11] To Malevich, architecture consists not in the design of the static form of a building, but in the "piloting"[12] of the changing status of matter through time. But then, to explore this dimension of nonobjectivity induces its own paradoxical goal: we set ourselves the task of digitally reconstructing a series of long-lost objects through the fixed medium of photography in order to better understand their drive toward dissolution.

But one question arises: does anything remain out of this process of continuous disintegration and change? Does anything endure through all of the flux of pure becoming? Malevich's response would be that what remains is "sensation." In this way, contrary to the rationality that might be usually associated with abstraction, the arkhitektons and planits reveal Malevich's full search for an "abstract sensuousness" achieved through photography: a means to stabilize the form of a changing object to the perception of an observing subject.

We encounter here a second methodological problem. In the planits Malevich explores the "nothingness" of "something" through drawing in a special way, by revealing that these objects only exist in terms of sensation. The planits are often represented by Malevich as axonometric perspectives in aerial view, but with each of their Cartesian axes treated in a different way. Accordingly, some volumes are warped by perspective while others are not because the object's other axes, of lateral depth for instance, are represented in plain axonometry. Consequently, depending on which vanishing point is used as a reference to deduce the actual form and size of the object, its virtual volumetric reproduction can have multiple variations, revealing that the planits are not representations of attainable objects, but only the production of painterly sensations performed through reverse perspective in the planits, and, we suggest, by the medium of photography in the arkhitektons. Moreover, Malevich consciously rehearses, through

following pages:
Kazimir Malevich's formal sequence of transformation as described in his "Art and the Problems of Architecture: The Emergence of a New Plastic System of Architecture," a script for an artistic-scientific film. © Paulina Bitrán and José Hernández. The film can be viewed at https://vimeo.com/1003262790?embed_email_provider=gmail. For the script, see Kazimir Malevich, *The White Rectangle: Writings on Film*, ed. Oksana Bulgakowa (Berlin: Potemkin Press, 2003).

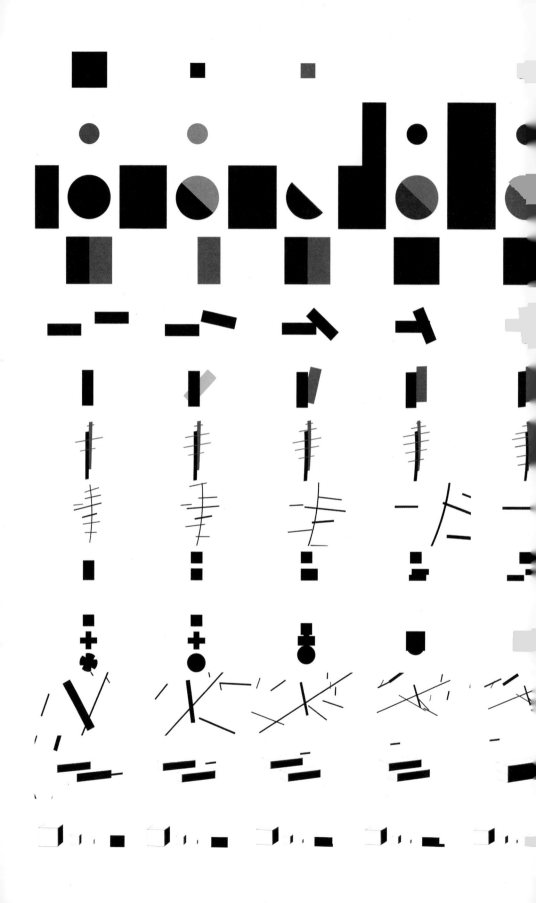

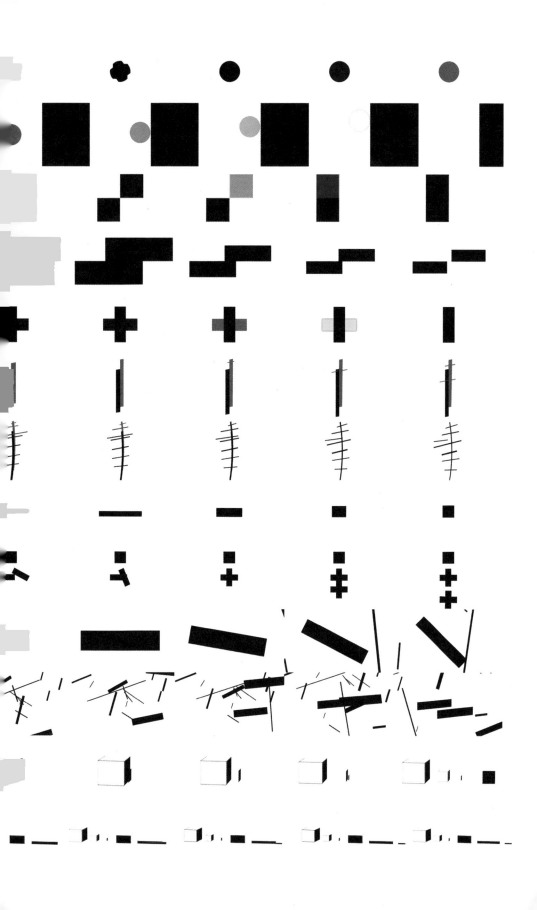

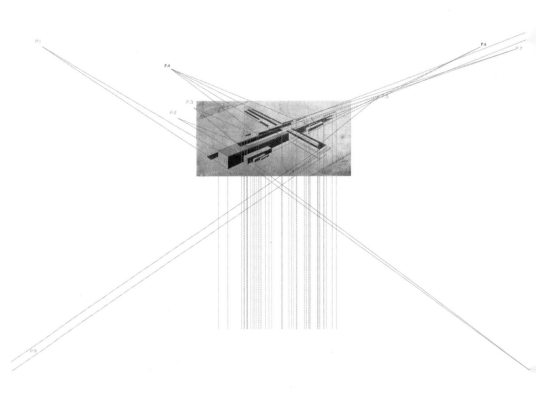

Study of differentiated vanishing points and perspectival axes at work in Kazimir
Malevich's planit Dynamic Nonutilitarian Suprematist Architecture (1925).

drawing effects, what we may call the "dissolution of prismatic elements," as a secondary strategy to render the object unattainable. From this it follows that the planits cannot be projective either. Nor even can they be translated into any knowable form. According to art historian Maria Gough, to define the arkhitektons as preliminary models for the design of a building would be to lose something essential about them: Gough explains that the arkhitektons are not at all the models of buildings. In the same way that Suprematist paintings had no denotative function, the arkhitektons have no projective function.[13] The planits, then, do not hold the drawing of an object, but only present the design of an image from which no object can be deduced. In fact, in his essay on "Painting and the Problem of Architecture," Malevich explains that he is arrested, principally, "by the structure and texture of the work, and by the force of the contrast achieved by the juxtaposition of a large number of different elements."[14] Malevich's arkhitektons are, therefore, conceptually more liquid than solid, as there is no bonding between their molecular components (in contrast to solids where bonding is what gives stability and resistance to separation). This quality of Malevich's search somehow relates to the argument put forward some decades later by the Polish-born philosopher Zygmunt Bauman, notably in his conceptualization of modernity, which Bauman maintained could only be usefully defined through the metaphors of "fluidity" and "liquidity." For Bauman, neither space nor time is fixed or bound by fluids, and whereas time is canceled by solids, it is fundamentally important for liquids. Hence his contention that fluids "are all snapshots, and they need a date at the bottom of the picture."[15] This in turn gives us a useful medium—literally a lens— through which to reencounter Malevich, for whom photography is ultimately what matters most. In the process, his architecture, as token of modernity, is nothing but a "process of liquefaction" of the solidity of the building. He would indeed assert: "The general philosophical path of these trends leads to the disintegration of things."[16] Only sensation, grasped by the painterly or photographic image, would remain.

At stake, then, is the construction of the image of an object without the stable object the representation is supposed to represent. And when one applies such an elision to building, it immediately subverts the conventions of architectural causality, which dictate that the building is the steady and stable object from which

Dissolution of the
prismatic elements
by fusion of planes
and lines at different
depths.

Analysis of the "dissolution of prismatic elements" at work in Malevich's planits.

several images are produced. With the arkhitektons, conversely, the image elucidates a lapse of stability, while the object remains transforming forever.

In architectural image-making, orthographic projections such as plans and axonometrics are both descriptive and analytical in nature. These are fundamental to our study, to the extent that they allow us to recognize the way in which the arrangement and agglomeration of elements have been subordinated to the production of an objectless sensation fixed through an image. Simultaneously, the paradoxical nature of planits bounces back onto the arkhitektons, exposing them as intermediary objects. This is why, together with the volumetric reconstruction we undertook of the arkhitektons, we also looked to study the way in which Malevich assembled his arkhitektons in order to return to two-dimensionality, largely through photography. Such a process shows him to be driven by a search for formal change, insofar as this would trigger pictorial effects. What Malevich wants when exploring different configurations is the variation of light as it works in the endless variation of formal states.

If we follow this thread, the arkhitektons become models in a literal sense, like a still life or a naked body in front of the painter. When confronting the camera, the arkhitektons become by definition naked and still. They are models in relation to photography (not in relation to buildings). They are abstract models in relation to abstract sensations: the painterly dimensions of the photographic framings. Here we find that Malevich has doubled down. He seeks to deobjectify (through photography) what is already nonobjective (the arkhitektons). This idea is reinforced by the fact that most of the arkhitektons clearly have both front and back sides (with some exceptions such as Alpha, Gota, and

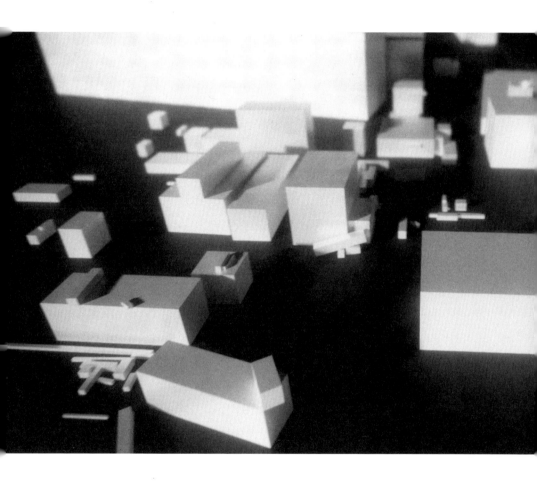

Dismantled elements of an arkhitekton. © Paulina Bitrán.

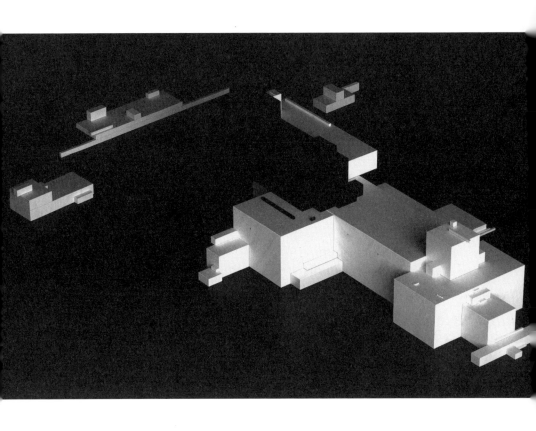

Arkhitekton A19. © Paulina Bitrán.

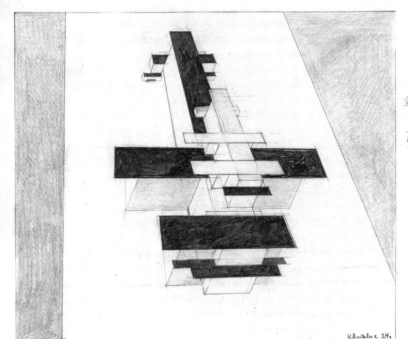

Future Planit for Leningrad: The Pilot's House (1924). Graphite on paper, 31 × 44.1 cm. Museum of Modern Art, New York.

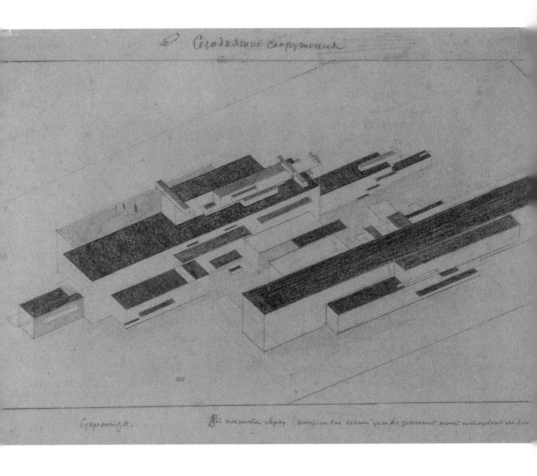

Kazimir Malevich, Modern Buildings, 1923–1924. Collection Stedelijk Museum Amsterdam.

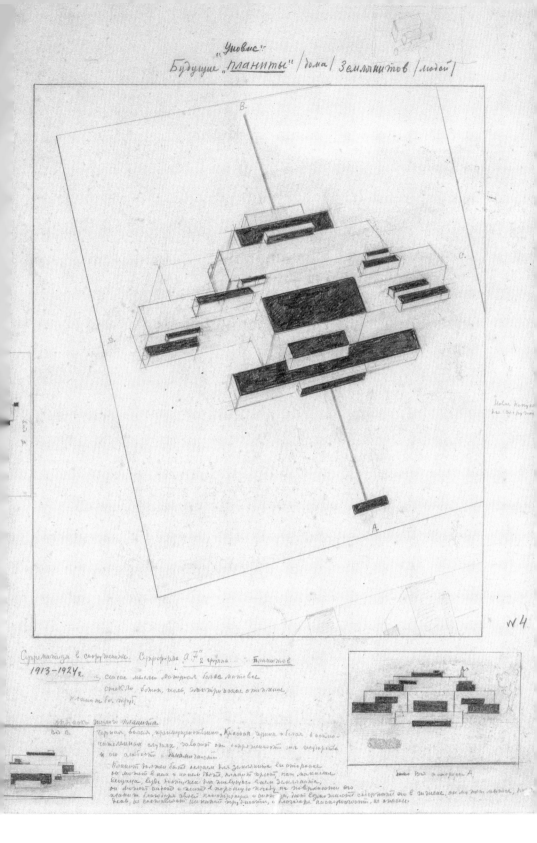

Kazimir Malevich, The Houses of the Future, 1923–1924. Collection Stedelijk Museum Amsterdam.

A7). In general, they have complex, elaborated fronts and bare, unadorned backs. They are oriented toward the photographic camera and lit accordingly, typically against a black or a white background. They are meant to be photographic and, we would suggest, painterly by means of chiaroscuro. The arkhitektons and planits, then, are models in relation to painting, that is to say, in

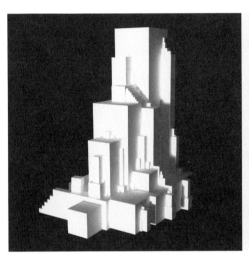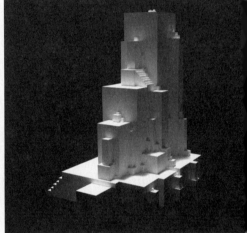

Arkhitekton Zeta, lighting study. © Paulina Bitrán.

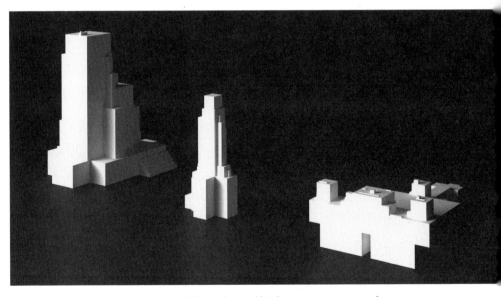

Opposition between back and front sides in arkhitektons Zeta, Gota 2-a, and Beta.

The Additional Element in Architecture

relation to sensation. If the individual volumes remain constrained and never look to shine by themselves, they manage to establish centers of luminous radiation on each model, from which a whole chromatic system generating forms then develops. The forms are not in this or that prismatic element, as they only emerge in the illuminated whole. The photographic records of the arkhitektons are Suprematist artworks in themselves. The task ahead is thus reconstructing sensation by producing the yet nonexistent photographs of previously unknown arkhitektons.

This book's ambition is not to find finitude, or to somehow exhaust the subject (an impossible task, indeed), but to investigate this body of work from within architecture: its history, its narratives, its debates, and its longstanding collective whims and expectations. In the process, Malevich's arkhitektons reveal themselves not as architecture per se, but as glowing mirrors through which one could survey the unfulfilled dreams of architecture.

In this way, the arkhitektons and planits are not just regarded as buildings that are waiting to be occupied by a new culture that would "conquer" them by introducing its own program in a kind of process of architectural specification (as Rem Koolhaas would have it).[17] An idea that was also entertained by Walter Gropius and other members of the Bauhaus when meeting Malevich in the

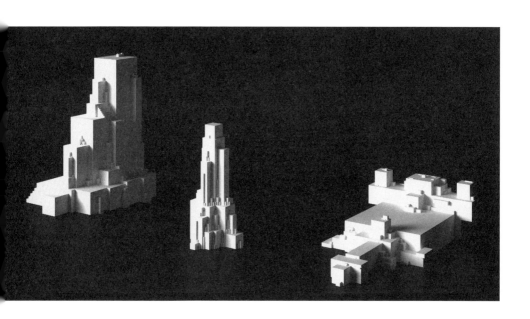

KASIMIR MALEWITSCH

DIE GEGENSTANDSLOSE WELT

BAUHAUSBÜCHER 11

Kazimir Malevich, *Die gegenstandslose Welt* (The nonobjective world), Bauhausbücher 11 (Dessau, 1927).

1920s. Despite the fact that they published *Die gegenstandslose Welt* in the Bauhausbücher series in 1927, Gropius and László Moholy-Nagy took the time to add a foreword saying that the book deviates "from our position in some key questions."[18] And one such question was the relationship between form and function. Gropius criticized Malevich because, according to him, the arkhitektons do not take into consideration the ultimate use of the building.[19] But Malevich was interested in something else. He wanted to produce works only ascribed to the artistic relationship of spatial form. In this sense, he was looking for something that Gropius and Moholy-Nagy were unwilling (or unprepared) to understand. It was all about the autonomy of form (and by extension of architecture) in relation to use, to program, to history, and to tradition. Malevich was interested in exploring the processes by which form is created, distributed, dissolved, and reassembled in time, and through various states of equilibrium. Several decades before Aldo Rossi would criticize the "naive functionalism" of modernist discourse, Malevich was bringing autonomy into architecture, as, he declared, he had learned from Paul Cézanne. He was also introducing another perspective that much later would be fundamental in the postmodern architectural appraisal of Gilles Deleuze's philosophy. Malevich was fundamentally *reversing Platonism*, the title of a 1966 essay by Deleuze in the *Revue de Métaphysique et de Morale*,[20] containing arguments from his doctoral dissertation that he would later publish as *Difference and Repetition* (1968). In this text the French philosopher revised a traditional understanding of the relations between identity and difference, where the notion of difference is often seen as a derivation of the identity of an object. On the contrary, he proposed that all identity is rather an effect of difference or, in other words, that the identity of an object (in this case an architectural identity) is not logically or metaphysically prior to the multiplicity of its possible variations. And this is precisely what Malevich then demonstrated through a series of arkhitektons and planits. There is no archetype and there is no *Urform* (in Goethe's terms). Providing Deleuze with an unpredicted example, the arkhitektons assert only difference, from which the identity of sensation can be derived.

Over the ensuing century, a wealth of literature and compelling interpretations have been prompted by Malevich's artistic works and writings—covering a wide sweep of topics that range from the fourth dimension and the ether of space[21] to Suprematism as an

FORMS

GINKhUK exhibition,
Leningrad, June 1926
Photo: Nikolai Punin

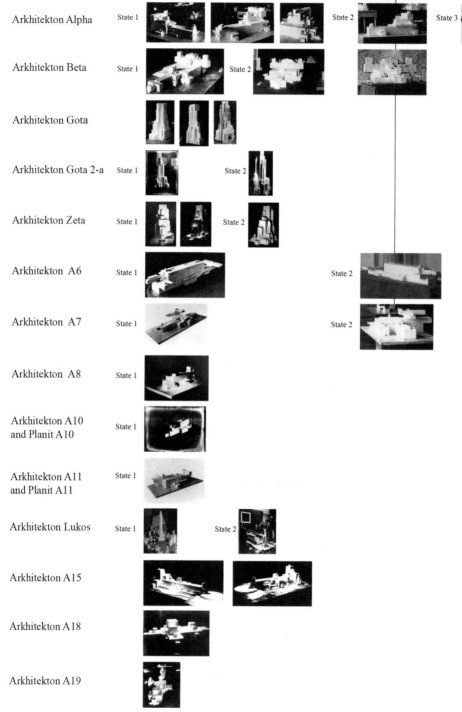

Chart comprising the published images of twenty-one arkhitektons and eight planits.

Arkhitekton A20

Arkhitecton A21

Arkhitekton A22

Arkhitekton A23

Arkhitekton A24

Arkhitekton A25

Arkhitekton A26

Planit X1, Spokoj

State 2

State 2

State 3

Future Planit for Leningrad:
The Pilot's House

Future Planit for Earth
Dwellers

Planit Dynamic Nonutilitarian
Suprematist Architecture

Planit Modern Buildings

Planit Suprematist
Composition

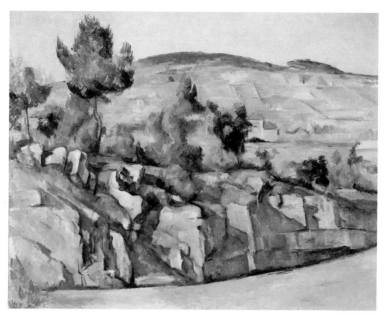

Paul Cézanne, *Paysage rocheux*, c. 1895.

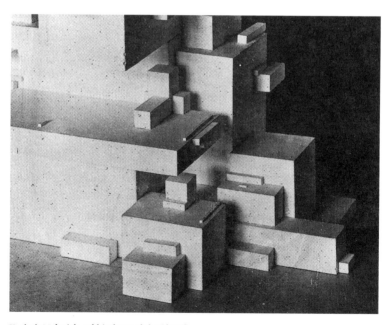

Kazimir Malevich, arkhitekton Alpha (detail).

embodiment of the infinite,[22] the relationships between Suprema-
tism and Constructivism or Russian Cosmism, and Malevich on
film. Even if taken collectively these are neither cohesive nor uni-
vocal, sometimes absorbing and sometimes repeating the very
contradictions and stray paths we find in Malevich's own argu-
ments and ideas. While following the threads of previous works, in
our own project we have tried not to repeat themes and arguments
already accomplished by other authors.

Rather, we are concerned with exploring the architecture of
the arkhitektons, aware that clear-cut distinctions between archi-
tecture and art or between building and painting can't be made.
The architectonic is in the paintings and in the drawings, just as
the painterly is in the models and in the buildings. And so the case
for the autonomy of architecture in Malevich's work—in relation
to use, program, and tradition—contrasts with the entanglement
of architecture with the realm of art and more specifically with
its related techniques of representation, geometry, and indeed
photography.

Malevich's prismatic plaster elements could relate to building
in the same way that Cézanne's abstract brushstrokes would ulti-
mately convey the leaf of a tree or the shape of a hill. But both the
brushstrokes and the plaster elements are not the abstract repre-
sentation of any tree or building. They are abstractions on their
way to becoming new, as yet unknown realities. This is, we believe,
the role assigned by both Cézanne and Malevich to "sensation":
the mechanism through which a novel reality becomes autono-
mous and, by means of relentless disfiguration, remains in the
realm of pictorial explorations.

2 Numbers

The way Malevich's arkhitektons and planits are identified, counted, and classified is a matter for discussion. Any effort to number them would depend on the theoretical framework set for it. In the specific case of the arkhitektons, this needs to take into consideration that no complete objects survived their original assembly in the 1920s. For instance, today there are two versions of arkhitekton Alpha that contain original elements. The one having the largest number of original elements belongs to the State Museum of Russia and was restored in 1988. A second version of Alpha was reconstructed by Poul Pedersen in 1978–1980 and contains just one original plaster element.

More, Malevich would have produced arkhitektons that he did not photograph. And we also have to consider the fact that not all photographs would have survived (especially if they were not published in books or magazines from the time). More importantly, because the arkhitektons are not monolithic structures whose volumetric components were attached to each other, they had to be reassembled every time the arkhitektons were moved from one place to another, leaving space for the emergence of different arrangements, or variations, that sometimes can be recognized in the photographic records and sometimes cannot.

According to Maria Gough, in the three existing photographs of the 1926 Leningrad exhibition, a dozen or so arkhitektons by

Malevich and his assistants can be identified, laid out on pedestals and tables, but "Ermolaeva reports in a letter to Mikhail Larionov . . . that 'the show included about twenty-five models in all.'"[1] So the ambiguity of counting, and the impossibility of entirely satisfying our typical positivistic impulse to list inventories, is therefore one of the first lessons we learned in working on this project—an ambiguity that relates to the changing status of the arkhitektons, and one that is integral to the way Malevich conceived Suprematism and his approach to architecture as a whole. The Suprematist form, he would say, "clearly indicates the dynamic state, and appears . . . according to a physical action through the magnetic interrelationships of a single form."[2] In fact, he sees "bodies in movement."[3] Malevich views architecture as an open space of uncertainty and transformation stippled with a few stable shapes, rather than a solid continent of elements.

Therefore, there are a number of different ways in which counting gets into a muddle. One way is when there are alterations of elements within the same arkhitekton, which are recognizable in individual photographs (such as those of arkhitektons Beta, Gota 2-a, and Zeta). A second is when an arkhitekton is moved from one place to another and thus reassembled, with elements removed, the addition of black eaves, or alterations in the positions of elements in the course of this reassembly (examples of Alpha, A6, and A7). A third way relates to forms that are "reused" by Malevich to create variations that are close to becoming another form altogether. We can see Alpha in A9, A19, in A22, and Lukos reflected in the column set at Malevich's funeral. We can also consider this to be the case in the relationship between planit Spokoj and arkhitekton A21. A fourth way occurs when the same form is performed both as an arkhitekton and as a planit (such as with A10 and A11). A fifth relates to the reconstructions performed by others after 1970. Replicas and reconstructions, even those having original elements, would show alterations (Alpha from the Centre Pompidou and Alpha from the State Russian Museum are different, as is the case with Gota and with others).

And so there would be no final or concrete number of arkhitektons, just temporary arrangements that follow some kind of flow and internal logic of formal stabilization. There is not a knowable number, just principles and variations. And while accurate counting of the actual physical plaster models is therefore elusive and, to an extent, pointless, the published photographs can be charted

The Additional Element in Architecture

in a more accurate way. Despite of the fact that Malevich was concerned with "dynamic states," what matters is the way in which the results of his investigations were fixed through photography or drawing.

Leaving the planits aside for a moment, the existing literature on the arkhitektons is only concerned with the identification of a number of objects from a universe of thirty-one photographs, dating between 1923 and 1929. Some of the objects are well known by the names Malevich gave using letters from the Greek alphabet: Alpha, Beta, and Zeta.[4] These are followed by arkhitektons where he used a different naming logic (Gota, Gota 2-a, and Lukos), as well as others he called Form A, Form C (in two different compositions), Form D (the most altered state of arkhitekton Alpha), and finally one that he called a Dynamic Suprematist Arkhitekton.

In 1970 Troels Andersen published a *Catalogue Raisonné of the Berlin Exhibition 1927*,[5] presenting all photographs so far known of Malevich's arkhitektons, and providing a numbering system from 1 to 15: arkhitekton 1, or A1; arkhitekton 2, or A2, and so forth. Out of this numbering, however, only two arkhitektons—A8 and A15—are new or different from the objects already labeled by Malevich. For instance, Andersen's A6 is Malevich's Dynamic Suprematist Arkhitekton, A7 is what he called Form A, A9 is Form D, A10 is Form C, A11 is also Form C, and A14 is Malevich's Lukos. At the same time, Andersen's A12, A13, A16, and A17 do not correspond to arkhitektons in the strict sense. Rather, they are Suprematist ornaments or monuments, and consequently, however interesting, they are not considered in the present study.

Therefore, the ten arkhitektons originally named by Malevich become twelve if we add Andersen's photographic evidence of A8 and A15. Moreover, we need to increase this number with two previously uncharted forms to complete this listing: an arkhitekton in a photograph published by Jean-Hubert Martin that he called A18 (faithful to Andersen's notation system); and a photograph published by Andrei Nakov referred to as Arkhitekton Type Form Beta. For the sake of clarity and consistency, and also following Troels Andersen, we call this figure A19. In total, therefore, the existing literature has identified fourteen arkhitektons.[6]

A closer scrutiny of the published photographic records, from Malevich's 1926 GINKhKUK exhibition in Saint Petersburg (then Leningrad), reveals another group of arkhitektons that have never been recognized or studied. From that group, we have retrieved

following pages:
Beta, Gota 2-a, and Zeta: discrepancies between different photographs of the same arkhitektons.

Arkhitekton Beta

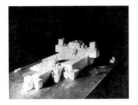

State 1

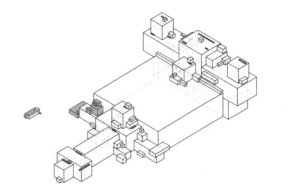

Arkhitekton Gota 2-a

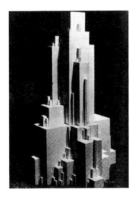

State 1

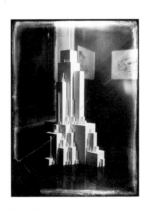

State 2

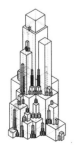

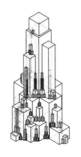

Arkhitekton Gota 2-a is represented by two photographs, each taken of the front of the arkhitekton but from different corners. Between them they show changes of size and quantity of elements in the grouping of ornaments. This difference was noted in Poul Pedersen's reconstruction in the catalogue of 1980.

State 2

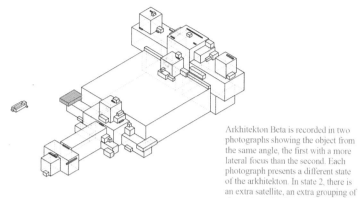

Arkhitekton Beta is recorded in two photographs showing the object from the same angle, the first with a more lateral focus than the second. Each photograph presents a different state of the arkhitekton. In state 2, there is an extra satellite, an extra grouping of elements, and a change of position in a plane element, breaking with the equilibrium present in the first state.

Arkhitekton Zeta

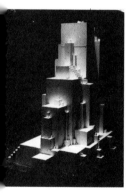

State 1

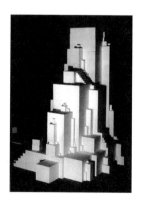

State 2

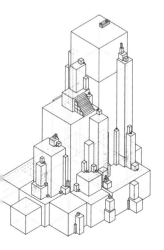

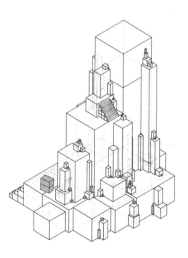

There are three photographs of arkhitekton Zeta, in which there are two distinguishable states. The two photographs here show the same angle and focus of the arkhitekton, but there is a dramatic change of illumination, with some elements appearing or disappearing.

Arkhitekton Alpha

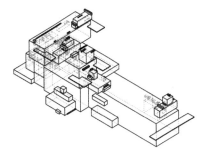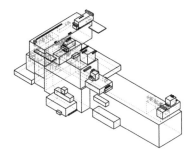

State 1
100 elements in total (95 volumes,
5 eaves in glass)

State 2
Arkhitekton Alpha was shown in the 1926
GINKhUK exhibition and owned by the State
Russian Museum. In photographs of the 1926
exhibition and two later exhibitions at the
museum, we can see that three eaves were
removed from it.

Arkhitekton A6

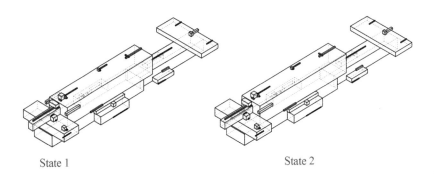

State 1

State 2

Arkhitekton A7

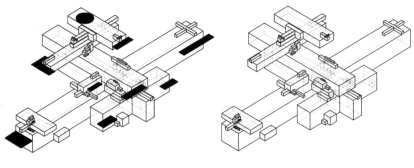

State 1

State 2

Alpha, A6, and A7 variously reassembled. © Paulina Bitrán.

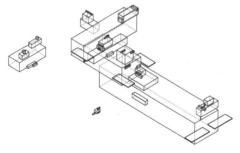

State 3

Published as Form D in 1926 and recognized as Alpha in the 1960s, this third state of the arkhitekton shows the minimum structural elements and groupings to still remain as the Alpha form. 50 elements in total (31 volumes, 5 eaves, and three satellites with 14 volumes).

hitekton Lukos

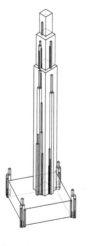

State 1

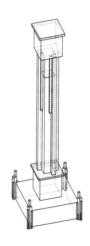

State 2

khitekton A19

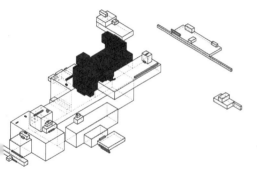

Arkhitekton A22

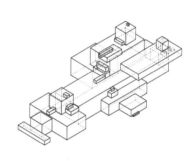

Alpha state 3, Lukos, A19, and A22. © Paulina Bitrán.

Arkhitekton A10

State 1 Arkhitekton

State 2 Planit

Side A

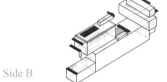

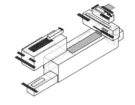

Side B

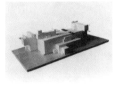

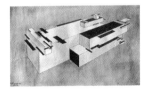

Arkhitekton A11

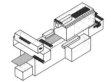

State 1 Arkhitekton

State 2 Planit

Side A

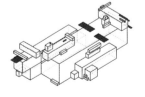

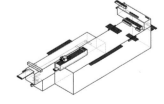

Side B

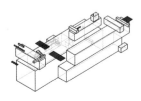

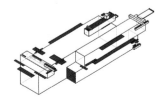

khitekton Alpha

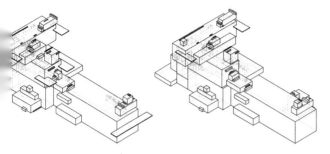

State 4
Arkhitekton Alpha was restored by the State Russian Museum in 1988. There are several changes in the placement, quantity, and type of elements, recognizable in the different catalogues' photographs.

State ∞
This Alpha restoration has alterations of the dimensions, positioning, and orientation of the elements, as one can see from different archival photographs.

Arkhitekton Gota

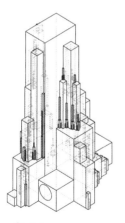

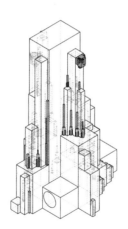

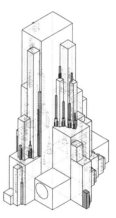

State 1

State 2
From the 157 original elements of arkhitekton Gota, two groupings of elements were found with additional groups of Suprematist ornaments stuck to them.

State 3
The second reconstruction of arkhitekton Gota (State Russian Museum) presents a different grouping of elements than the first reconstruction.

Different reconstructions of Alpha and Gota. © Paulina Bitrán.

facing page:
A10 and A11 as planits and as arkhitektons. © Paulina Bitrán.

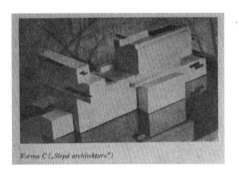

Forma C („Slepá architektura")

"Form C,"
ReD (Czechoslovakia, 1927), p. 60

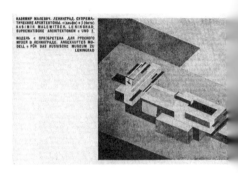

"Arkhitekton Beta,"
CA (Leningrad, 1927), p. 105

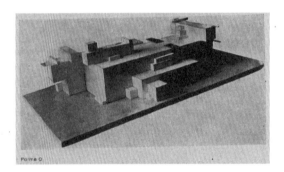

Forms C

"Form C,"
Praesens, no. 1 (Poland, 1926), p. 29

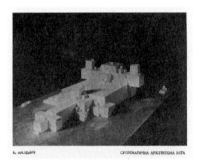

"Suprematist Arkhitekton Beta,"
Nova Generatsiya, no. 3 (Russia, 1929)

Discrepancies in naming: arkhitekton A10 as it appears in different publications called Form C or Beta.

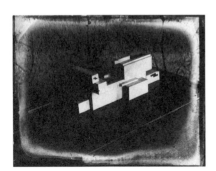

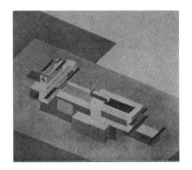

"Arkhitekton A10,"
Andersen catalogue, 1970

"Arkhitekton A10,"
Martin catalogue, 1980

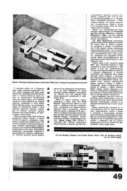
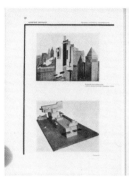
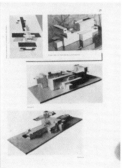
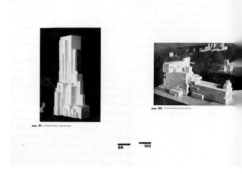
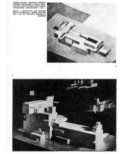

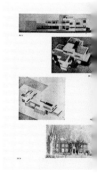
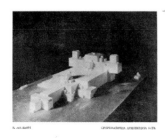

Arkhitektons and planits. All existing publications between 1924 and 1935.

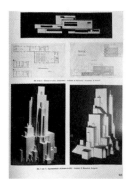

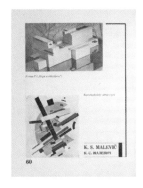

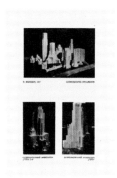

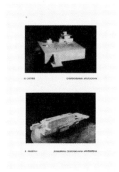

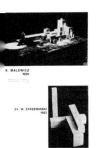

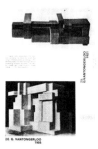

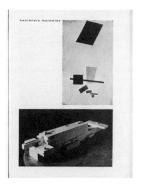

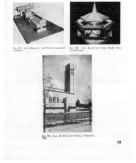

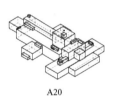

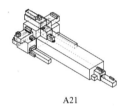

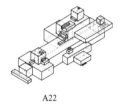

A20 A21 A22

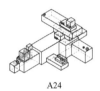

A24

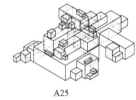

A25

A26

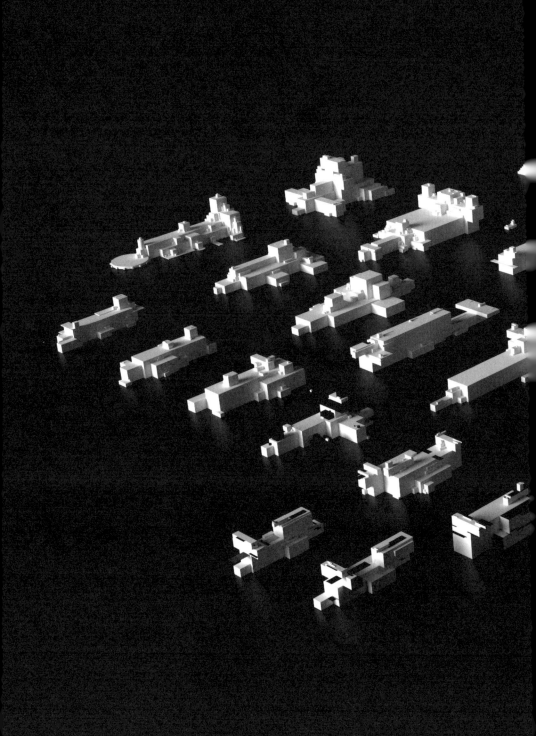

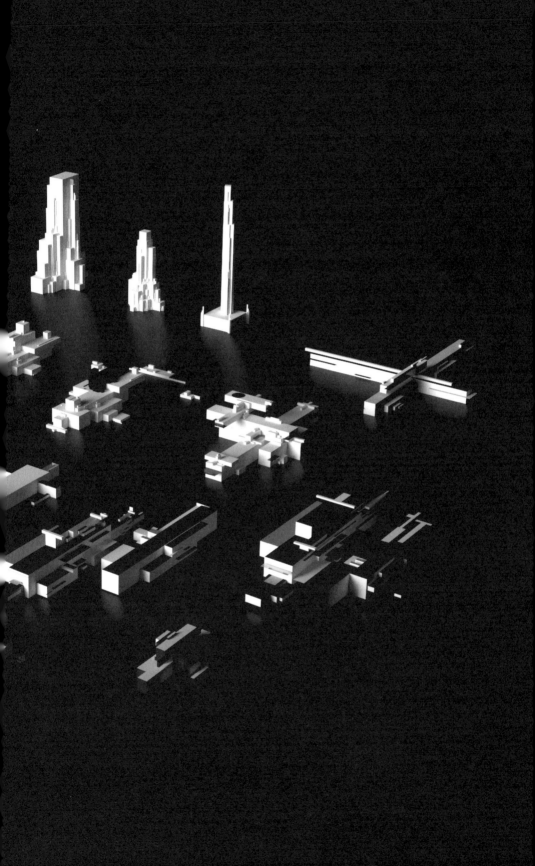

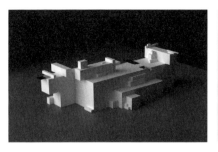

A11 in five objects and five techniques.

seven objects that we have called A20, A21, A22, A23, A24, A25, and A26.[7]

If we add the planits to this account, the elusive number of arkhitektons and planits created by Malevich would become an overall working number of twenty-nine objects for study: twenty-one arkhitektons (volumetric plaster models), and eight planits (axonometric or perspectival drawings). Because two of these planits are the axonometric or perspectival versions of arkhitektons (A10 and A11), the total number of individual forms is twenty-seven. We use the term "forms" here in order to differentiate them from "techniques," "states," and "positionings." These distinctions matter when explaining our digital reconstruction of Malevich's work.

One given "form" could have been carried out through different "techniques" that, in turn, would eventually present different "states" of the same form, which, furthermore, could have been "positioned" in different locations. In other words, we use "form" to refer to the stabilization of a recognizable configuration, independent of its appearance through different techniques, its variations in various states, and their appearance in different places.

For example, A11 is a "form" that came to light through five different techniques: the making of a physical three-dimensional plaster model; the photograph of that model; an axonometric drawing; a perspectival axonometric drawing (the last two corresponding to planits); and a photomontage—the well-known 1924 Suprematist transformation of the emblematic New York skyscrapers of the first decades of the twentieth century. As described by Jean-Louis Cohen, "The Woolworth and Singer buildings can be seen on the left, and the Bankers Trust Tower, on the right. The A11 . . . appears upright, wiping out both Trinity Church and part

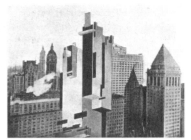

of the Equitable Building."[8] This is in fact a vertically rotated version of an A11 planit drawn in axonometric that Malevich published as a perspectival axonometric in *Blok* magazine 8–9, in Warsaw, in 1924.

A11 is not, in fact, the same in each of these appearances. There are three variations, or "states," of the same "form": the plaster model and its photograph are the same and correspond to one state, the axonometric and axonometric perspective to a second, and the New York photomontage to a third. Despite such shifts, and largely because of the quantity, size, position, rotation, and density of the volumetric components, there are some stable features in this construction that allow us to recognize A11 as A11 in all techniques and states. Form thus becomes the stable configuration shared by all states through all techniques. These distinctions also apply to all other forms devised by Malevich. The placement of A11 in Manhattan through its appearance in *Blok* is what we call "positioning," as it is something different from the arkhitekton's form, techniques, and states.

3 Architects

For many years Malevich's arkhitektons and planits have sparked architects' curiosity and imagination. In his own time he drew the attention of students and collaborators at the UNOVIS atelier in Vitebsk, like Nikolai Suetin, Lazar Khidekel, or Ilia Chashnik, or artists and architects in the Russian or European avant-gardes from El Lissitzky to the Bauhaus, including the Polish artist Władysław Strzemiński who in 1936, one year after Malevich's death, made an album with photographs of his arkhitektons. Strzemiński was a student and then colleague of Malevich from 1918 to 1921. This album contains ten vintage photographs of arkhitektons. One of the two copies is now at the Museum of Modern Art in New York.[1]

Later in the century, Malevich also influenced Oswald Mathias Ungers, Rem Koolhaas, Steven Holl, and Zaha Hadid when his work began to be revisited from within architecture. This moment really began when German architect Hugo Häring, having been guardian of the material Malevich left behind in Berlin after his 1927 exhibition, sold his entire collection to the Amsterdam Stedelijk Museum in 1957. Before that, however, a few years after Strzemiński's compilation, in the late 1940s O. M. Ungers discovered the Russian artist when visiting Häring's house, which, in Ungers's words, "was stacked from top to bottom with works by Malevich."[2] This encounter would leave a lasting mark on the

architect: "It was the rational, basic forms in architecture that really concerned me," he would later say, "the pure geometry."[3] Following this discovery, Ungers developed greater interest in the early twentieth-century Russian avant-garde. According to Leon Krier, by 1965 Ungers already had an impressive library, specially of Russian Constructivism.[4]

A few years after Häring's collection arrived in Amsterdam, Troels Andersen initiated the four-volume publication containing the English version of Malevich's *Essays on Art* (1968–1976).[5] Almost simultaneously, he also edited Malevich's *Catalogue Raisonné of the Berlin Exhibition 1927* for the Stedelijk Museum.[6] These were soon followed by other significant contributions to the growing scholarship on Malevich, including the work of Jean-Claude Marcadé (1979),[7] Jean-Hubert Martin (1980),[8] and Larissa A. Zhadova (1982).[9]

The French reception—through Marcadé and Martin—was additionally informed by works coming from Anna Aleksandrovna Leporskaya's Malevich archive, which was exhibited for the first time at the Centre Pompidou in 1978. According to Andersen, Leporskaya formed a lasting relation with Nikolai Suetin, who had been one of the central figures in the UNOVIS group formed around 1919–1920 by Malevich's followers in Vitebsk.[10] In this capacity, throughout the siege of Leningrad and the years of terror before and after World War II, manuscripts and several hundred drawings were held for safekeeping by Suetin and Leporskaya, including some scattered elements of Malevich's arkhitektons.[11]

Leporskaya's own collection of parts of Malevich's architectonic models in turn allowed the Danish painter Poul Pedersen to reassemble them. Pedersen, Andersen, and a group of students at the University of Aarhus had previously reconstructed two models as deduced from photographic records.[12] The subsequent and more comprehensive reconstruction of the arkhitektons undertaken at the Centre Pompidou is featured in the book edited by Martin in 1980.[13]

Taken together, all these publications contain Malevich's oeuvre in a broad sense, comprising drawings, paintings, and writings, including photographs of his arkhitektons and planits. Most of these photographs were now reappraised after disappearing from public attention for about thirty years. These decades of silence could be explained largely by Malevich's own fate after the rise of Joseph Stalin as General Secretary of the Communist Party of the Soviet Union (1922–1952), when Malevich suffered imprisonment

and his abstract work was censured, banned, and ultimately confined to the cultural and political periphery of his own country. After the death of the artist in 1935, aged only fifty-seven, the only remaining traces of the arkhitektons were those handful of fragments kept by Leporskaya.

In the field of art and art history the retrieval of Malevich in the postwar period was mainly the result of efforts by scholars and institutions in Russia, Germany, the Netherlands, Denmark, Poland, and France. But in terms of a more specific architectural reappraisal, and more specifically still of the arkhitektons, the attention took a more independent trajectory in England. In particular, we could consider Rem Koolhaas's and Elia Zenghelis's 1975–1977 Diploma Unit 9 at the Architectural Association (AA) School of Architecture in London, devoted to "Malevich sky/earth scraper." At the time, Koolhaas had just returned from Cornell University where he had worked alongside O. M. Ungers. While there is always a risk of oversimplifying the way influence and supervision work in academic circles, it is possible to see the emergence of a subtle thread connecting Malevich and Häring to Ungers, Koolhaas, and Zenghelis. A risk that is particularly real if this thread unfolds in a British context already engaged in revisiting Russian Constructivism at large.

A few years earlier, in 1971, when Koolhaas was still a student at the AA School, a major exhibition on "Art in Revolution: Soviet Art and Design after 1917" took place at the Hayward Gallery on London's South Bank.[14] The exhibition included a full-scale reconstruction of Tatlin's model for the Monument to the Third International (1919–1920). Built by Christopher Cross, Jeremy Dixon, and Christopher Woodward, the reenactment of the tower was installed on the gallery's sculpture terrace and visible from far along the river Thames. According to architect Rodrigo Pérez de Arce, this installation had a major impact at the AA.[15] Especially so because for a number of years the school had cherished the art and architecture of the USSR, starting in 1932 when the photographer F. R. Yerbury installed an exhibition showing materials gathered during his travel to Russia, including photos of Constructivist buildings as well as drawings, books, and posters. By the end of that decade the AA had started to build its own collection of books on the Russian avant-garde, including a copy of Yakov Chernikhov's *Architectural Fantasies* and subscriptions to the journals *USSR in Construction* and *Voks Bulletin*. And so, at the AA,

Architectural Association School of Architecture

34-36 Bedford Square, London WC1B 3ES

Telephone 01-636 0974

Events list 4

Autumn term

27-31 October 1975

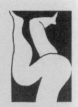

K. Malevitch: Suprematist Architectonics, 1923

Unit projects

Intermediate/Unit 2 — Nursery accommodation and playground, Camden Square, NW1
The programme is divided into two parts. The initial part is concerned with basic design process and placing a building in a site, considering the site in relation to its urban context. In the second part of the programme students will tackle the problem of placing nursery schools in available spaces or vacant urban spaces in general and develop a prototypical and adaptable nursery school, using more advanced methods of construction.

Intermediate/Unit 5 — Flying pigs and waltzing balloons
Students are to design a fairground attraction based on a traditional or novel theme (sound, light, colour movement). Ideas should be synthesized to produce an event that works well as a fairground attraction and illustrates the appropriateness and fun of the technical solution. A necessary part of the project is a study of the problems of designing readily demountable structures. The presentations will take the form of a large-scale model.

Diploma/Unit 4 — A dwelling for 20 to 30 beings
The site is defined only as a long rectangle between cross walls in an inner urban but otherwise undecipherable area. This is a project of interiors. It was the conceit of modern architects to believe that form should always follow function, turning the house into the proverbial machine for living in. The brief proposes that in place of this formula students could approach the design with the idea that form sometimes follows the pattern of our lives and at other times follows its own route.

Intermediate/Unit 6 — Chair programme
This project has been designed to give students an insight into how people read and display information. Each student has been given drawings and a photograph of a chair fabricated in timber — information which indicates the elements of the structure but not the exact methods of jointing. They are then invited to construct the chair from the available information. Another aspect of the fabrication process which they are invited to explore is the appropriateness of the fixing methods (established by the student) to the material being used. At what point does one solution become inappropriate and another become 'right' and what are the criteria for these decisions?

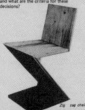

G. Rietveld, Holland, 1934 Zig zag chair

Diploma/Unit 8/Unit 6 — Starter project and beginning of inter-unit collaboration
Before reorganising the environment of other people and communities, the architect and urban designer must at least

show proof of understanding his own locality. If we cannot be something of an expert on where we live or have lived, then it is doubtful that we can offer 'expert' advice elsewhere. Imagination should be one of the attributes of the sensitive designer, but in our complex society imagination is not always in the doing but, first and foremost, in the understanding. Corners may or may not be heroic, but they are certainly pathetic, sad, happy, wistful, annoying, exhilerating, daft, smelly dark and beautiful. They may also be illegal. Traps. Places of murder outside brothels... and so on. They are also political statements, social phenomena... They can be oppressed, invaded and defended... AND THAT'S ONLY CORNERS... what of streets, towns, cities, lavatories?

A range of projects on this theme will include: The death of a street; My cottage in the country; How a slum works; The military as planners; A provincial backyard; "Chez nous"

There will be a two-day exhibition in the Diploma/Unit 8 space beginning on Tuesday 28 October There will also be a joint Unit 6 and Unit 8 meeting on the project at 2pm Tuesday October 28th, and anyone else in the School is welcome to attend.

Diploma/Unit 9 — Malevitch sky/earth scraper
In the early twenties in the USSR Casimir Malevitch and students of his atelier produced a series of architectural models which they called 'tektoniks' The models had only an outside — the interiors were never planned or specified. The buildings would rest casually on the earth waiting to be occupied by the representatives of a new culture who would find the enigmatic buildings and 'conquer' them in a process of architectural specification. In the thirties the Surrealists invented a game which they called 'le cadavre exquis' (the terrific corpse) A verbal version of the children's game where the first participant draws a head, folds the paper the second draws a rump, etc., they used this device to produce poetic sentences and stories whose unpredictability and unexpected juxtapositions were valued in a time when the conscious and rational production of meaning appeared suspect and stagnant. In New York, when a building such as a skyscraper reaches a certain 'critical mass', a spontaneous architectural version of the same Surrealist recipe is inevitable. The total volume of a building is so gigantic that at any one time several architects may be planning conversions, interiors etc. without any awareness of simultaneous activity by other colleagues in the same building. These architectural enclaves are linked only by the objective data of common services and the external skin of the building. The project intends to combine the above three anecdotes, taking a 'tektonik' as the point of departure, to design a building in a Metropolitan location and then dismantle it conceptually and develop internal sectors with maximum explicitness and precision.

New Planning Department staff

The Planning Department has added two new members to its staff: Ruth Issacharoff, who is running the Development of Cities course, and Paul Lawless, whose primary concerns are with planning issues, techniques and philosophies.

Ruth Issacharoff, BA Dip TP
Studied history at University College, London and social administration at LSE, and planning at North London Polytechnic. Worked in research at LSE, the Centre for Environmental Studies and currently at School of Environmental Studies, University College, and Urban and Regional Studies Unit, Kent University Has written on community action and race relations, and on housing in Greater London. Currently working on the political and ideological aspects of the growth of owner-occupation, and processes of suburbanisation 1919-39. Has worked in spare time in a community action group in Camden. Joined AA staff 1975 for one day per week.

Paul Lawless, MA (Cantab) Geography, B Phil Latin American Studies (Oxon)
Worked in planning authorities for three years. Joined AA Planning Department 1975.

Gail Turner — Photographs

An exhibition of photographs taken by Gail Turner between 1972 and 1975 will be shown at the AA in the Lecture Hall Seminar Room from 27 October to 7 November Monday to Friday 10 am to 7 pm; Saturday 10 am to 3 pm. (The Lecture Hall Seminar Room will be closed for short periods during this time for meetings)

Gail Turner is a member of the Communications Department at the Architectural Association.

Architectural Association School of Architecture, Events List week 4, Autumn Term, 27–31 October 1975.

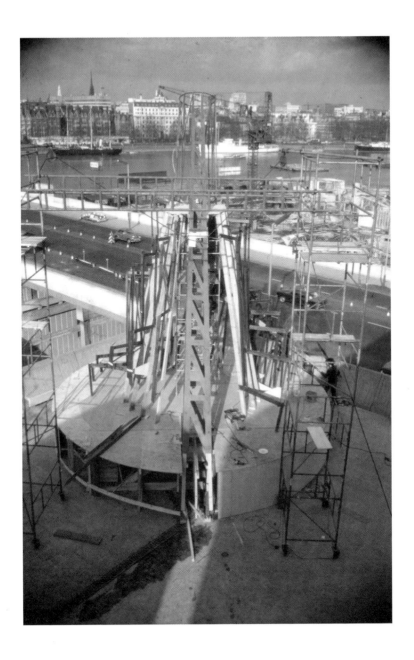

Full-scale reconstruction of Tatlin's model for the Monument to the Third International: the 1971 Hayward Gallery reconstruction, showing Waterloo Bridge and the site of the emerging National Theatre behind. Courtesy Jeremy Dixon.

the reappraisal of Malevich's arkhitektons and planits during the 1970s did not take place on a blank slate. The efforts at the AA also involved a coterie of other authors and scholars, not least the historian Catherine Cooke, whose PhD thesis at Cambridge University and her subsequent extended research, writing, and lecturing on the Russian avant-garde are credited with having transformed an understanding of the Constructivist movement in British academic circles, and in the English-speaking world more generally.

This, then, was the background to the course run by Koolhaas and Zenghelis, which, as they wrote in the studio program, explored "a series of architectural models Malevich and his students called 'tektoniks.'"[16] The models, they continued, "had only an outside—the interiors were never planned or specified."[17] The studio itself combined this starting point with the Surrealist practice of the *cadavre exquis* and an appraisal of New York's "gigantic buildings." Conflating these elements, they used Malevich's arkhitektons as prompts "to design a building in a metropolitan location and then dismantle it conceptually."[18] Soon a vertically rotated version of arkhitekton Alpha appeared illustrating the work of the studio in the AA Events List. By the end of the academic year, the school's Prospectus would present the work of three of its students, Alex Wall's tektonik revitalizing the McGraw-Hill Building, Tom Zacharias's YMCA in tektoniks, and Zaha Hadid's tektonik on the Thames.

Hadid's project is well known. In it, she makes explicit reference to Malevich's arkhitekton Alpha, introducing the object with a hotel program on top of Hungerford Bridge across the River Thames in London.[19] Now held at the archives of the Zaha Hadid Foundation in London, the title page of her diploma project shows a Constructivist-like photomontage featuring Malevich's original photograph of Alpha's state 3 (called Form D), composed of fifty-one elements. Her final project, however, is a much-simplified version, with twenty-eight elements, and does not correspond to any of the states ever assembled by Malevich.

But Hadid's was not the only bridge inspired by Malevich's arkhitektons. Around the same time, US architect Steven Holl also designed a bridge, with a gymnasium program, again with the arkhitektons in mind. Malevich was, he says, "really my beginning, the pivotal inspiration in making my buildings, my first compositions worth mentioning."[20] While his first published project was an underwater house in Saint-Tropez, literally a Suprematist

Current unit projects

Philip Chudy: Matopos 1975

Zimbabwe

Three photographic essays by Philip Chudy
16 February — 6 March
Lecture Hall Seminar Room

Philip Chudy, a photographer, is presenting three separate photographic essays on Zimbabwe. The first, which was on display last week, was about the dramatic landscape of the region. This week's will be about African shops — a contemporary vernacular style. The third will be a series about people, including portraits and group studies.

The three essays are drawn from a much larger portfolio of work collected by Philip over a number of years.

The purpose of the exhibition is as much to inform us about the landscape and the people that Cecil Rhodes once claimed as part of his personal estate as it is to reflect the eye and the art of the photographer.

All of the studies are for sale.

AA FC

The AA Soccer Club scored a tremendous victory over YMCA National College by 6 goals to 5. Scorers were:
Hughy McIntyre 1
Louis Pinnock 1
Aristides F. Marques 1
Paul Walker 3
The following is a schedule of the remaining fixtures:
Feb. 25 vs. Croydon
March 3 vs. Putney College F.C.
March 10 vs. Central London Poly
March 17 vs. Ealing Tech and School of Art.
New players are always welcome.

A letter to the Editor

Dear Editor,
Self-perpetuating governing body
May I draw the AA Students' Union attention to the facts? It deplores the whole system of a self-perpetuating governing body of the AA (School Community Meeting last Thursday).

Generally the AA Council numbers eighteen people each year, with officers and ordinary members restricted from holding office for more than two or three consecutive sessions *but requiring re-election each year nevertheless.*

In 1971 twelve new members were elected to the Council; in 1972 eight; in 1973 seven; in 1974 eleven, and in 1975 five. Really not a bad record when compared with the much more static bodies most other student unions have to operate with.

Yours,
Edouard Le Maistre
Secretary

*Annetta Pedretti (2nd Year)
Intermediate/Unit 1 "Simple Simon's architectural recipe"*
The programme was concerned with some ways of understanding "place". Students were asked to examine and describe a place, and from this analysis to design an improvement in the performance of that place.

John Knights (5th Year): Bayswater Road Housing
Diploma Unit 4 "Four sites" programme
An architecture of inhabited rooms which, in their range, reflect and hopefully augment the various situations that go to make up human affairs. An architecture which acknowledges differences in age and circumstances but which accommodates these without segregating them; which suitably houses both convivial and solitary occasions, buildings which are intended for habitation and not solely for use.

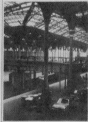

Intermediate Unit 5 'Liverpool Street Station walkways'
Jury on Tuesday at 10.00. The aim of the programme is to explore the potential of the overhead walkways at Liverpool Street Station and to prepare a scheme showing how these could be exploited.

*Barbara Sawdon: Typical street sections.
Diploma Unit 2 'Urban design programme'*

Diploma Unit 9 'Malevitch project' model

Chilternscape '76

A competition has been organised by the Chiltern Society to celebrate its tenth anniversary. They are looking for schemes for any leftover scraps of urban or rural landscape, pedestrian precinct, village green, waste tip, skyline horror or anything else that, with bold imagination and resourcefulness, could transform the landscape somewhere in the Chilterns area.

The competition will be in two stages and will have three classes — Professional, Lay and Junior. The prizes for students will be £400 (1st), £250 (2nd) and £150 (3rd)
Entry forms must be submitted by 31st March. First entries (2-D) are due on 30th April, and final entries (3-D) are due on 22nd October
Further details from Helen Roe via pigeon-hole.

Correction

A video presentation by Fantasy Factory was mistakenly advertised for last Tuesday in Events list 6. It will in fact take place on Tuesday 24th February at 6.00 in the Communications Studio.

Notes

There will be a meeting at 10.30 on Friday 27 in the AA Workshop for people interested in constructing and testing solar collectors. This will form a preliminary investigation for the house conversion project in Islington.

Solar Energy for Buildings

A seminar to be held at the North East London Polytechnic, on Thursday 26 February.
The purpose of this seminar will be first to review some of the existing hardware available for Solar Heatings applications and, secondly, to present examples of buildings which are using or intend to use Solar Energy for heating purposes. Papers will be presented by a number of experts followed by an open forum discussion and the showing of a film on Solar Building projects in the USA.
Further details are available in the Information Centre.

David Foster is going to Vienna to deliver drawings for the competition. He is leaving on 28 February for 1 March and is prepared to take other entrants' drawings for a share in the costs. Contact him via his pigeonhole.

RIBA Wales Region Bursary 1976 £250
Open to students born or residing in Wales to research any aspect of the built environment. Applications to the Chairman, SAW Education Committee, 49 Boc Lane, Wrexham, Clwyd by 1st March.

The Victorian Society are looking for someone to do research. The job is part-time and will run into the summer Typing ability is required.
Contact Hermione Hobhouse in General Studies for further details.

The Illuminating Engineering Society 'Lighting for Architects', 8–9 March, Mayfair Hotel

This is the third year the seminar will take place and it has been proposed that students of architecture should be invited to participate in a study of a specific lighting project.
Further details are available in the Information Centre. Any students interested in attending should give their names to John Starling, TSSU

*Henrietta Salvesen (3rd Year): Farmyard — point of arrival.
Intermediate Unit 2 'Rural Centre'
Second interim jury Friday*

Copy date Monday 5pm

The Events list is published every Friday. If you want to get something listed give details with pictures to your department secretary in time to reach the Information Centre by Monday

Produced by Mary Wall (Editor) and Bridget Cooke. Graphics by Martin Langdon. Photographic reproduction by Alex Wall. Typesetting by Dominique Murray Printing by Hill and Garwood.

DIPLOMA UNIT 9

Unit Masters
Rem Koolhaas and Elia Zenghelis

Tutors
Jeanne Sillett
Peter Wilson

Visitors
Gerrit Oorthuys
Dimitri Porphyrios
Anthony Vidler

Students

Roger Bennett	Keith Keller
Manuel de Castilho	Sefi Kiriaty
Bob Chan	Kay Lim
Nigel Crump	Ken Lloyd
John Edwards	Jackie Lynfield
Mohammad Fazaeli	Ricardo Maldonado
Tony Feldman	Michael McCrum
David Forster	David McGhee
Freddy Gerstl	Hillel Schocken
Gerard Filgallon	Uri Shaviv
Roger Gilles	Kenichi Shimomura
Andrew Goodenough	Orly Shrem
Harriet Gordon	Bill Smith
Peter Green	Terence Smith
Hamid Hamidzadeh	Dan Stranescu
Zaha Hadid	Herbert Tonkin
Richard Johnston	Alex Wall
	Angela Wilcox
	Tom Zacharias

The aim of Diploma Unit 9 has been to rediscover and develop a form of urbanism appropriate to the final part of the 20th Century: new types of architectural scenarios that exploit the unique cultural possibilities of high densities and that will result in a critique and eventual rehabilitation of the Metropolitan lifestyle.

Unit 9 is after an architecture that accommodates, provokes and supports the particular forms of social intercourse which realise the full potential of urban density: an architecture that houses in the most positive way the 'culture of congestion' in formally sophisticated structures.

The Unit works on projects which cover the spectrum from 'theoretical' to 'real' on one end of this continuum are 'ideal' projects that, without actually being built or even buildable, act as architectural 'theorems' ideological standards against which existing and projected buildings can be 'measured' — on the other end are projects that could be realised within the existing system but incorporate the critical principles which have been generated through the 'theoretical' work.

In all cases, the connection between ideology and architecture, and the justification of one in terms of the other is seen as the essential criterion for evaluating the works of the Unit.

Programme 1 — Tektonik

Taking one of Malevitch's Tektoniks (architectural sculptures undefined in terms of program or materiality), its implications and suggestiveness were investigated through a campaign of architectural specification, whereby the sculpture was given a size and metropolitan location; it was then dismantled. Fragments of it were given to the members of the Unit who, accepting the external envelop and such communal points as service cores and elevators, were asked to develop their sections with maximum explicitness. Through the extrapolation of the logic implied in forms, they inserted appropriate programmes to each part, developed interior spaces and specified internal and external materials.

After each fragment was completed, the entire Tektonik was reassembled, an episode of modernism concretized in retrospect.

Tektonik in Thames, Hadid

Tektonik revitalizing McGraw Hill, Wall

Programme 2 — Pools as Urban Types

The architects of the 20's in post revolutionary Russia, coined the term "Social condenser" for the new urban structures that were to be injected into the fabric of existing cities, as instruments of cultural emancipation, and magnetic centres of social interaction.

The pool project was offered in conjunction with the Malevitch programme, as a further exploration of urban prototypical structures. The aim was to culminate in a catalogue of individually designed pools which cover a spectrum of types and attitudes both in terms of location, and in terms of programme activity ranging from the rural and simple, to the metropolitan and sophisticated.

YMCA in Tektonik, Zacharias

Baths in Les Halles-hole, Crump-Goodenough

Unit 9. Unit Masters Rem Koolhaas, Elia Zenghelis. Tutors: Jeanne Sillett, Peter Wilson. Visitors: Gerrit Oorthuys, Dimitri Porphyrios, Anthony Vidler. Architectural Association School of Architecture, Projects Review 1975–1976.

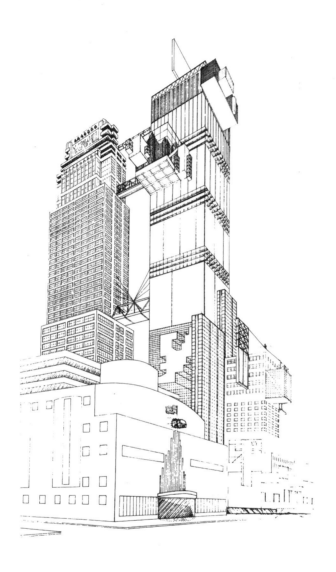

Alex Wall's tektonik revitalizing the McGraw-Hill Building. Architectural Association School of Architecture, Projects Review 1975–1976.

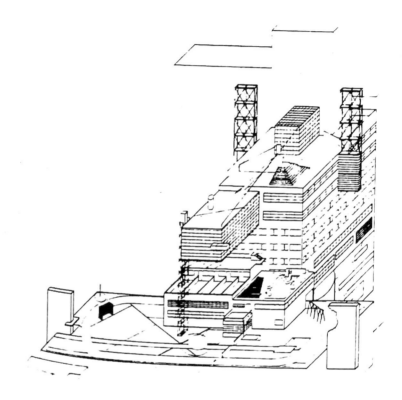

Tom Zacharias's YMCA in tektoniks. Architectural Association School of Architecture, Projects Review 1975–1976.

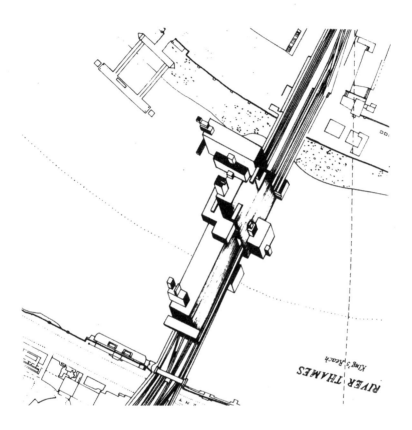

Zaha Hadid's tektonik on the Thames. Architectural Association School of Architecture, Projects Review 1975–1976.

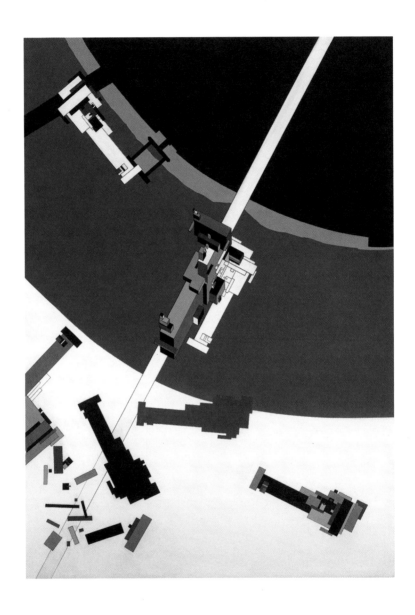

Zaha Hadid's tektonik on the Thames, painting. © Zaha Hadid Foundation.

Zaha Hadid, Malevich's Tektonik, diploma project, title page, 1976–1977. © Zaha Hadid
Foundation.

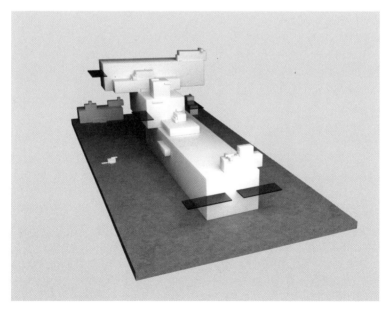

Form D. © Paulina Bitrán.

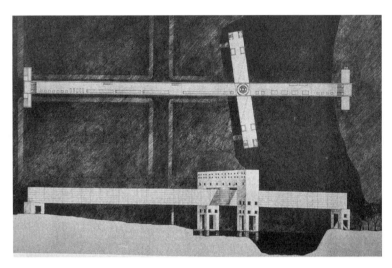

Steven Holl, Gymnasium Bridge, 1977. Graphite on paper, 22 × 29¾ in. (55.9 × 75.6 cm).
© Steven Holl.

"X" suspended under the sea, his second, the Bronx Gymnasium Bridge, "was practically a Malevich drawing turned into a bridge. I have a strong affinity for Malevich, including his writing, which is incredibly impassioned and has a disturbingly urgent feeling, as well as those plaster formal experiments, the architectones."[21] Not by chance both Holl's gymnasium-bridge and Hadid's hotel-bridge appeared in *Pamphlet Architecture* (issues 1 and 8 respectively),[22] a publication created in the mid 1970s by Steven Holl, with William Stout and William Zimmerman, when Holl had returned to New York after studying at the AA School in 1976. These bridges, however, could also be assessed in relation to a much earlier bridge that was also close to Malevich's arkhitekton Alpha, namely El Lissitzky's Bridge I (or Proun 1A) of 1919.

Back at the AA School, it should be stressed that Koolhaas and Zenghelis not only revisited Malevich as a teaching strategy, but also absorbed his work into their professional practice, notably for the first projects undertaken by OMA—the Office for Metropolitan Architecture, founded in 1975 by Koolhaas and Zenghelis and their partners, Madelon Vriesendorp and Zoe Zenghelis. As highlighted by Pier Vittorio Aureli, Malevich's arkhitektons were part of a tight constellation, or as he writes, a "Valhalla," of Koolhaas's favorite archetypal buildings, together with the RCA Building,

The Additional Element in Architecture

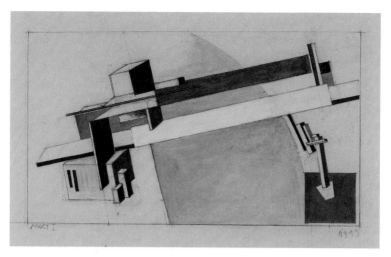

El Lissitzky's Bridge I (or Proun 1A), 1919.

Superstudio's Isograms, El Lissitzky's Lenin Tribune, Mies's typi-
cal American building complex, and even an elevator.[23]

In 1977 the early works of OMA formed the subject of a special
issue of the then highly influential *Architectural Design* magazine,
presented as part of a larger ongoing research project that Kool-
haas called "Manhattanism."[24] The following year Koolhaas reit-
erated the same rubric with the publication of his famous book
Delirious New York: A Retroactive Manifesto for Manhattan. OMA's pro-
posals for New York were presented in both publications. *Delirious
New York* included five such projects in an appendix titled "A Fic-
tional Conclusion"—in chronological order, The City of the Captive
Globe (1972), Hotel Sphinx (1975–1976), New Welfare Island (1975–
1976), Welfare Palace Hotel (1976), and The Story of the Pool (1977).

Two of these projects, the City of the Captive Globe and New
Welfare Island, feature reenactments of Malevich's arkhitektons.
The former brings a rather free version of a vertical structure, sim-
ilar to arkhitekton Gota.[25] The comment in *Architectural Design*
reads:

Architecton of Malevich: in the early 20s Malevich and his
UNOVIS Atelier in Vitebsk produced a series of architectural
models that display a striking parallelism with the forms
that would emerge later in Manhattan through the

Architects

OMA, The City of the Captive Globe, 1975–1976. © Rem Koolhaas with Zoe Zenghelis, courtesy OMA.

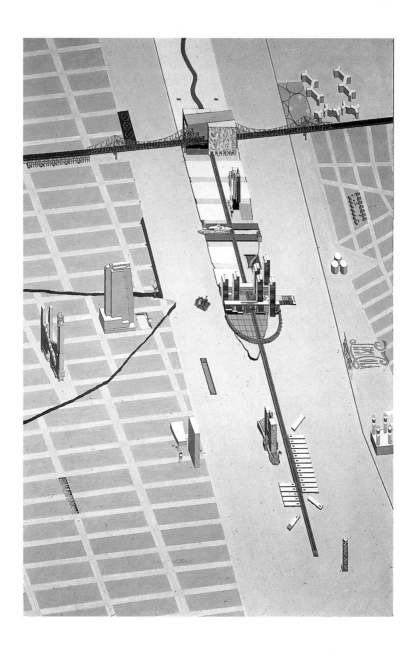

OMA, New Welfare Island, axonometric, 1975–1976. © Rem Koolhaas with German
Martinez, Richard Perlmutter; painting by Zoe Zenghelis.

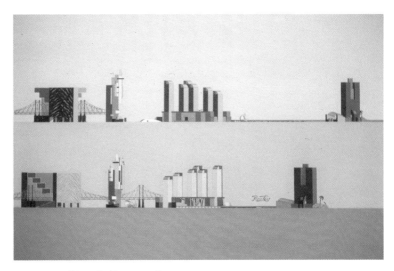

OMA, New Welfare Island, 1975–1976. © OMA.

imposition of the Zoning Law. They were an "architectural forecast" (equivalent of weather forecast) without scale, location, programme, occupants, to be realised by later civilizations (now?).[26]

The project for a New Welfare Island features a vertically rotated version of A11, a reinterpretation of the planit Malevich famously inserted into his collage of New York City.[27] OMA clearly considered the planit as if it were a real building—"once proposed for New York, but for whatever reason aborted"—before returning to the idea that it "will be built 'retroactively' and parked on the blocks to complete the history of Manhattanism."[28] And so, in the New Welfare Island, the rotated planit is reinterpreted as a colorful skyscraper. Koolhaas more fully describes the OMA approach as follows:

> Due to an unspecified process of levitation that would be able to suspend gravity, the involvement of Architectons with the surface of the earth was tenuous: they could assume, at any moment, the status of artificial planets visiting the earth only occasionally—if at all. The architectons had no programme: "Built without purpose, (they) may be used by man for his own purposes . . ." They were supposed to be conquered programmatically by a future civilization that deserved them.[29]

The Additional Element in Architecture

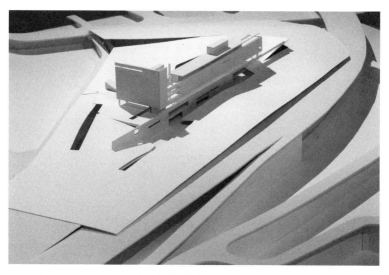

João Luís Carrilho da Graça, model of School of Communication and Media Studies, Lisbon, 1987–1993. © Tiago Casanova. Archive João Luís Carrilho da Graça.

All of these OMA projects from the late 1970s were clearly conceptual and therefore remained wholly unrealized. But about ten years later, the Portuguese architect João Luís Carrilho da Graça would build his School of Communication and Media Studies in Lisbon (1987–1993), a structure that he considered an homage to Malevich's arkhitekton Alpha. Like many others, Carrilho da Graça came upon Malevich, and Constructivism more generally, through Koolhaas's publications,[30] and spoke for a whole generation of architects in his admission that he "was enthralled by this sculpture by Malevich," and that his building in Lisbon "reflects that fascination."[31]

Ranging from Ungers's "discovery" of Malevich in the 1940s, through Koolhaas's and Zenghelis's appraisal of his "enigmatic buildings" or Holl's "pivotal inspiration" in the 1970s, up to Carrilho da Graça's realized "fascination" in the 1980s, there seems to be an ongoing tension between the form of the arkhitekton and the introduction of a program. Architects appear to have always seen the arkhitektons as models of unrealized buildings, like empty forms craving occupation and reinterpretation. Such a reading is perfectly understandable, but there is a rhetorical leap that must be assessed in the assumption—encouraged by Malevich himself—that the arkhitektons are equivalent to architectural

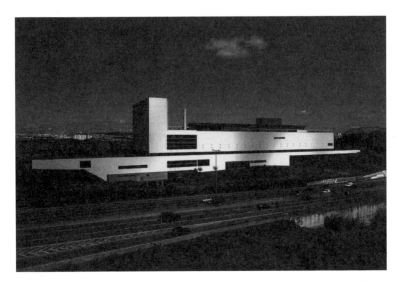

João Luís Carrilho da Graça, School of Communication and Media Studies, Lisbon, 1987–1993. © Maria Timóteo. Archive João Luís Carrilho da Graça.

models, and therefore to buildings (as he often said, the new art of Suprematism would become a new architecture, transferring forms from the surface of the canvas into space).[32] It's true that from the point of view of the actual objects, the plaster models do in fact resemble some kind of abstract, geometrized buildings, but the assumption that the objects have an existence outside themselves (as the representation of something else) deserves further attention.

All of these architects may well have seen physical models of recreated arkhitektons, but more probably they would have seen photographs, drawings, and photomontages. And so what is enigmatic, in the first place, is not so much the objects per se, but the carefully crafted photographs that Malevich produced of them. Or rather, beyond the actual model, what is enigmatic is the image of an object that is taken to be the model of a building. In this sense, the seduction that many architects seem to have experienced when encountering the arkhitektons may in reality have been Malevich's painterly technique that allowed photography to resemble architecture. Seduction and sensation are therefore within the model, but also in all of the techniques Malevich deployed in its presentation, including a sharply contrasting chiaroscuro as well as perspectival distortion. Taken together, Malevich reveals both larger

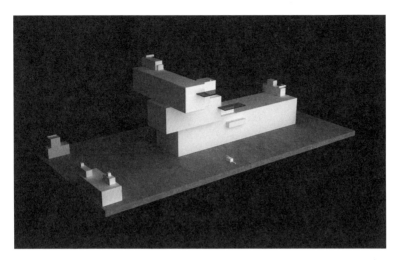

Rear view of arkhitekton Alpha state 3. © Paulina Bitrán.

and smaller prismatic volumes as if they were brushstrokes, positioned more or less close to each other, differentiating the multiple planes of the arkhitektons, as well as a multiplicity of tones subjected to variations in light. What he was seeking was a natural order, a rigorous articulation of the masses, an affirmation of the deep rhythms of the universe.

We tend to see drawings and models as scaled representations of actual buildings, rather than perceiving buildings as their blown-up representations. Such a distinction gets to the very core of a dispute of what is and what is not real. The building is real, the drawing is representation. But in Malevich's case, the arkhitektons, as volumetric plaster models, are the blueprints for going back to two-dimensional framings. The photograph is real, the arkhitekton is its representation. In order to fully grasp this sleight of hand, the image, and not the object, must be assessed. And in order to best present an architectural reading of Malevich's arkhitektons and planits from within the images he produced, we need to pursue an approach to "techniques."

4　*Techniques*

Every single picture created and published by Malevich was carefully planned and filled with purpose and intention, both the images themselves and the media through which they were to be distributed and positioned. This is the case for the way the planits were drawn, as for the way arkhitektons were photographed. For Malevich, the photographs are not some sort of subsidiary element to present his architectonic volumes, but in some sense they *are* the architecture, certainly to the point that the objects subjugate themselves to their visual depiction. The arkhitektons have their volumes positioned in such a way that their edges are consciously aligned both vertically and horizontally. This generates a visual continuity between planes, an effect that is particularly noticeable when they are located at different depths. One can see such deference by noting that the choice of plaster used to produce the arkhitektons relates directly to the way light works in the photographs, rather than to the way it would facilitate the arkhitektons' making. In other words, materials and techniques deployed in the fabrication of the arkhitektons belong to the realm of an effect achieved only through photography. And this effect, as in all cases, is a painterly "sensation." While it is certainly right to say that the Alpha, Beta, Gota, and Zeta pieces were a reversal of Malevich's former technique (where he projected three-dimensional spaces onto the canvas), it is also true that the

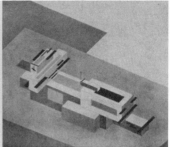

A10 as arkhitekton and planit.

making of volumetric models was a necessary step to casting them back into a photographic frame.

But there is another aspect of the technique of plaster modeling that also relates to photography. Malevich, it seems, liked plaster because of its fragility, producing objects that were appealing precisely because they would not survive the test of time without breaking up or dissolving into dust. In that sense he did quite a good job. Such a material condition endorsed Malevich's obsession during much of the 1920s with nonobjectivity, disintegration, the pulverization of matter, and the destruction of the object. In using plaster to make hundreds of loose prismatic volumes—in our estimation, about 1,800—he was making sure that the individual pieces of the arkhitektons would inevitably be lost or destroyed, never able to endure long enough to make their way into museum collections (we should not forget that at least 500 of these plaster pieces were about 2 × 2 mm in size). But the deliberate disintegration of one medium was balanced by the methodical endurance of another, for the ephemerality of plaster only served to reassert the importance of photography in the whole process of recording and thus preserving his works. Photography reproduces to infinity what has occurred only once, as Roland Barthes would have it.[1]

The ascendancy of the photographic meant that the picture of the arkhitekton becomes a kind of canvas onto which one is encouraged to read perspectival shifts, or to consider the oblique positioning of the camera angle, the framing and depth of field of the object, and the use of dark backgrounds to rehearse the painterly techniques of chiaroscuro: a treatment of light and shade to create realistic three-dimensional effects. Or to put it another way, the powerful three-dimensional qualities of the arkhitektons

reside just as strongly in their photographic depiction as in their material objecthood.

Yet in neither photography nor drawing did Malevich follow a rigorous mathematical system, like any of those precise perspectival approaches adopted during the Italian Renaissance. Rather, his method belonged to what is generally termed "distorted" or "false" perspective, or what Pavel Florensky referred to as "reverse perspective," to borrow the title from his celebrated essay of 1920.[2] From his longstanding investigation of Russian and Byzantine icons, Florensky maintained that these older religious artifacts present "particular relationships [that] stand in glaring contradiction to the rules of linear perspective." The problem, as addressed by Florensky, is that these "illiteracies of drawing" and the "obvious absurdity of such a depiction," instead of arousing rage, "are perceived as something fitting, even pleasing." So there is an "enormous artistic superiority in that icon which demonstrates the greatest violation of the rules of perspective, whereas the icons which have been drawn more 'correctly' seem cold, lifeless and lacking the slightest connection with the reality depicted on it." He concludes, "If you allow yourself simply to forget the formal demands of perspectival rendering for a while, then direct artistic feeling will lead everyone to admit the superiority of icons that transgress the laws of perspective."[3] Malevich was fully aware of this reading. In writing about Paul Cézanne, he praised the French artist as someone "in the forefront of these artist-painters, who have freed painting from the state of three-dimensional illusion and brought back two-dimensional plane painting, thus restoring to it its own true nature."[4] According to Raoul-Jean Moulin, writing four decades later, Cézanne upset "the traditional conception of pictorial space, gave a decisive blow to the linear perspective inherited from the Renaissance, and proposed to represent perspective solely through colour."[5] In other words, the true nature of paining is in the two-dimensional construction, not in the three-dimensional illusion (of perspectival space).

In the photographs of arkhitektons, we argue, chiaroscuro is also at play. As Florensky adds:

Further, if we turn to chiaroscuro, here we also find in icons a distinctive distribution of shadows that emphasizes and singles out the icon's lack of correspondence to a representation demanded by naturalistic painting. The

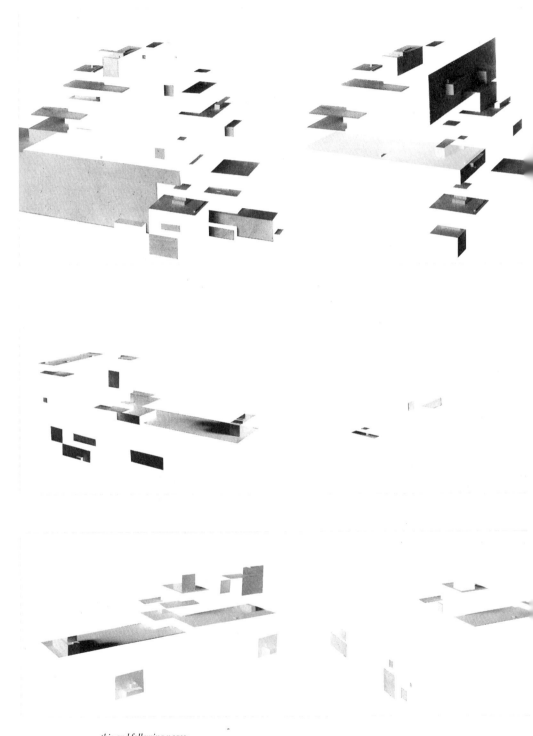

this and following pages:
Visual continuities in planes' edges, both vertically and horizontally. A study performed with photographs of arkhitektons Alpha (state 1), Alpha (state 3), Beta, A6, A7, A8, A11, and A19.

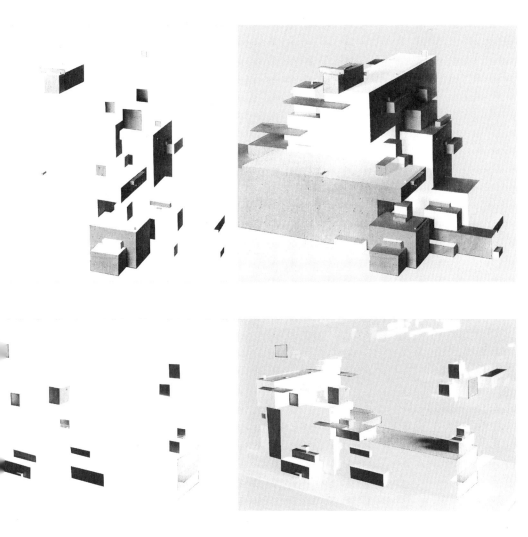
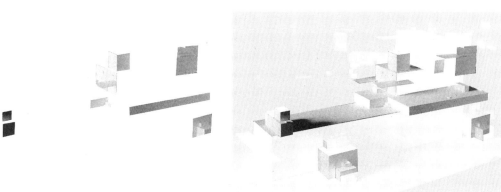

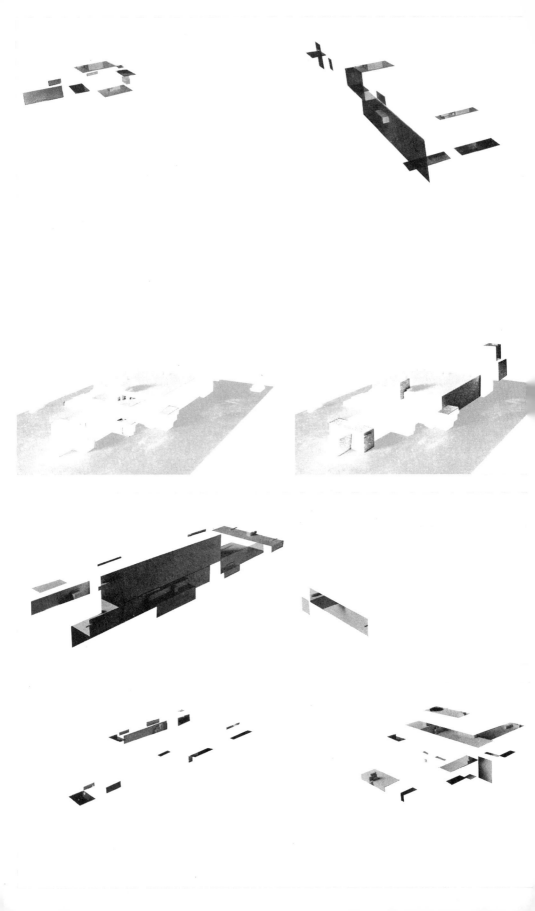

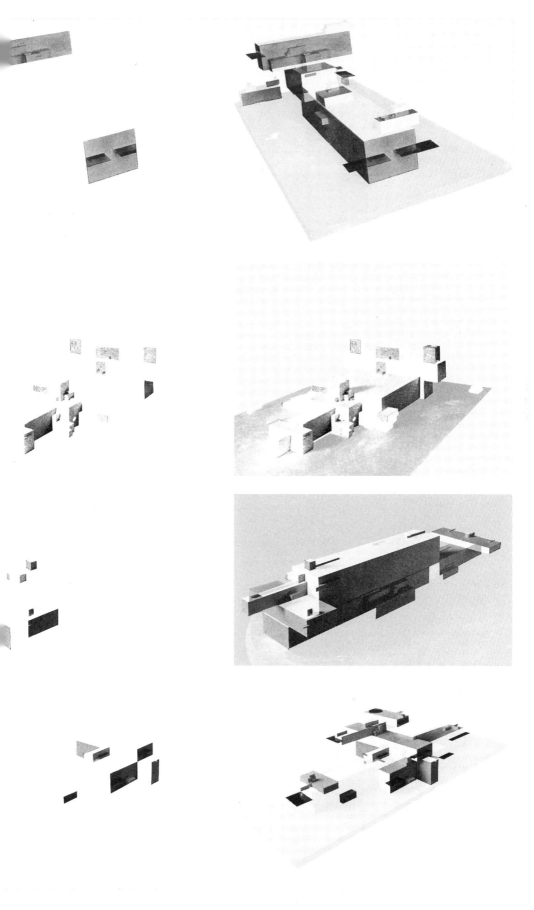

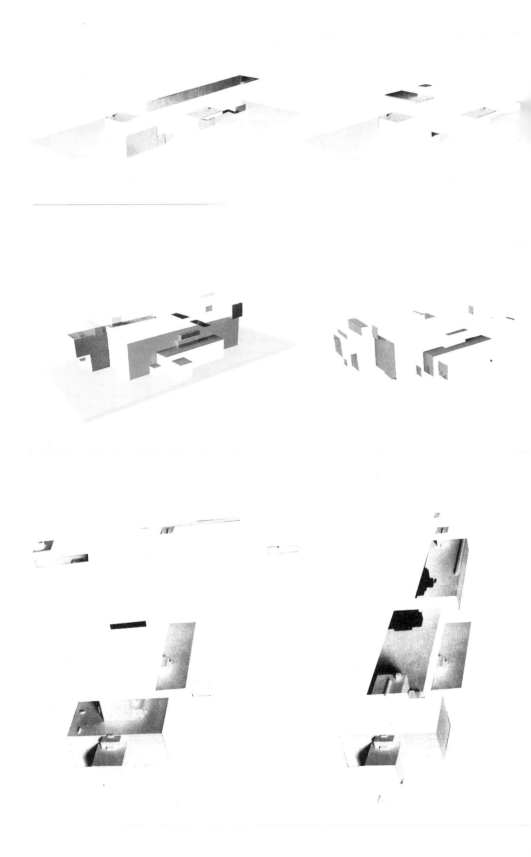

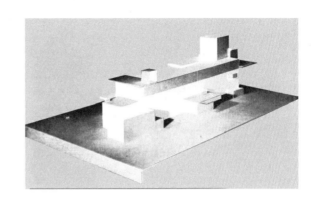
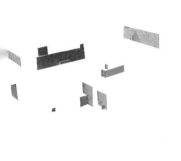
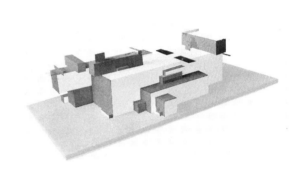
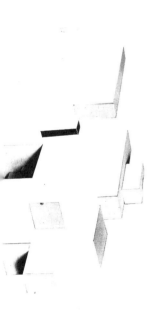
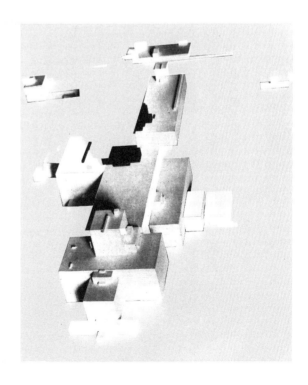

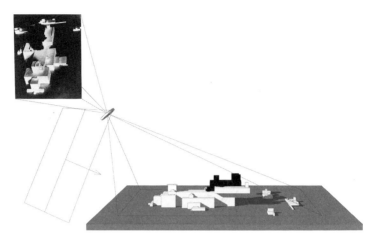

Arkhitekton A19. The projection of the volume onto a two-dimensional surface.

absence of a definite focus of light, the contradictory illuminations in different parts of the icon, the tendency to project forward masses that should be in shadow—these factors are once again not accidental, not the blunders of a primitive painter, but artistic calculations which convey a maximum of artistic expressivity.[6]

This reading can be easily applied to all of Malevich's published photographs of the arkhitektons, and especially to images of A19, where a black area merges with the dark background, the result of the addition of black prismatic elements on top of white ones. It is our contention that one reason to rehearse such a rare addition (black three-dimensional objects are only to be found in one other arkhitekton, A24) is that it is here that one best sees chiaroscuro at play, and with a reverse perspective in the coalescence of an alluring picture. By merging with the dark background, the black elements "work" as negative forms within the arkhitekton, appearing as a void.

The image of the arkhitekton is fabricated just as much as the arkhitekton's objecthood. Or rather, the arkhitekton is conceived so as to rehearse chiaroscuro in a "non-naturalistic" way. Regardless of whether he was working with painting, modeling, or photographs, Malevich always traces a geometric framework as a marking device to delimit a zone of action where the plastic composition must be made. This is the actual role of the base planes

where the arkhitektons and planits are delimited. The contradictory illuminations in different parts of the arkhitekton, the tendency to project forward masses that should be in shadow, would effectively violate perspectival unity, yet the photograph "acquires an aesthetic persuasiveness."[7] At stake is the fact that false perspective is false in regard to the techniques of perspective, not in regard to perception, even less to sensation (in arresting our senses). The fact is that we are not seeing a drawing that is mimicking reality, rather we are "experiencing a visual phenomenon."[8] According to Florensky, "the task of painting"—or in Malevich's work, the task of photography—"is not to duplicate reality, but to give the most profound penetration of its architectonics, of its material, of its meaning."[9] This includes the manifestation of light that depends on the material itself, "on the assembling of elements which make up a node or a form of energy . . . which colours its own movement[;] then it follows that in endless creation a transformation of materials is produced and the formation of new energetic assemblages."[10]

Reversing perspective is therefore a way of "reconstructing the perceived object in the consciousness."[11] This same reversal "now begins to be valued not as the pathology, but as the physiology of visual art."[12] Breaking the rules of a perspectival schema is nothing but an expedient to attain "truth to perception."[13] In Florensky's account, as well as in Malevich's practice, such perception is a multiple, even collective, flagrant "violation of the single viewpoint, the single horizon, the single scale. It is a violation of the perspectival unity of the representation."[14] In the process, the individual judgment of a single person, with their single point of view, at a singular specific moment is eroded by a new, multiple consciousness. This can also be noted in Malevich's use of what Florensky calls "polycentredness": "the composition is constructed as if the eye were looking at different parts of it, while changing its position."[15] In his text on Suprematism, published in 1920 alongside his thirty-four drawings, Malevich would in fact state that having invented a system, he "began to make a study of the passing forms that must be discovered and whose essence must be revealed."[16]

In *Techniques of the Observer*, Jonathan Crary highlights the emergence in the nineteenth century of a "new objectivity" according to subjective phenomena. Tracing this back to Johann Wolfgang von Goethe, Crary explains that such experiences—notably visual phenomena such as afterimages—"attained the status of optical truth."

P.4

P.1

Study of the vanishing points in the perspectival axonometries of planits. © Paulina Bitrán.

They are no longer deceptions that obscure "true" perception, but rather "they begin to constitute an irreducible component of human vision." Describing Goethe's observations on afterimages, Crary provides examples of an "empirical demonstration of autonomous vision, of an optical experience that was produced by and within the subject" that also implied "the introduction of temporality as an inescapable component of observation."[17] According to Patricia Railing, "Malevich initially took his colours and light from afterimages which the eye sees when stimulated by strong light, especially the sun."[18] Malevich, among numerous painters, Railing suggests, "discovered the basic principles of seeing from the three-volume *Treatise on Physiological Optics* by Hermann von Helmholtz, published in the 1860s,"[19] and translated into Russian in the 1890s. Whether following Goethe, von Helmholtz, or other parallels in contemporary philosophical discourse (including that of Friedrich Schelling), perception and cognition were regarded "as essentially temporal processes dependent upon a dynamic amalgamation of past and present."[20] For Malevich, the final constructed images should become "afterimages": they "move as the eye moves."[21]

Read through this wider intellectual milieu, Florensky's analysis of icons appears to be inscribed within just such a new, modern sensibility, through which we can also see Malevich's treatment of the relationship between his physically constructed arkhitektons and the images obtained from them, considering that perception and cognition are essentially temporal processes dependent on a dynamic amalgamation of past and present. In fact, for Schelling, Crary concludes, vision is founded on just such a temporal overlapping.[22] Therefore, it should be clear that Malevich's deviations from the rules of perspective are neither fortuitous nor mistakes, "but entirely premeditated and conscious."[23] Or to appropriate Florensky, the "incorrect" and contradictory details represent a "complex artistic calculation."[24] Instead of demonstrating a lack of knowledge or experience, they show rather the maturity of Malevich's art and the liberation from the subjectivism and illusionism of perspective.[25] Through such an appropriation, Florensky's conclusion becomes our own: "in those historical periods of artistic creativity when the utilization of perspective is not apparent, it is not that visual artists 'don't know how' to use it, but that they 'don't want to.'"[26]

This is especially apparent when regarding arkhitekton Alpha in all of its various states and as presented through photography.

The Additional Element in Architecture

More particularly, a perspectival study of the photographs shows that the vanishing point in the vertical axis is set very low. This effect shows a mismatch between the way an orthogonal prism deforms through the photographic lens and the way it does in Malevich's shoot. What then emerges, in our contention, is that Malevich did not plan the arkhitektons by playing around with volumes on top of a table, but composed them by looking at their assemblage through the camera lens.

Since these models, and in particular the horizontal models, are usually photographed from an aerial viewpoint directed toward a corner, the top and side elevations are the most visible. This angle provides the most information that a two-dimensional image can offer of the photographed object. At the same time this is the same angle often chosen by Malevich to represent the planits. One lesson learned from this initial type of analysis is Malevich's intention to avoid any perspectival distortion on the vertical axis in most of the photographed models, the same operation he performed in all the planits.

If we then turn our own attention to the planits, we can see the manner in which reverse perspective is fully at work, and how in the process a visual sensation becomes much more direct. Visually, the planits seem to be configurations of forms in equilibrium or in stasis, many arranged symmetrically, while in reality they are exactly the opposite. They are small visual exercises of mismatch. They are not drawings to buildings; they are tests in deception, a means to deliberately affect the eye. For instance, on pages 106 and 107, on the bottom of each pairing is an object as drawn by Malevich, and on the top is the way the object would have to be physically constructed in order to look that way.

There is one initial technique evident in all of Malevich's objects, through which at first sight we perceive a certain equilibrium in the volume and its tonal planes. The objects are apparently dynamic in their longitudinality, as well as distributing their elements symmetrically aligned along the longitudinal axis. But this apparent equilibrium is not matched by the state of the object that the drawing is alluding to. Here, the form has already been distorted in such a way that the equilibrium is only a matter of perception. In fact, the planits often present an apparent symmetry that, in order to be visually achieved, would need the elements in rear planes to be larger, so as to show a visual equilibrium.

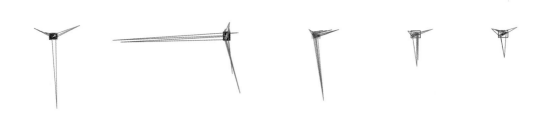

Study of vanishing points in the arkhitektons. © Paulina Bitrán.

The vanishing points are mainly two, but they are usually accompanied by additional vanishing points that are deduced from sets of volumes whose deformation is autonomous with respect to the rest of the planit. It would seem that the object was less deformed by defying perspective and prioritizing the orthogonal appearance of the elements. In this case, the form's interpretation and reproduction are made possible by considering those "individual deformed elements" as real-deformed prisms with nonorthogonal edges. Deformation would not be caused by perspective, but by the straight deformation of the form. These strategies performed by Malevich belong, in fact, to reverse perspective. He would suggest:

> Let us take another range of forms or lines which will change in size, if we make an especial use of the scales and directions of lines. Thus, two identical lines will give the impression of being different lengths if at each end of one is placed a v-shape pointing outwards, and at each end of the other a v-shape pointing inwards. Then the impression of our perception of dimension is changed not by colour but by various other relations between linear elements and their directions.[27]

Another strategy is visible when Malevich "opens up" the form. This is what we call the "dissolution of prismatic elements." The elements of the planits sometimes have two different planes, coming from two different prismatic volumes, but are visually merged as if they belong to a single element. This is a visual trap where it is impossible to tell whether one element is inside or outside the other. If this cannot be determined, the actual putative object cannot be attained. There are, also, elements with corners that are hidden in such a way that the volumes are not closed, so they are not proper prisms. We see a prismatic element where there is none. Or elements where false visual perceptions of gravity, weight, and stability are pretended though in fact the volumes are floating. This generates a sensation of dynamism. There is a typical operation used by Malevich, where is it also impossible to tell whether the two smaller prismatic volumes are inside or outside, or whether they are floating or resting in the ground.

The Additional Element in Architecture

Study of vanishing points in arkhitekton Alpha's original photographs. © Paulina Bitrán.

Working hypothesis on how the Future Planit for Earth Dwellers (1923–1924) and Future Planit for Leningrad: The Pilot's House (1924) would have to be constructed in order to look as they do in Malevich's planits.

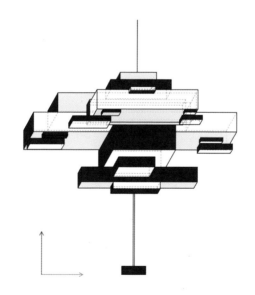

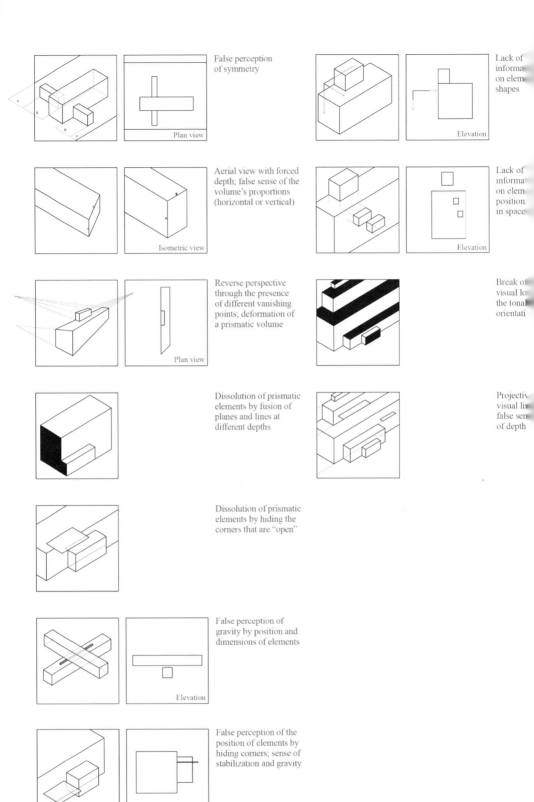

False perception
of symmetry

Plan view

Lack of
informa
on elem
shapes

Elevation

Aerial view with forced
depth; false sense of the
volume's proportions
(horizontal or vertical)

Isometric view

Lack of
informa
on elem
position
in space

Elevation

Reverse perspective
through the presence
of different vanishing
points; deformation of
a prismatic volume

Plan view

Break of
visual lo
the tonal
orientati

Dissolution of prismatic
elements by fusion of
planes and lines at
different depths

Projectiv
visual li
false sen
of depth

Dissolution of prismatic
elements by hiding the
corners that are "open"

False perception of
gravity by position and
dimensions of elements

Elevation

False perception of the
position of elements by
hiding corners; sense of
stabilization and gravity

Elevation

The dissolution of prismatic elements. A study of Malevich's visual traps in planits.

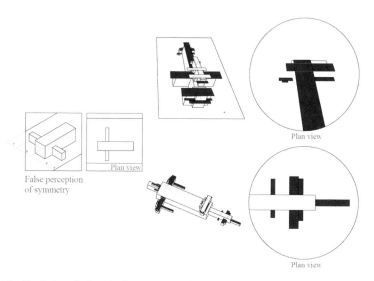

The dissolution of prismatic elements. Example from Future Planit for Leningrad: The Pilot's House (1924) and Spokoj (1925).

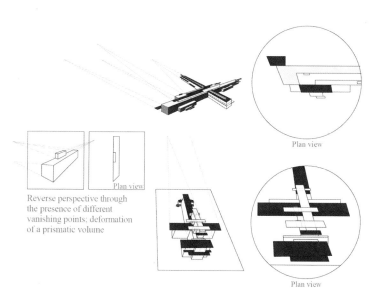

The dissolution of prismatic elements. Example from planits Dynamic Nonutilitarian Suprematist Architecture (1925) and Future Planit for Leningrad: The Pilot's House (1924).

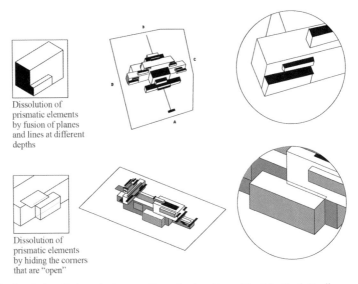

Dissolution of prismatic elements by fusion of planes and lines at different depths

Dissolution of prismatic elements by hiding the corners that are "open"

The dissolution of prismatic elements. Examples from Future Planit for Earth Dwellers (1923–1924) and planit A10.

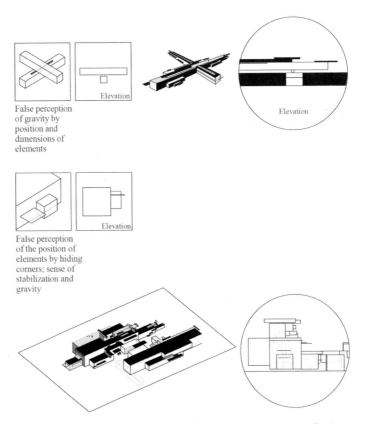

False perception of gravity by position and dimensions of elements

Elevation

Elevation

False perception of the position of elements by hiding corners; sense of stabilization and gravity

Elevation

The dissolution of prismatic elements. Examples from planits Dynamic Nonutilitarian Suprematist Architecture (1925) and Modern Buildings (1923–1924).

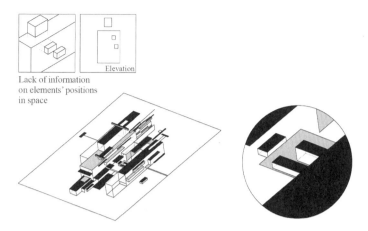

Lack of information
on elements' positions
in space

Example with planit Modern Buildings 2.

If we look at a set of drawings filled with all these ambiguities, not only do the objects become elusive, but they also "vibrate" in perception. This is of course not part of a vain and playful exercise on representation but holds a deeper meaning. The expression of these sensations "may really be an expression of the essence of phenomena in the nonobjective functions of the universe."[28] We may see geometry, abstraction, and some rigorous objectivity in the manner in which the planits are drawn, while in fact these are means toward sensation. The drawings, paradoxically, fix the objects while simultaneously being the proof of the impossibility of fixing them. They exist and do not exist at the same time.

5 *Archaeology*

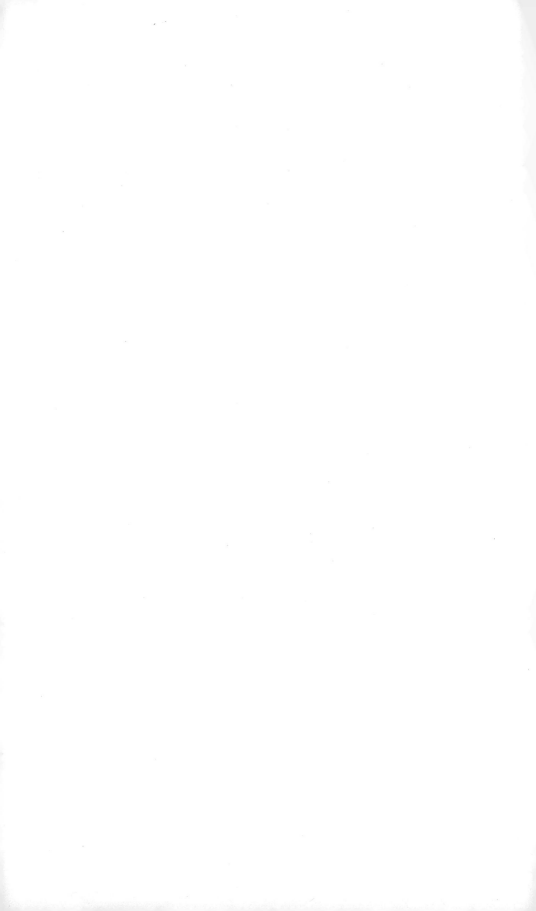

As highlighted by Troels Andersen, toward the second half of the 1960s, all the photographs of Malevich's arkhitektons had been reassembled. The main source "was an article published by Malevich himself . . . in the *Wasmuths Monatshefte für Architektur (1927–28)*."[1] This article featured forty-three photographs, considered in hindsight as the entirety of the "public" appearance of the arkhitektons and planits (with thirty-one photographs just of the arkhitektons). A similar process of counting can assess how often each respective arkhitekton and planit has been published since then. The numbers are uneven from one object to the other: while some photographs have been published many times, and in some cases a given model has been photographed from different angles, for most of the arkhitektons only a few images remain, and in many cases none at all. At the same time, by looking at the *Wasmuths* photos, we can chart seven models that are visible in panoramic views of Malevich's exhibitions (i.e., Leningrad 1926 and Berlin 1927) but that lack individual shots, and so have not yet been identified in the existing literature.

Because only a few original parts of arkhitektons and their reenactments remain in museum collections, the available information for each of the twenty-seven objects we are studying is in a few cases complete but for the majority is scant and fragmentary. This is precisely why we would pursue a visual archaeology,

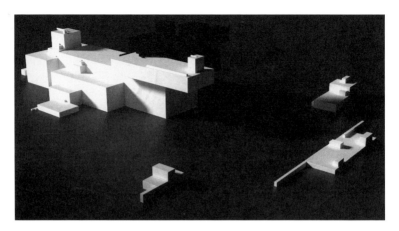

Rear view of arkhitekton A19. © Paulina Bitrán.

a process that is essentially unconcerned with the objects them-
selves (which may not be available) but rather with their depiction
(i.e., with their photographs, drawings, and publications). Such a
process involves careful study of the available images, inquiring
about the kind of photograph made, the lighting, the angle of
the point of view, the perspective formed by the combination of
lenses, the distance of the photographer, and the height at which
the image was captured, as well as the whiteness of the plaster,
the shade and the shadow, and those elements Malevich had
blacked out.

Rather than lamenting the difficulties posed by gaps in the
historical record, we took inspiration from the French natural-
ist Georges Cuvier, who famously boasted that the careful study
of a single bone was sufficient to reconstruct the whole animal
to which it belonged.[2] This approach encouraged us not only to
reconstruct the arkhitektons and planits on the basis of a few
photographs, but also to chart, and to compare, their different
configurations. Cuvier's conception of paleontology as a "his-
torical science" based on the study of fragments is the kind of
reverse induction that Thomas Henry Huxley later addressed as
the "method of Zadig,"[3] in reference to the Babylonian philoso-
pher who, according to Huxley, is cited in one of the most impor-
tant chapters of Cuvier's work,[4] and who "sharpened his naturally
good powers of observation and of reasoning; until, at length, he
acquired a sagacity which enabled him to perceive endless minute
differences among objects which, to the untutored eye, appeared

The Additional Element in Architecture

absolutely alike."[5] According to Huxley, "Cuvier's *Recherches sur les Ossemens Fossiles* is, from cover to cover, nothing but the application of the method of Zadig,"[6] adding that all sciences which have been termed historical or paleontological are the result of the accurate and rigorous application of Zadig's logic. In this sense, they are "retrospectively prophetic" and strive toward the "reconstruction in human imagination of events which have vanished and ceased to be."[7] We have adopted the very same reasoning when furnished with a fragment or a photograph, either to prophesy on the character of a genealogical series, or to predict the nature of the earlier terms.[8] At the core of this book, then, these *retrospective prophecies* (Cuvier) are reckoned with *reverse perspective* (Florensky) in order to disclose a kind of *reverse Platonism* (Deleuze).

Inspired by these approaches, our reconstruction of the arkhitektons employs processes of collecting, recording, observing, and representing the available images in order to construct working theses for each model. In the same way that they challenge the conventional idea of morphological variation from archetypal forms or ideals, through digital modeling we attempt to resolve the assembly of Malevich's components from their photographs and the study of differences and deviations between them, however small. Each arkhitekton speaks of a gradual transformation determined by a process of differentiation in response to Malevich's explorations on sensation.

In order to create digital models of these twenty-seven forms, the visual archaeology was compared with the available information from the few remaining original models in the collections of the Stedelijk Museum in Amsterdam and the State Russian Museum in Saint Petersburg, as well as the previous reconstructions by Poul Pedersen for the Centre Pompidou in Paris. Because his work was thoroughly documented, Pedersen's physical reconstructions of Alpha, Beta, Zeta, Gota, and Gota 2-a were directly translated into digital models. The remaining forms required further work and the necessity of distinguishing between the knowns and unknowns of these absent objects. Above all, the process required the formulation of well-informed assumptions that could fill in the missing information. These working hypotheses were needed, in particular, to cast light on the hidden sides of arkhitektons and planits—that is, the reconstruction even of those flanks of the objects where no photographic record is available. Thus the proposed hypotheses go together with the redesign of the models.

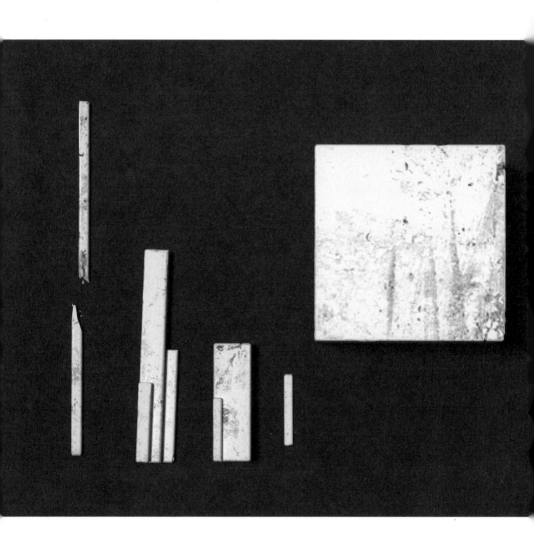

Scattered and fragmented plaster elements of arkhitektons. © Paulina Bitrán.

Once a visual archaeology is declared, the flat surface of the image is turned into an excavation site of sorts. The photograph is thus subjected to study and speculation: adjusted with more or less brightness or contrast; the figures sharpened, or sometimes the edges of small or large prismatic volumes blurred or softened. At stake is the possibility of deducing the position and size of the actual bodies, just from the way they work in the flat plane of the chiaroscuro. If Malevich imagined that he was transferring forms from the surface of the canvas into space, this archaeology aims at the opposite process of transferring forms from the surface of a photograph into a set of volumes.

The visual archaeology and digital reconstructions thus employed a process of design—given that the only way to see and test different reconstruction alternatives was by redesigning them to create a series of iterations. The process itself became a design-based quest, since the act of reconstruction demanded a constant movement between Malevich's writings, arguments, and concepts and the elusive array of arkhitektons and planits as found in the photographs.

Different types of graphic work and reconstruction models resulted from this process, starting from the study of the arkhitektons' original published photographs and their translation into digital models and line drawings. This analytical work included an appraisal of the implicit perspectival deformations in the photographs, as well as identifying as many volumes as possible within each image, with the exception of the prismatic elements hidden by the point of view or by the angle of the camera. The main obstacle to better understanding all of the assorted elements is the low quality of most of the photographs, with their high exposure and often high contrast of light and shadow, a result of their status as black-and-white reproductions in older books, catalogues, and magazines. Furthermore, the intensity of what would have been the gloss of the plaster is concentrated along the concave edges formed when two or more elements are set together, making it difficult to understand the limits, the shape, or even the existence of smaller components. Yet, by drawing each element's perspectival lines, it became possible to discover minor elements and their general arrangement.

This first stage of studying the photographs and the perspectival deformations within them allowed for the rehearsal of a first digital model of the arkhitekton in the image. Such a prototype

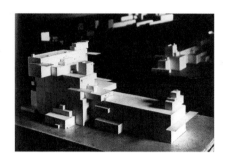

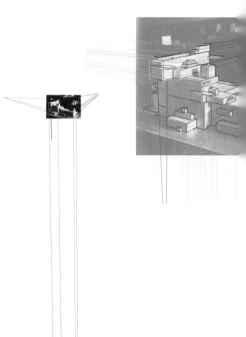

Arkhitekton Alpha state 1

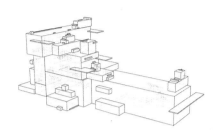
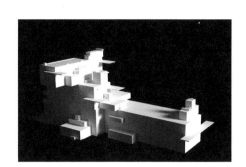

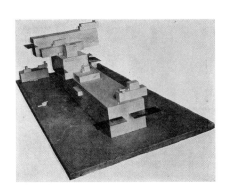

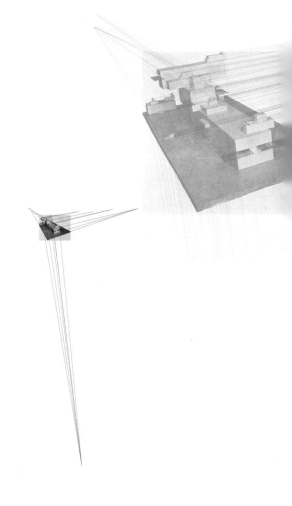

Arkhitekton Alpha state 3.

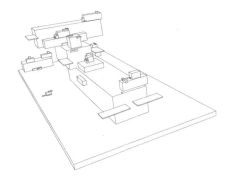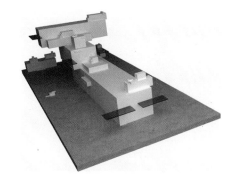

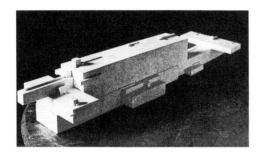

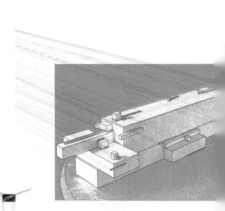

Arkhitekton A6.

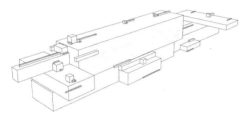
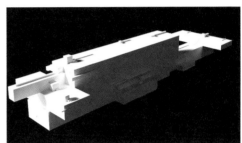

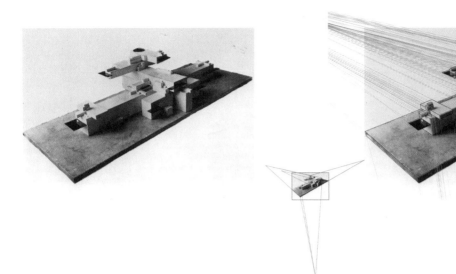

Arkhitekton A7.

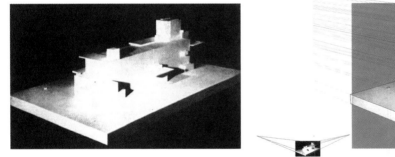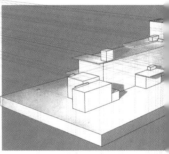

Arkhitekton A8.

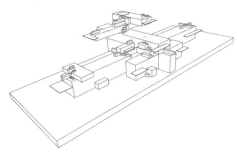 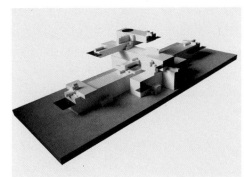

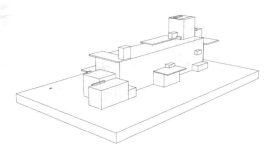 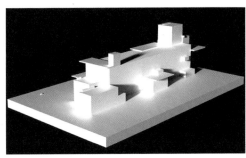

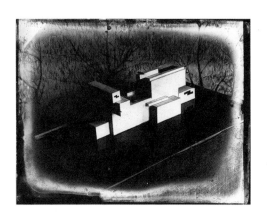

Arkhitekton A10.

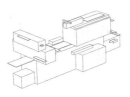

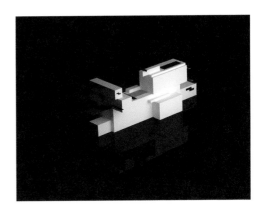

following pages:
The arkhitektons: a series. Rendering © Paulina Bitrán.

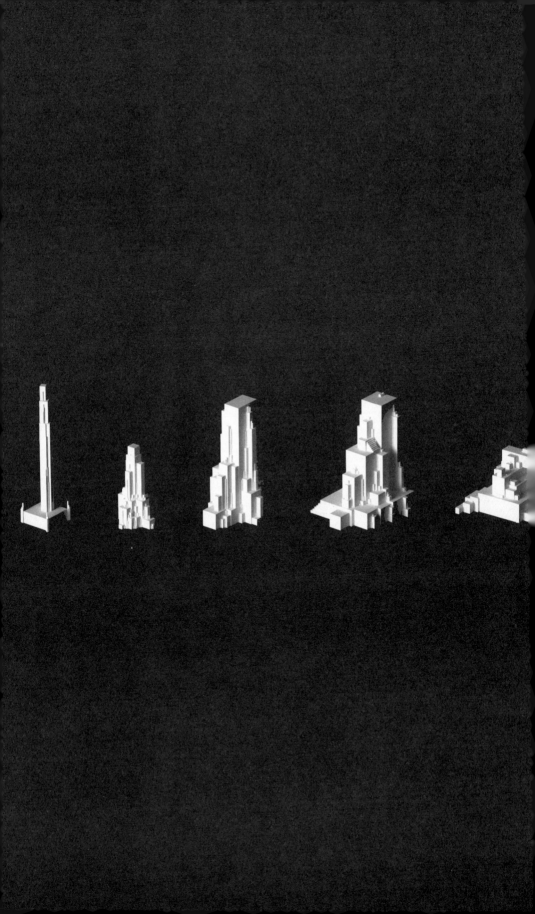

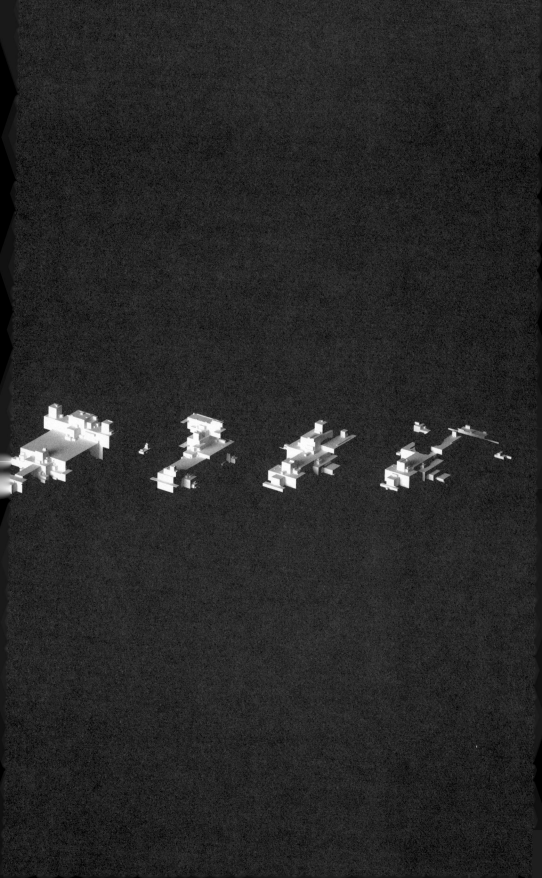

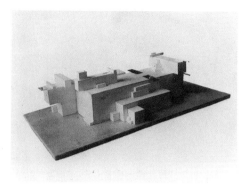

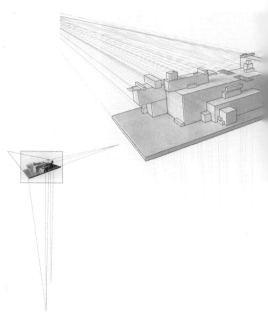

Arkhitekton A11.

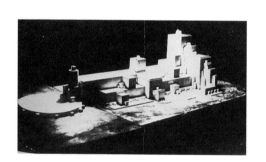

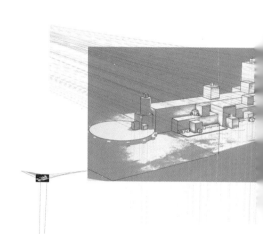

Arkhitekton A15.

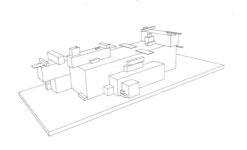 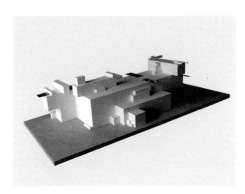

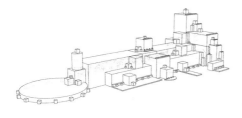 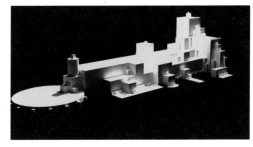

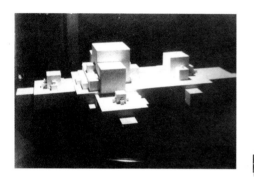

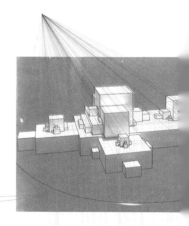

Arkhitekton A18.

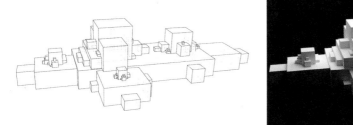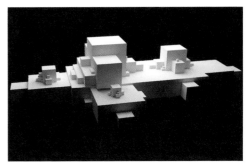

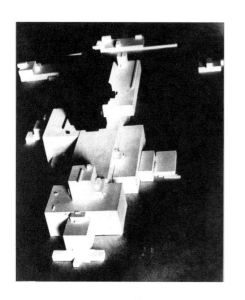

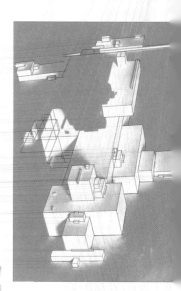

Arkhitekton A19 (Arkhitekton Type Form Beta).

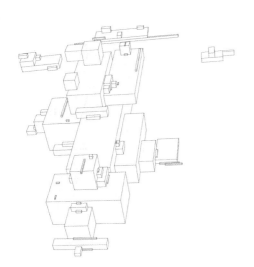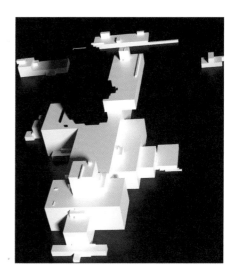

 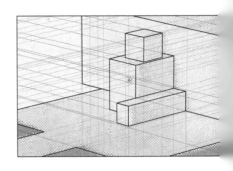

 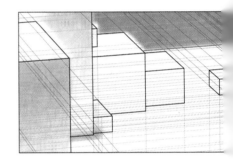

 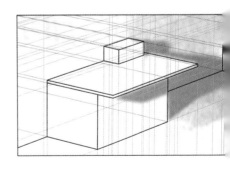

Perspectival study from published photographs.

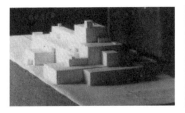
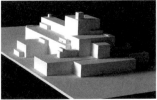

Arkhitekton A20.

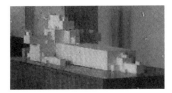
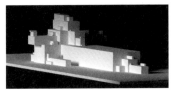

Arkhitekton A21.

had a double purpose. On the one hand, it allowed for the recognition of the size and position of the composing elements, while on the other, the rendering of the model enabled us to grasp the ways light and shadow work in a given configuration. A second phase then became a testing tool to corroborate the assumptions implicit in the distribution of elements within the model. In other words, the reproduction of the perspectival (and reverse perspectival) deformations, together with the simulation of lighting, would corroborate the accuracy of the overlaying between the original photograph and the new image. By repeatedly testing these renderings, we arrived at what we considered the most convincing digital reproduction through the combination of three-dimensional modeling, perspectival deformations, and light simulation.

Once a digital reconstruction was accurate enough, for a moment we suppressed the rendering and our attempts at matching it to the original photograph, and returned to the supposedly correct volumetric compound of the digital model, to deduce from it line drawings such as plans, elevations, and both isometric and axonometric two-dimensional layouts. This level of design allowed us to clearly see the manner in which the arkhitektons are not closed objects with a unique shape, but conceptually correspond to sets of volumes gathered according to well-staged relationships, and capable of integrating different states. These drawings, with

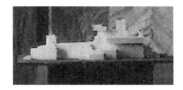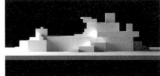

Arkhitekton A22.

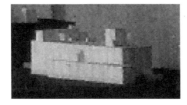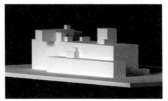

Arkhitekton A23.

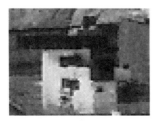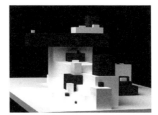

Arkhitekton A24.

arkhitektons devoid of all their lighting, chiaroscuro, and pictorial qualities, illustrated the constellation of individual elements that by means of gravity and balance made up mass compositions of such variable states.

These line drawings allowed us to establish a set of assumptions about the actual size of each element. In fact, the digital model facilitated the accurate reconstruction of the arkhitektons by determining their scale. The empirical deduction that the size of the smallest element that can be fabricated from plaster is 2 mm enabled us to assume a measure from which the sizes and scales of all other objects were then calculated. And so the size of the elements can be categorized in three main groups, namely structural elements (between 65 mm and 200 mm), medium elements (between 10 mm and 65 mm), and ornaments (between 2 mm and 10 mm). While the latter are unessential to the overall configuration of an object, they are fundamental to the arkhitekton's

The Additional Element in Architecture

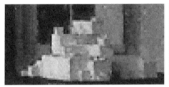
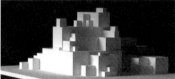

Arkhitekton A25.

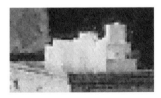
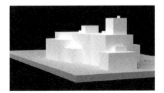

Arkhitekton A26.

texture, grain, porosity, and overall appearance in relation to light and shadow, as well as simultaneously stating an implicit assertion on the problem of scale. As Francisca Cortínez has pointed out, in the hypothetical case that an arkhitekton shrank, the smallest volumes would immediately disappear, while the medium ones would become the ornaments, the structural elements would be transformed into medium-size objects, and so on.[9] By the same token, if an arkhitekton is blown up in scale, several new small particles will emerge out of nowhere. This is what Cortínez has called the "Malevich scale," with the different groupings and satellites being treated as if they were independent compounds, like minute arkhitektons in scalar correspondence. Besides reckoning scale from the smallest possible plaster elements, there is another clue to scale in Malevich's addition of human figures to the planits Modern Buildings (1923–1924) and Future Planit for Earth Dwellers (1923–1924). This particular feature enables the observer to estimate the size of the structures, with the former being much bigger than the latter. In these drawings, again, it is clear that the added silhouettes wouldn't fit in all volumes in the composition, indicating which elements could (potentially) have interior space, while others remain in the realm of furniture or, indeed, the ornamental.

In addition to checking and double-checking the number of elements and their sizes and relative positionings within the digital model of each arkhitekton, we are able to move into the disassembling of the configuration as seen in the photographs, in order

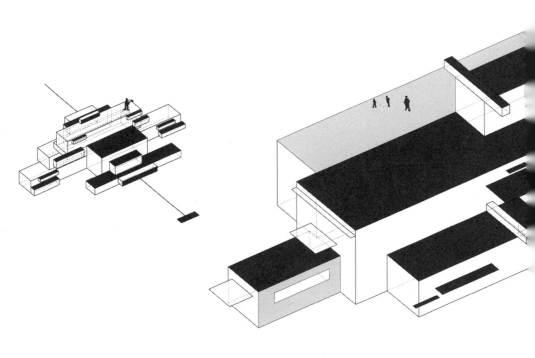

Scale comparison between Future Planit for Earth Dwellers (1923–1924) and Modern
Buildings (1923–1924).

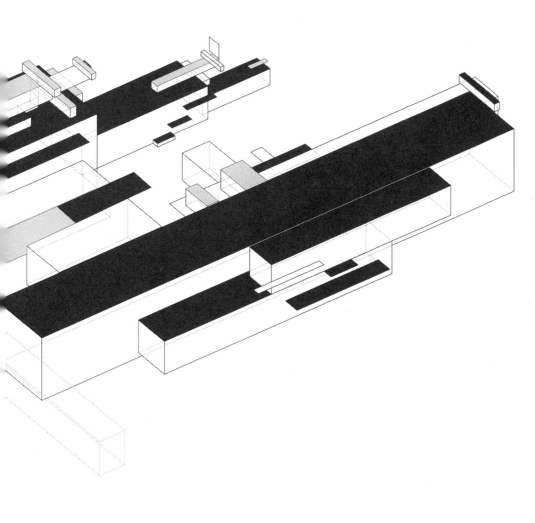

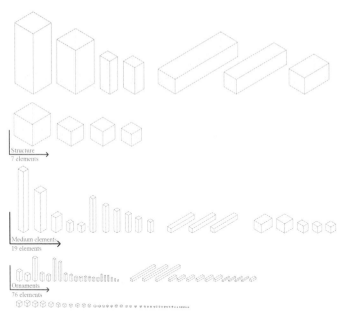

A sample catalogue of prismatic volumes of arkhitekton Zeta.

to classify their elements in a catalogue. In total, in our digital reconstructions we count around 1,800 elements in the plaster models and 285 in the planits.

Together with the arkhitektons, in this book we present digital modeling of Malevich's planits, and a study of the representation techniques deployed in their making. Two of these drawings were made combining both axonometric and (reverse) perspectival techniques. But all planits have their vertical axis drawn in axonometry, without deformation by perspective. This means that a planit is never fully deformed on all of its axes. Similarly, planits are never totally immersed into the axonometric, the perspective, or the reverse perspective.

Malevich depicted the eight planits in this study through ten drawings in total, with four different drawing representation techniques: four trimetric axonometrics, one in oblique view, one in isometric, and four in axonometric perspective. Each technique presented challenges to the visual perception and formal understanding of the planits. In all cases, there are discrepancies between a form's elements, proportions, or position and its visual perception, a situation that was fully intended by Malevich, through visual traps, as previously mentioned in the description

The Additional Element in Architecture

of his painterly and visual techniques. Those observations are thus integral to the way we have performed the digital reconstruction of the planits, even if what we have extrapolated in terms of the planits we do present is ultimately pure conjecture, because of course there will always be a mismatch between the volumetric information and the visual perception proposed by Malevich.

For us to be able to interpret the forms, we consciously suspended all the different ways Malevich used to distort or disintegrate the objects. For example, for elements with hidden corners, or when confronted with volumes with edges that are not closed or conclusive, we assumed them to be closed and conclusive. In general, there are two main vanishing points in the planits, but they are always accompanied by additional vanishing points that are deduced from sets of volumes whose deformation is autonomous with respect to the rest of the planit. In such cases, we have ignored all the additional small individual vanishing points Malevich applies to individual elements. Moreover, in terms of the aerial views, the height is typically much greater than is visually perceived. In this way, the object that in the drawing is seen as longitudinal would actually be compact and vertical in its digital reconstruction. This difference entails a mismatch between the longitudinal dynamics of perspective as perceived in the drawn object and the dimensional reality required for it to be perceived in this way from that point of view.

From all of this we were able to reach an obvious conclusion: that objects and their representation are not the same. For the planit to look like the object it is intended to represent, it must in fact be the perspective view of some other object. In other words, for perspectives to be visually perceived as symmetrical, they must be—paradoxically—asymmetrical: the objects' weight is balanced, not in their potential physical reality but in their visual perception.

All the technical drawings and the analytical visual comparison of twenty-seven forms that appear in this book are shown so as to link both planits and arkhitektons as belonging to a continuous series. With this in hand, we move into rendering, shifting the focus to the reconstruction of the actual images shown in Malevich's photographs, or, in Malevich's own terms, moving toward sensation.

6 *Forms*

This chapter presents all twenty-seven forms of arkhitektons and planits and their various states. It provides plan drawings and analytical schemes, as well as axonometrics to visualize the number of discrete elements at play in each arkhitekton or planit. These sets of drawings are the same for every form, in order to have a coherent and consistent base for comparison, including final renderings with light and shadow, matching Malevich's original photographs of these arrangements.

Arkhitekton Alpha (1922–1923)

This is primarily a horizontal arkhitekton that is nonetheless characterized by a staggered and vertical growth toward its back side. The accumulation of both structural and medium elements in this zone defines a cross-shaped form. Its main body is surrounded by a large number of medium and ornamental elements. Unlike other forms, it is porous. That is to say, its volumes define spaces in between, generating an effect of relative lack of density.

Arkhitekton Alpha, called A1 in Troels Andersen's and Jean-Hubert Martin's catalogues, is the arkhitekton that was photographed most often by Malevich, with four photographs in total. It is also the arkhitekton that was exhibited the most, and it was

149

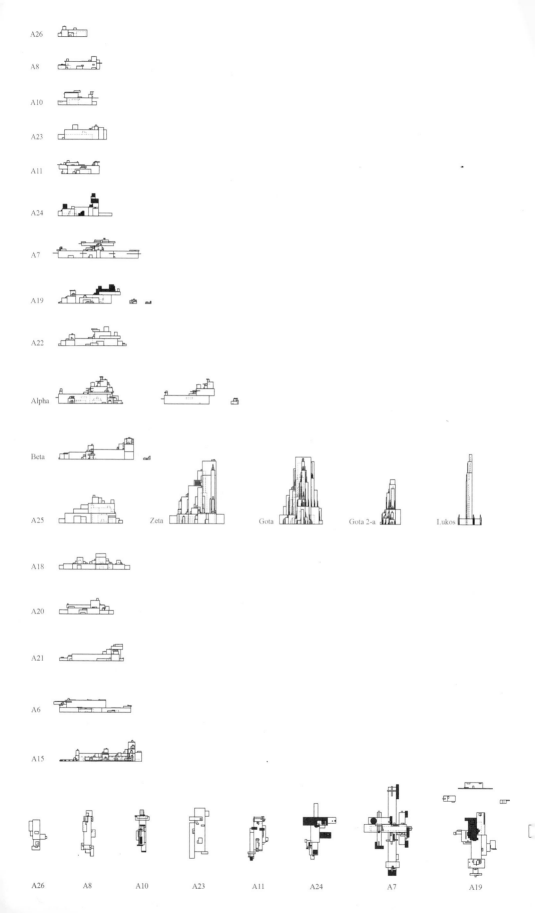

A26

A8

A10

A23

A11

A24

A7

A19

A22

Alpha

Beta

A25 Zeta Gota Gota 2-a Lukos

A18

A20

A21

A6

A15

A26 A8 A10 A23 A11 A24 A7 A19

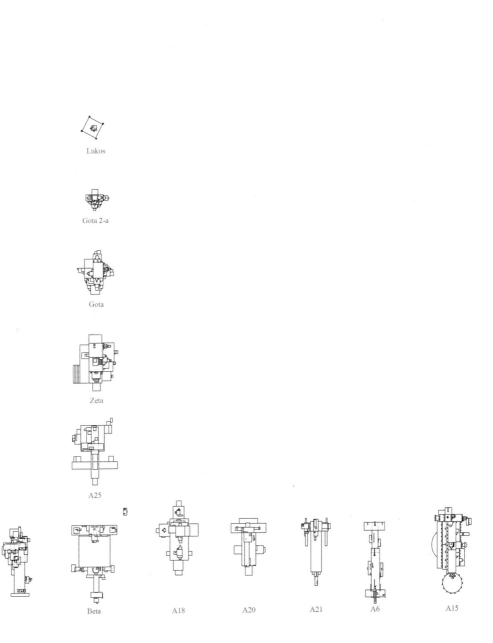

Lukos

Gota 2-a

Gota

Zeta

A25

Alpha Beta A18 A20 A21 A6 A15

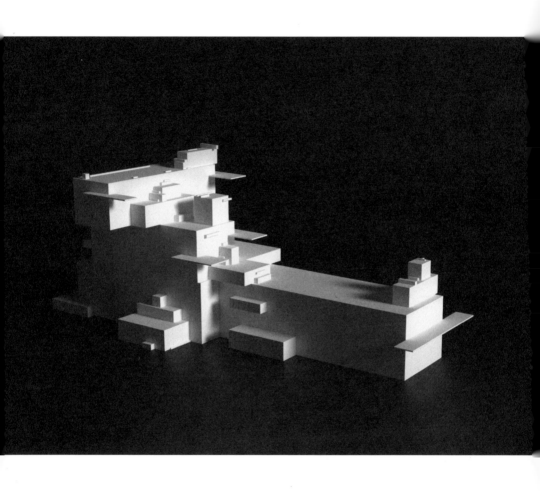

this and following pages:
Arkhitekton Alpha states 1–3 (1922–1923). © Paulina Bitrán.

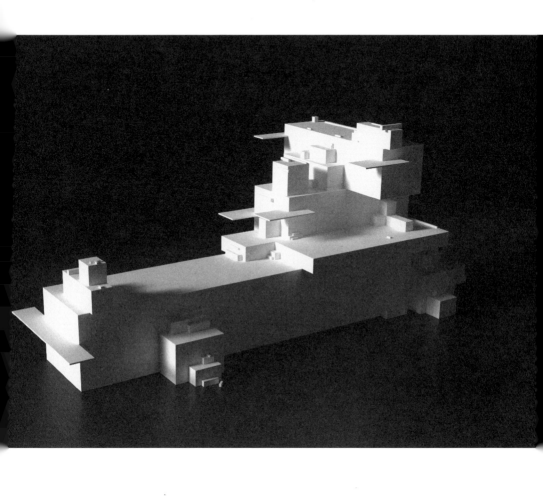

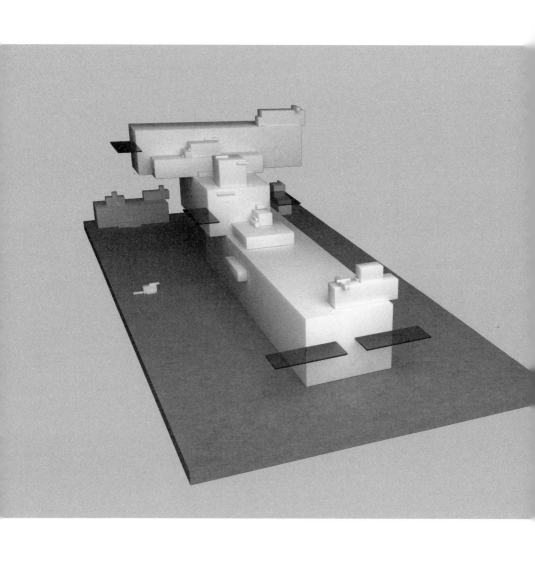

...kton Alpha (1923)
...hitekton was rebuilt by
...dersen, Centre Georges
...ou, 1978–1980, with 1
...element and 95 rebuilt
...s (5 eaves in glass).

State 1

In this study, we are
reconstructing Alpha
from original photographs
rather than following the
reconstruction work of
Poul Pedersen. In this
drawing: 100 elements
(95 volumes, 5 eaves in
glass); length 89 cm,
width 38 cm, height 34 cm,
volume 0.022 cubic meters.

State 2

Arkhitekton Alpha was
shown in the 1926 GINKhUK
exhibition and owned by the
State Russian Museum. In
photographs from the
exhibition and from two
later exhibitions at the same
museum, we can recognize
that three eaves were removed
from it. Total elements: 97.

State 3

Published as Form D in
1926 and recognized as
Alpha in the 1960s, this
third state of the arkhitekton
shows the minimum
structural elements and
groupings to still remain as
the Alpha form. 50 elements
in total (31 volumes, 5
eaves, and three satellites
with 14 volumes).

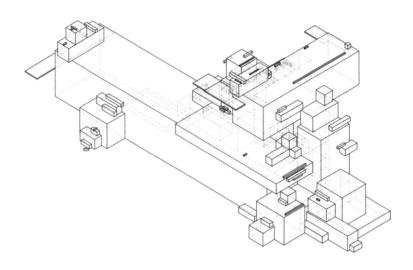

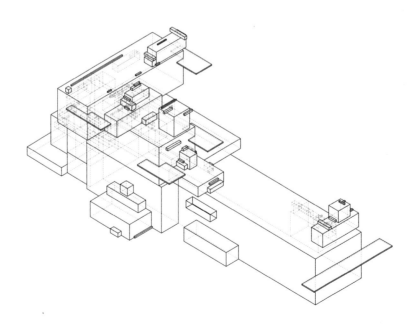

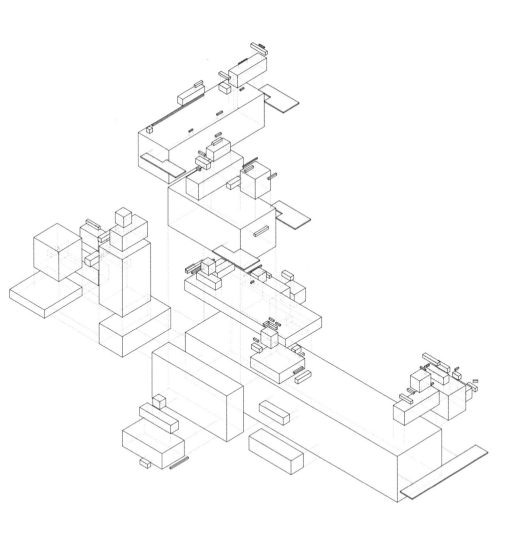

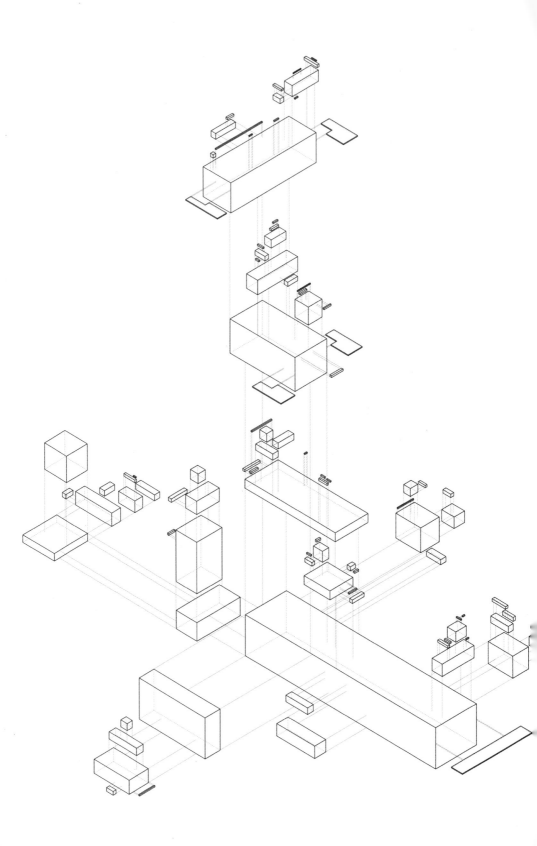

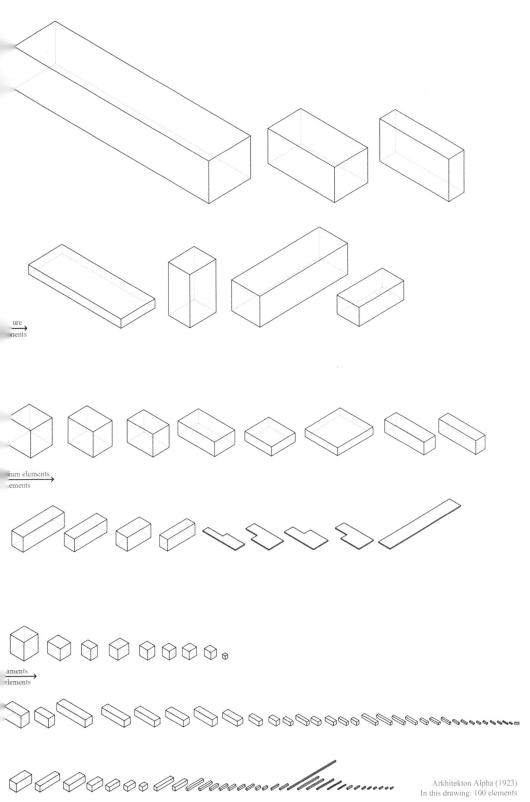

ure
nents

ium elements
ements

aments
elements

Arkhitekton Alpha (1923)
In this drawing: 100 elements

Scale 1:10

Arkhitekton Alpha (1926)
State 3

In this drawing: 51 elements
(32 volumes, 5 eaves, and 3 satellites
with 14 volumes)
V= 0.02m3
Scale 1:10

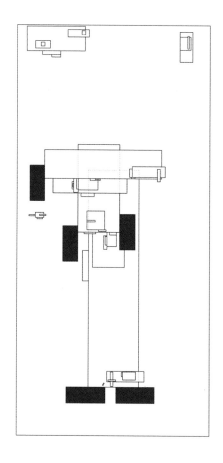

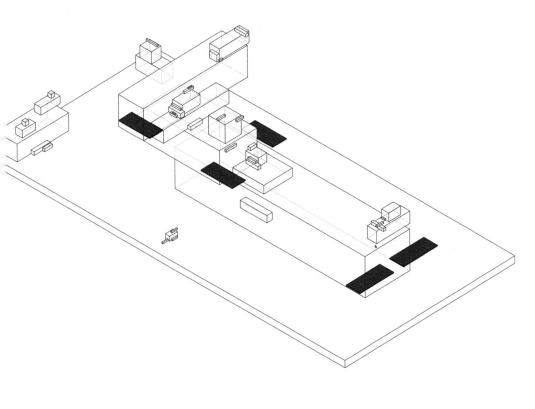

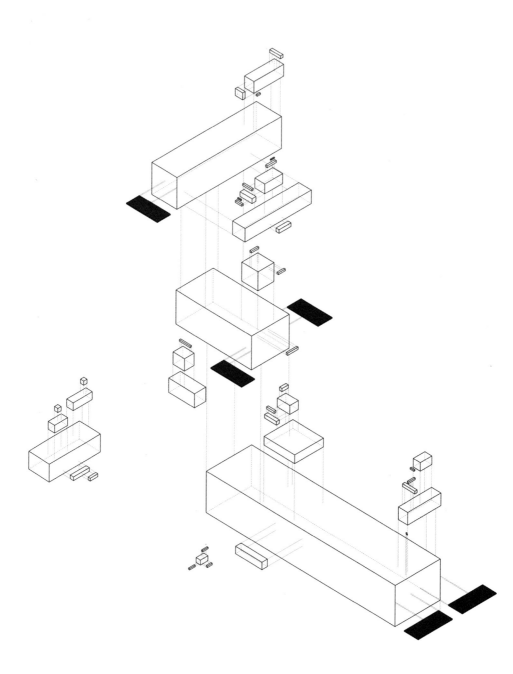

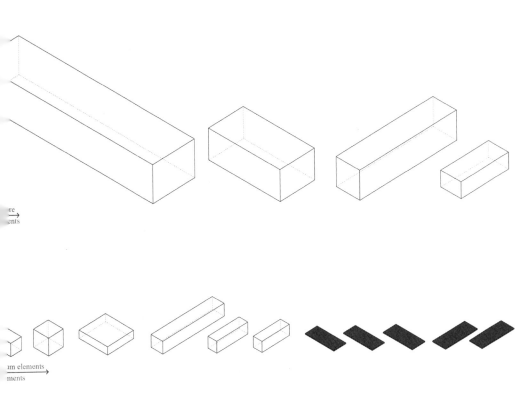

re
→
ents

ım elements
→
ments

ments
→
ements

Arkhitekton Alpha (1926)
State 3
In this drawing: 50 elements

Scale 1:10

presented in at least two of its states. One of these versions was purchased by the State Russian Museum in Leningrad in 1926, and was shown in exhibitions such as "The Latest Trends in Russian Art" (1927) and "Installation Art of the Epoch of Imperialism" (1931–1932).

In 1926 Alpha was presented by Malevich in its second state, entitled Form D. This altered form was initially considered something different from Alpha, and thus catalogued as A9 by Troels Andersen. It was later considered a version of Alpha, and is seen as such both in Zaha Hadid's thesis project Malevich's Tektonik (1976–1977) and in the 1980 catalogue by Jean-Hubert Martin. Consequently, Alpha has three states; the first is the one in the three studio photographs by Malevich, the second state corresponds to the model presented at GINKhUK (the State Institute of Artistic Culture) in Leningrad in 1926 and was purchased by the State Russian Museum in 1926, and a third state corresponding to Form D was published in 1926.

This arkhitekton is the one that is mentioned most by Malevich in his writings, and it also seems to be the initial Suprematist architectural form, as it is named after the first letter of the alphabet; it is the only arkhitekton that has the title "Suprematist Order" (written on its podium in the GINKhUK exhibition in 1926). Malevich wrote that "the Suprematist structure of the volume line manifested itself, then, in two phases: that of the dynamic diagonal structure, the first (Alpha) related to the metallic culture, the second (Beta) to the static culture of art as such, each one comprising the determination of architecture."[1] Malevich refers to arkhitekton Alpha as the basis for the elaboration of a new classical architecture. In Alpha—as in Beta and Gota—a new architecture will be found.[2]

In the world today there are two models of Alpha (both with original elements). One, which is the one with more original elements, belongs to the State Museum of Russia, and was restored in 1988. A second version has only one original plaster element (coming from Anna Aleksandrovna Leporskaya's collection), and it was reconstructed by Poul Pedersen in 1978–1980. Variations can be distinguished between these two reconstructions in the positioning, size, and number of elements that compose them. Apart from these two existing physical models, this is the arkhitekton with the greatest number of reproductions, also made by Poul Pedersen.

The Additional Element in Architecture

Arkhitekton Beta (1923–1926)

This arkhitekton is close to Alpha in a number of ways, despite the fact that it is relatively flat, almost symmetrical, and with a very clear central axis. Its symmetry is only broken by the distribution of ornamental elements. It is divided into three different parts: front, center, and back. In has two known states, both of which have satellites.

Arkhitekton Beta, called A2 in Troels Andersen's and Jean-Hubert Martin's catalogues, is known from two original photographs, both taken from the same side, yet with a slight difference in the camera angle. These two photographs are also different in

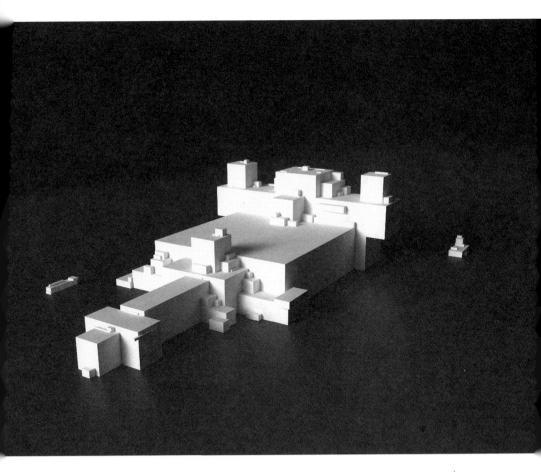

this and following pages:
Arkhitekton Beta (1923–1926). Rendering © Paulina Bitrán.

Arkhitekton Beta (before 1926)
State 2
Rebuilt by Poul Pedersen, Centre Georges
Pompidou, 1978–1980, with 29 original
elements and 40 rebuilt elements

In this drawing: 71 elements; length
99.3 cm, width 60 cm, height 28 cm,
volume 0.042 cubic meters

Scale 1:10

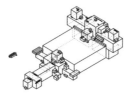

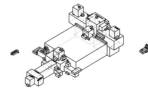

State 2

State 2

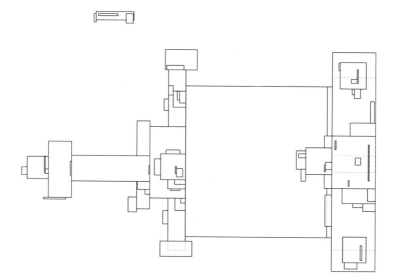

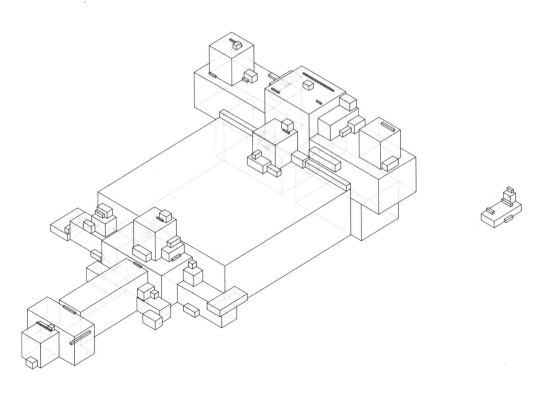

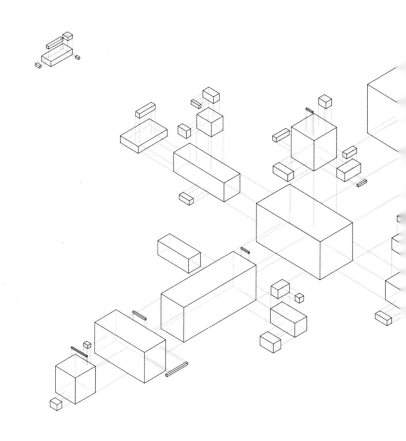

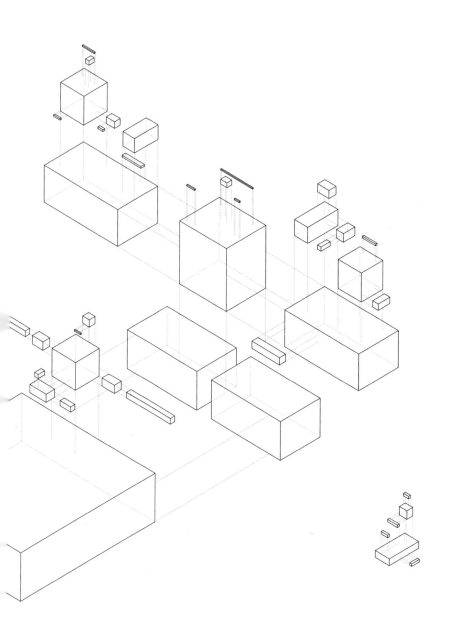

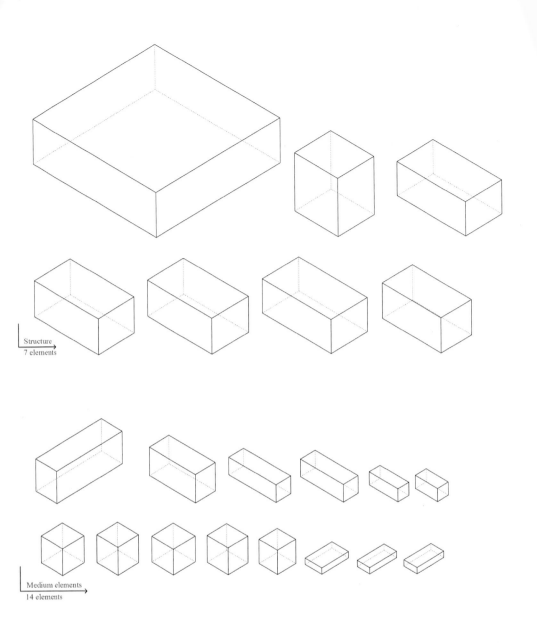

Structure
7 elements

Medium elements
14 elements

Ornaments
57 elements

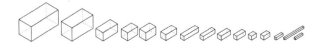

Arkhitekton Beta (before 1926) St
In this drawing: 78 elem

Scale

the positioning of some prismatic elements of the compounds. Like Alpha, this was also one of the most often exhibited of the arkhitektons. In fact, Malevich would say that while Alpha is the origin of things, Beta is their fulfillment. There is another Suprematist form titled Beta by Malevich, which corresponds to A10, that was published in the Russian magazine *CA* in 1927. Today there is one reconstruction of Beta, with twenty-nine original elements (out of seventy-nine), made by Poul Pedersen in 1978–1980. Beta has two states, recognizable from the original photographic records.

Arkhitekton Gota (1923)

This is a tall, vertical arkhitekton of spiral ascending growth. The groupings attached to each side of a main structural element follow the rule of being attached to its inner angles. Rising from there, they look like extruded lines escalating at different rates. In one of the cubic elements at its base, it presents the Suprematist circle, made of black painted glass, embedded in the plaster cube. In this way, Gota is one of two arkhitektons that present one of the (three) Suprematist shapes (A7 also has a circle). This arkhitekton is composed of three strata from classical architecture, presenting base, shaft, and capital, which are more visible on the frontal photograph.

Arkhitekton Gota, called A3 in Troels Andersen's and Jean-Hubert Martin's catalogues, is represented by three original photographs. Each of them shows a different angle or side of the arkhitekton, allowing for the understanding of the object in its entirety. This is one of the four vertically shaped forms, and is the arkhitekton with the largest number of elements, 248 according to our study.

In his essay on "painting and the problem of architecture," Malevich says that "the new architecture is still in the process of establishing an order or a motive, an establishment in the elaboration of which a new classical architecture can be developed. . . . The architectons of horizontal construction (Alpha, Zeta [i.e., Beta?]) and vertical construction (Gota) reveal the moments that should, in my opinion, be found in the new architecture."[3] There is also a drawing by the artist that is associated with the arkhitektons Gota and Gota 2-a. Some sets of elements from this arkhitekton

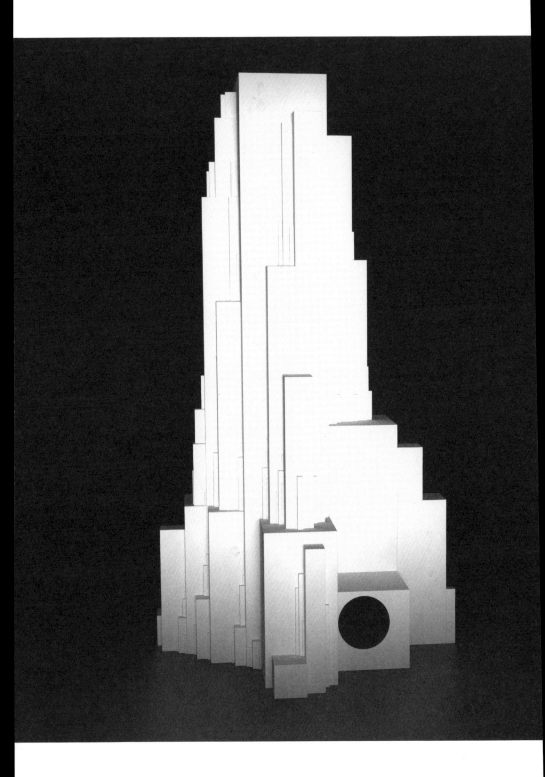

this and following pages:
Arkhitekton Gota (1923). Rendering © Paulina Bitrán.

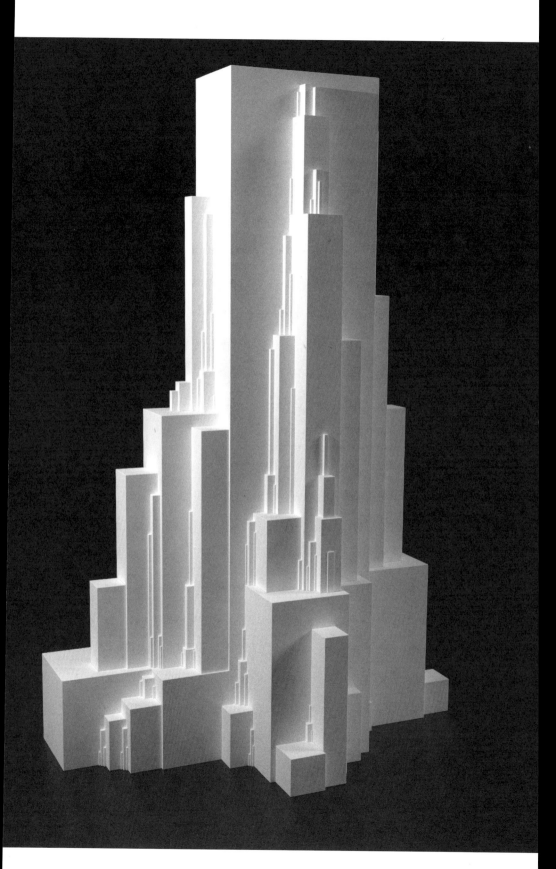

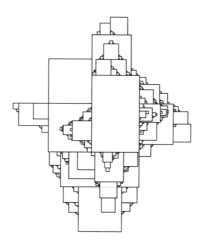

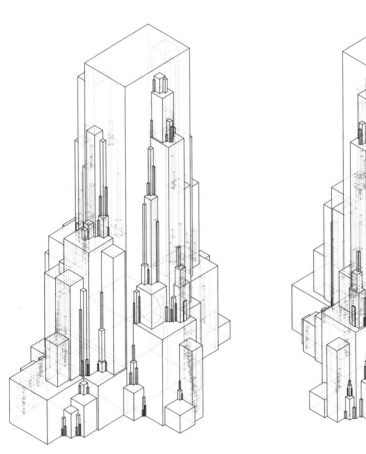
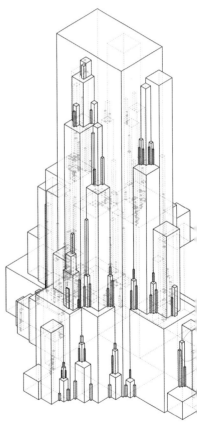

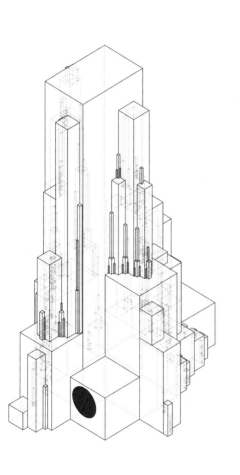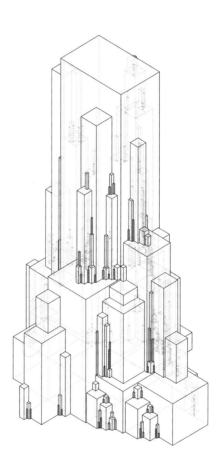

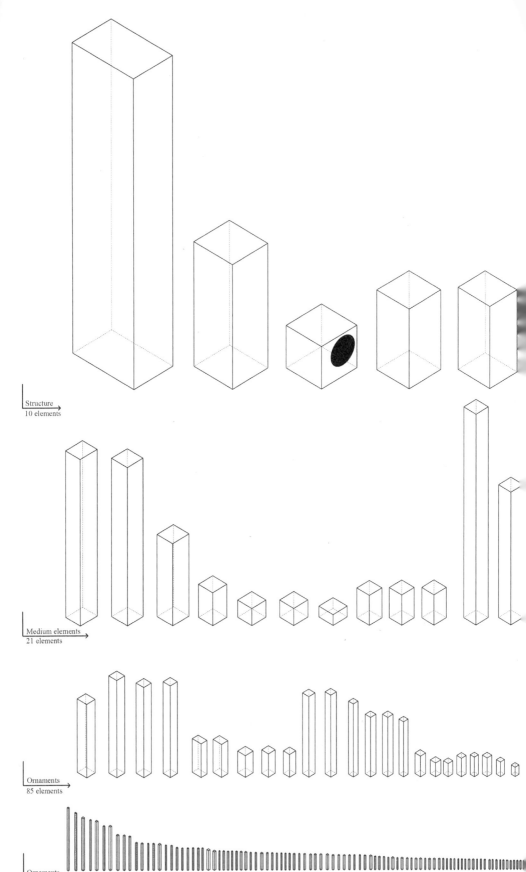

Structure
10 elements

Medium elements
21 elements

Ornaments
85 elements

Ornaments
132 elements

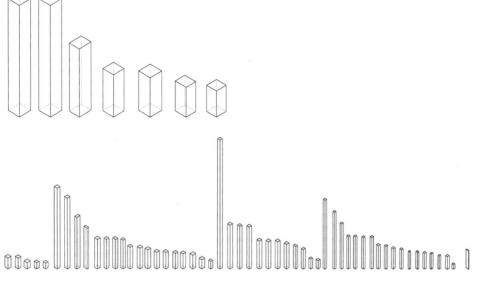

Arkhitekton Gota (1923)
In this drawing: 248 elements

Scale 1:10

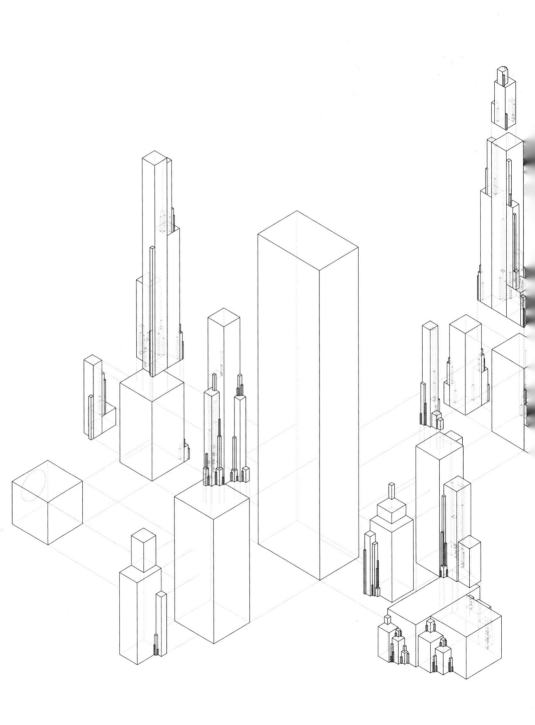

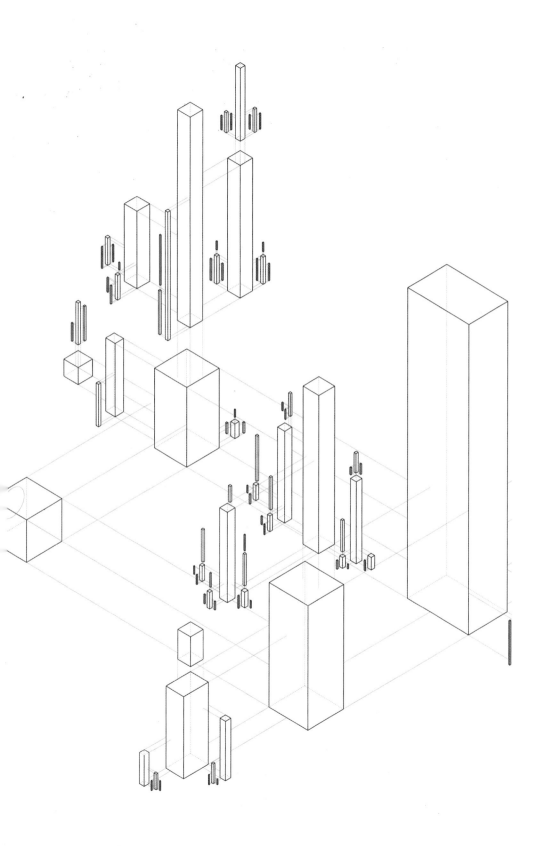

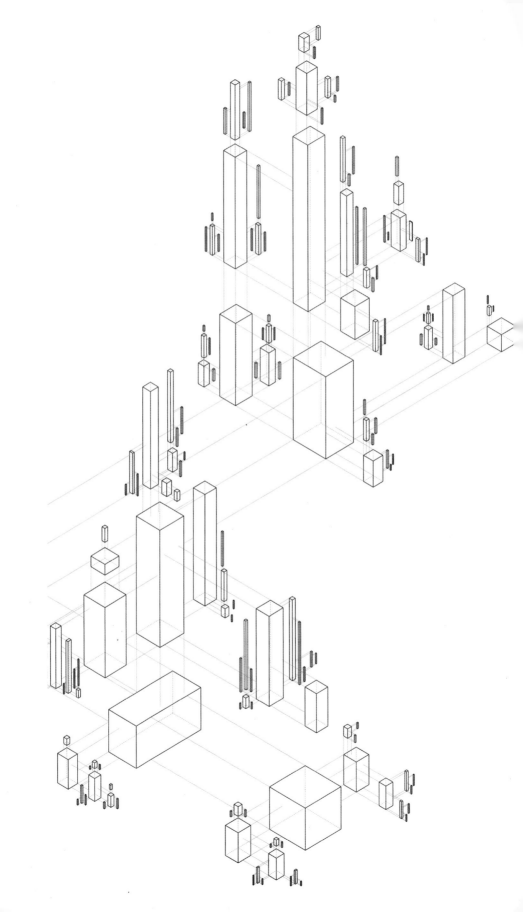

were reused by the artist in the production of his Suprematist monuments.

Today there are two versions of arkhitekton Gota, both having original elements. The first one was produced by Poul Pedersen between 1978–1980 at the Centre Pompidou, and has the largest number of original elements (187 original elements out of 243 in that version of the arkhitekton). The second belongs to the Russian State Museum in Saint Petersburg. It is possible to observe differences between these two versions, both in the quantity and the type of elements (especially in their different sets of ornaments). Gota is considered to have just one state, corresponding to the one portrayed in the three available original photographs.

Arkhitekton Gota 2-a (1923–1926)

This arkhitekton is one of the four vertical ones, yet much smaller than the other three (Zeta, Gota, and Lukos).[4] It is characterized by a cross-shaped structure. It is a much more stratified structure than the other vertical arkhitektons, clearly differentiating between base, shaft, and capital.

Called A4 in Troels Andersen's and Jean-Hubert Martin's catalogues, arkhitekton Gota 2-a is known from two original photographs, disclosing three of its four sides. There is no information about the fourth side. At the same time, these two images are different, indicating that the portrayed object is not the same. Elements change in number as well as in type, size, and proportion.

Some sets of elements from Gota 2-a were reused by Malevich in the production of his Suprematist monuments. There is a version of Gota 2-a produced by Poul Pedersen in 1978–1980 at the Centre Pompidou, with 80 original elements (out of 115). There are also reproductions made by Pedersen. Gota 2-a is considered to have two states, corresponding to the two original photographs.

following pages:
Arkhitekton Gota 2-a (1923–1926). Rendering © Paulina Bitrán.

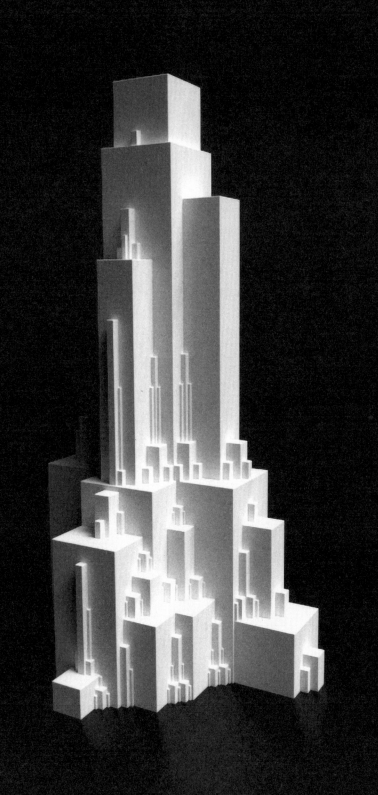

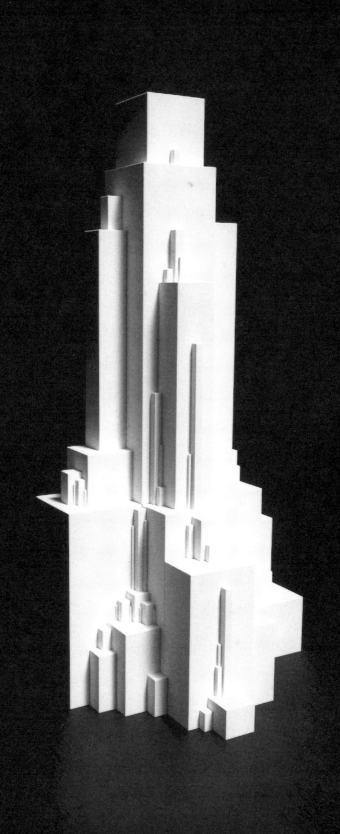

Arkhitekton Gota 2-a (before 1926)
State 1
Rebuilt by Poul Pedersen, Centre Georges
Pompidou, 1978–1980, with 80 original
elements and 35 rebuilt elements

In this drawing: 129 elements; length 30.3 cm,
width 26.6 cm, height 57 cm

Scale 1:10

State 1 State 2

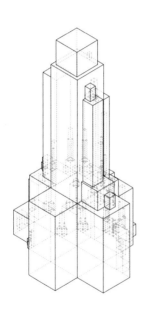 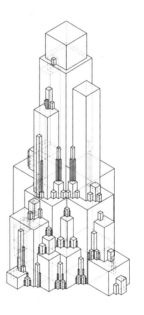

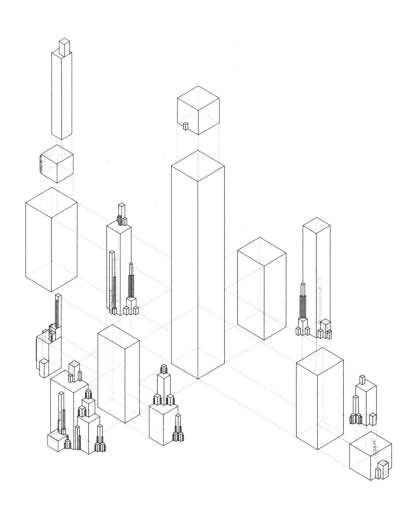

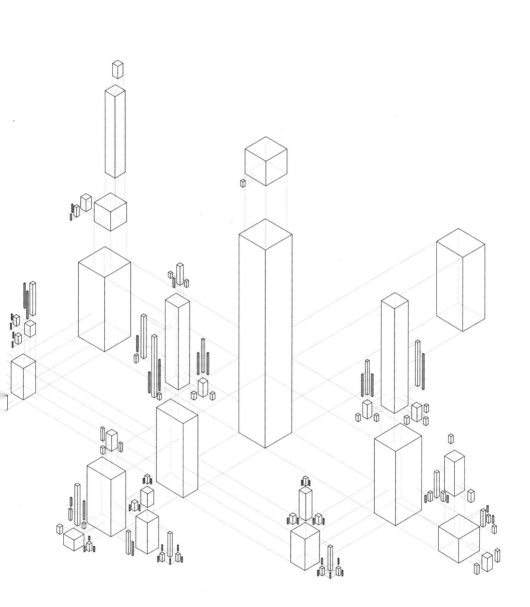

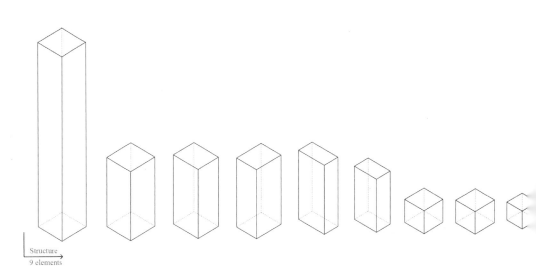

Structure
9 elements

Medium elements
8 elements

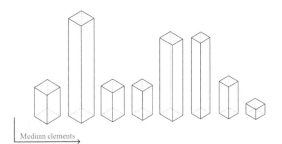

Ornaments
112 elements

Arkhitekton Gota 2-a (before

In this drawing: 129 e

Sc

Arkhitekton Zeta (1923–1927)

A remarkably vertical arkhitekton, like an ascending and staggered tower, this has a rather square base supporting two structural elements extruded from square plans. It contains large, medium, and small elements (ornaments). The ornaments remain as small cubes, or as vertically extruded lines. This is the only arkhitekton that has an element that looks like a staircase. There are three available photos of Zeta, which differ slightly in the arrangement of some elements. These images provide different degrees of lightning contrast to the extent that they either reveal or conceal a grouping situated on top of the overall form, which looks like a satellite.

Arkhitekton Zeta is called A5 in Troels Andersen's and Jean-Hubert Martin's catalogues. The original photographic record shows three sides of the arkhitekton, and consequently there is no information on the elements of the fourth side. One of the photographs presents a fully frontal view of Zeta, while the other two capture an angular side of the arkhitekton's front. In one of these two photographs one can observe how Malevich makes a change in the way the model is lit, also adding two stacked prisms to the base platform where the arkhitekton rests.

In his work for the Centre Pompidou (1978–1980), Poul Pedersen reconstructed arkhitekton Zeta, with 61 original elements (out of 114 in total). Zeta has two states, one that is recognizable in the first two photos, and a second state that can be deduced from the third photo. The latter is different in that stacked prisms are added to the base platform where the arkhitekton rests.

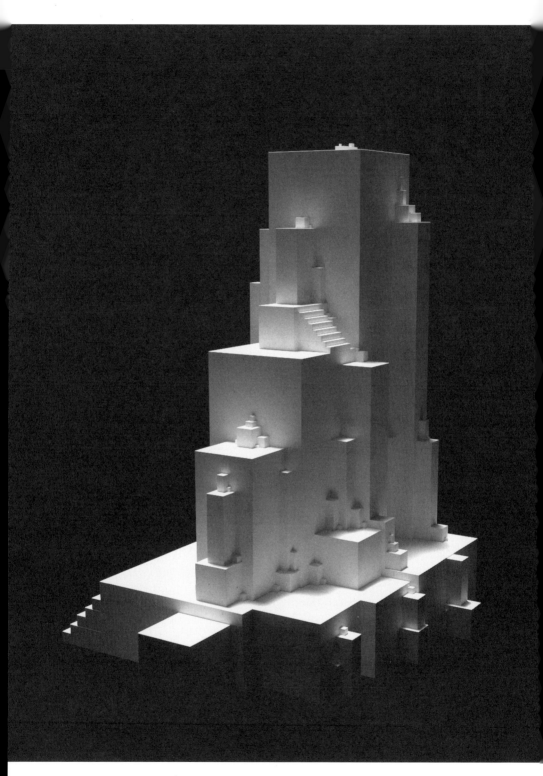

this and following pages:
Arkhitekton Zeta (1923–1927). Rendering © Paulina Bitrán.

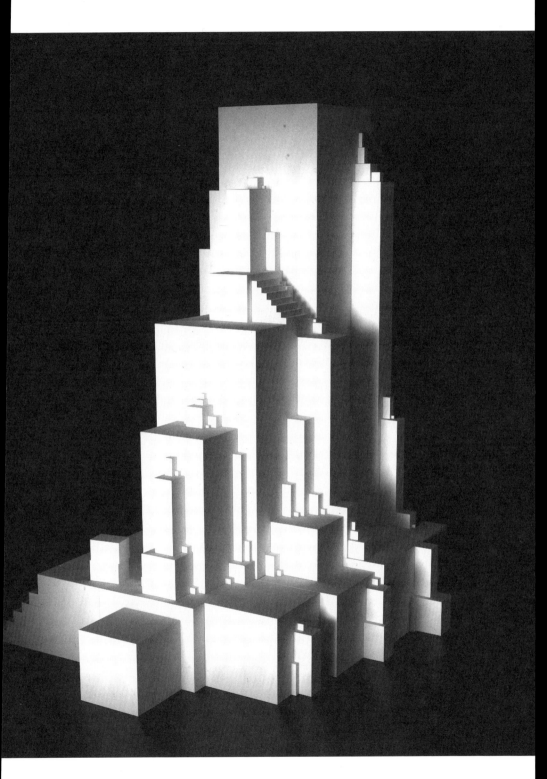

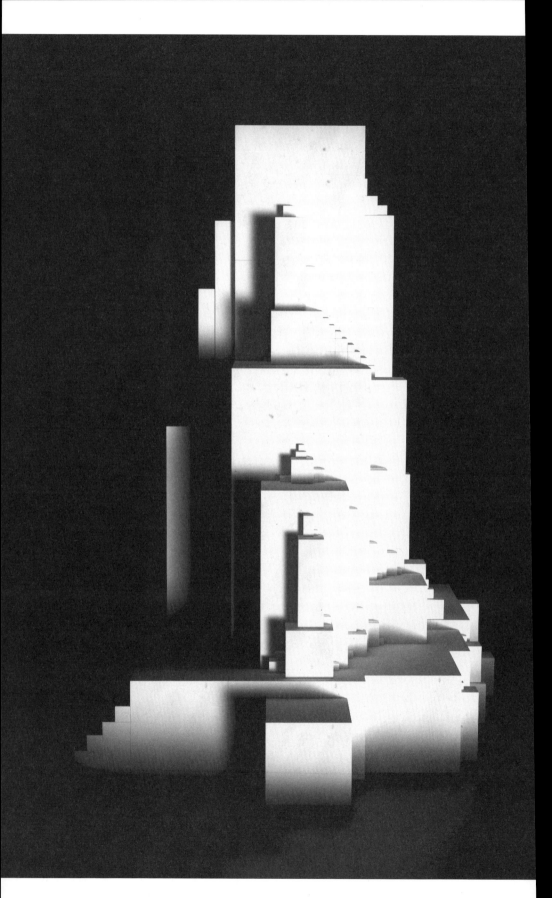

kton Zeta (before 1926)

by Poul Pedersen, Centre Georges
ou, 1978–1980, with 61 original
s and 53 rebuilt elements

Irawing: 106 elements; length
width 59 cm, height 80 cm

10

State 1 State 2

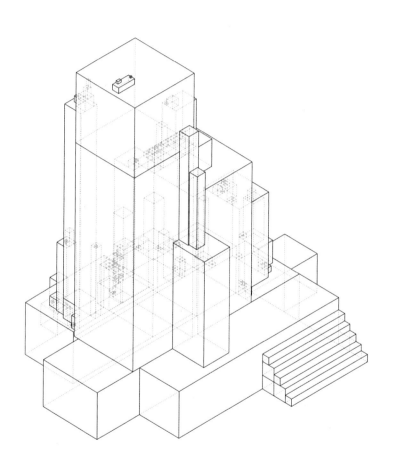

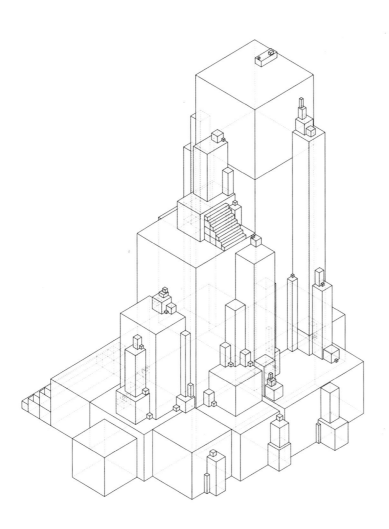

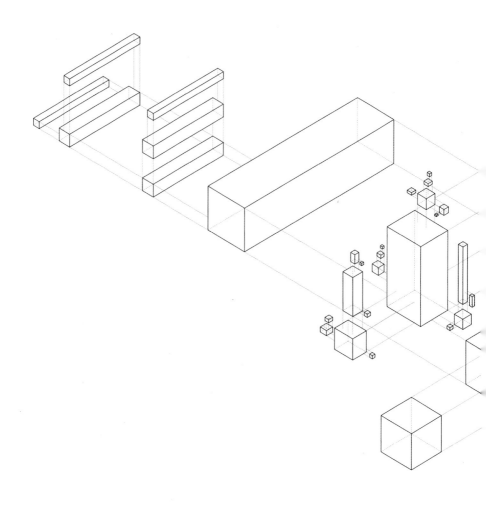

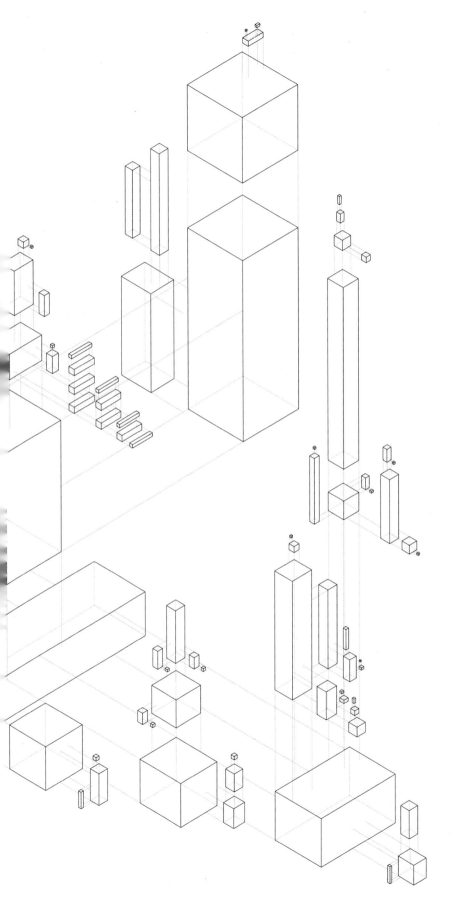

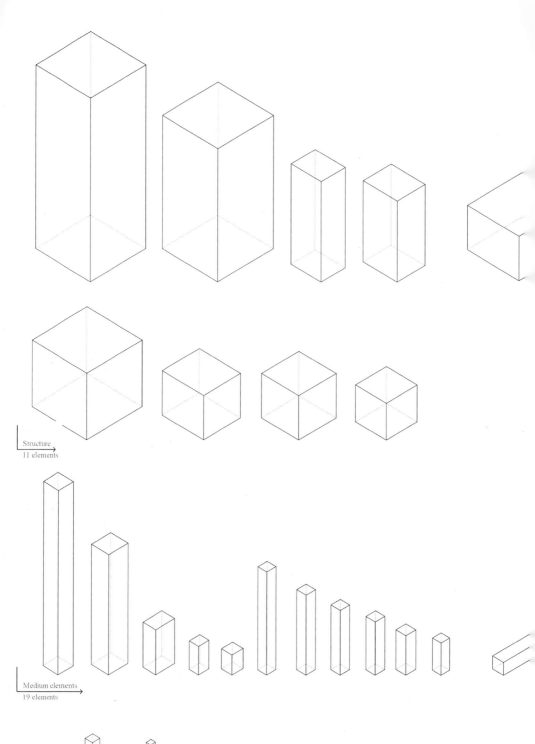

Structure
11 elements

Medium elements
19 elements

Ornaments
76 elements

Arkhitekton Zeta (before 1926)
State 1
In this drawing: 106 elements

Scale 1:10

A6—Dynamic Suprematist Arkhitekton (before 1926)

This is the most longitudinal of all arkhitektons, with some minor perpendicular elements in both extremes. These allow for the perception of it as cruciform but in no way affecting the overall elongated appearance. It is composed of a number of ornamental elements that are almost like volumetric lines pointing in the same direction, thus emphasizing its longitudinality.

This was originally called Dynamic Suprematist Arkhitekton, as in the Warsaw magazine *Praesens*, 1929, and is called arkhitekton A6 in Troels Andersen's and Jean-Hubert Martin's catalogues. It is represented by a single original photograph but was also featured at the GINKhUK Leningrad exhibition, June 1926. Thanks to a general photograph of that exhibition, it is possible to see both sides of this arkhitekton's composition. Small changes in the ornamental elements can be distinguished by looking at these images. Therefore, we consider that arkhitekton A6 has two states. The model itself was not preserved. There are no known reproductions.

The Additional Element in Architecture

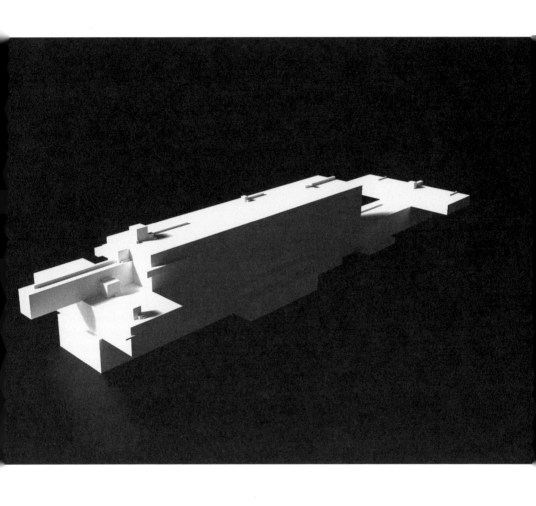

this and following pages:
Arkhitekton A6 (before 1926). Rendering © Paulina Bitrán.

Arkhitekton A6
State 1
In this drawing: 47 elements; length 104 cm,
width 27.7 cm, height 17.3 cm

Scale 1:10

State 1 State 2

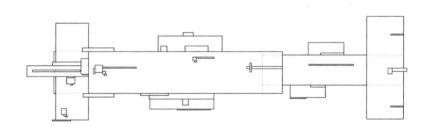

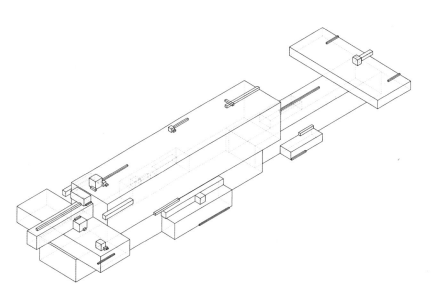

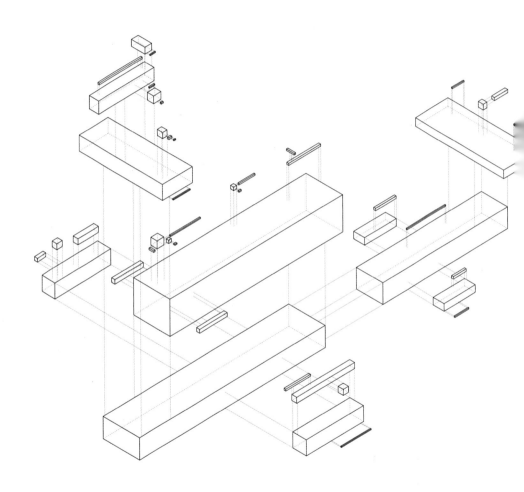

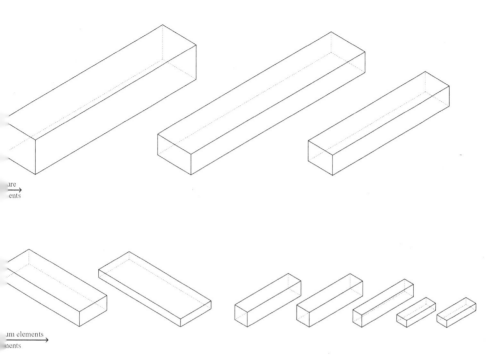

are
ents

am elements
ents

ments
ements

Arkhitekton A6
State 1
In this drawing: 47 elements

Scale 1:10

A7—Form A (before 1926)

This is largely characterized by the existence of eight black eaves and a black circle in its top volume. It is also notable for being composed of an interlocking of longitudinal and transverse elements, forming a series of crosses that develop as it grows in height. The plaster volumes are stacked in balance, alternating in their orthogonal cross orientation. It has eight additional compounds formed by medium and small elements, distributed across the object.

This was originally called Form A, as in *Praesens*, 1926, and is arkhitekton A7 in Troels Andersen's and Jean-Hubert Martin's catalogues. It is recorded in a single original photograph, showing three of the five sides of the object. It was presented at the GINKhUK show in Leningrad in June 1926. Thanks to a photograph of this exhibition, it is possible to know a fourth side of the arkhitekton. By assessing both photographs, one can distinguish small changes in the ornamental elements, particularly the disappearance of the black glass eaves and of the basic Suprematist shape of the circle, present in the upper element of the construction and then removed in a different version. Therefore, arkhitekton A7 is considered to have two states. This arkhitekton was not preserved and there are no known reproductions.

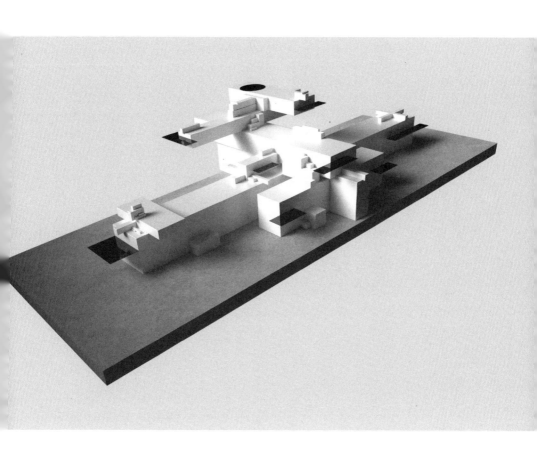

this and following pages:
Arkhitekton A7 (before 1926). Rendering © Paulina Bitrán.

Arkhitekton A7
State 1
In this drawing: 62 elements (54 volumes,
8 eaves); length 116 cm, width 62.3 cm,
height 25 cm

Scale 1:10

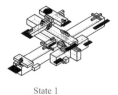
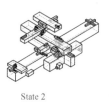

State 1 State 2

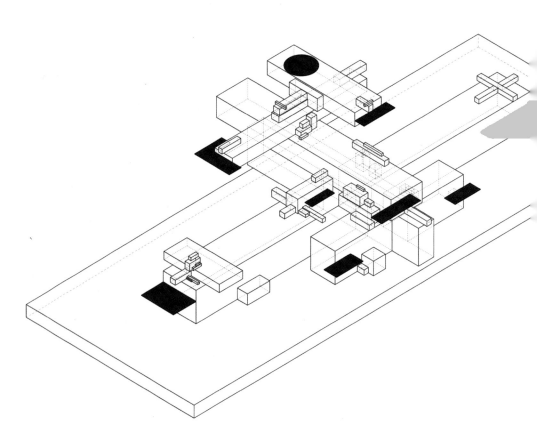

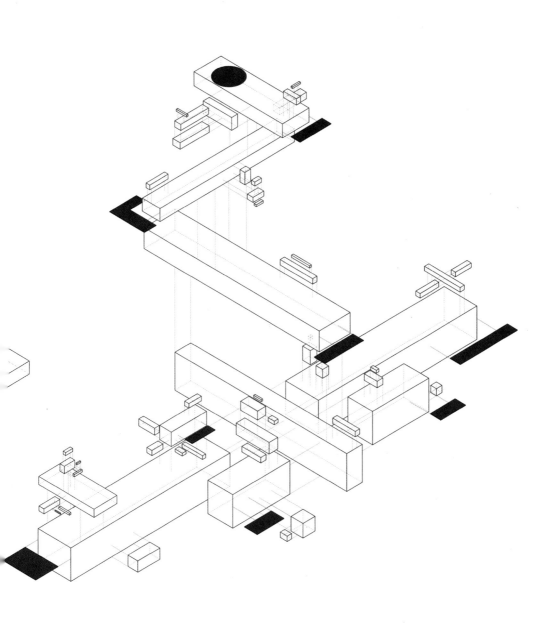

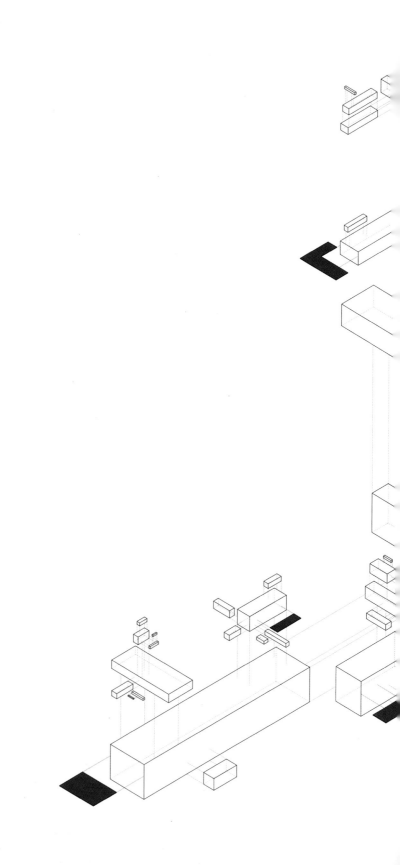

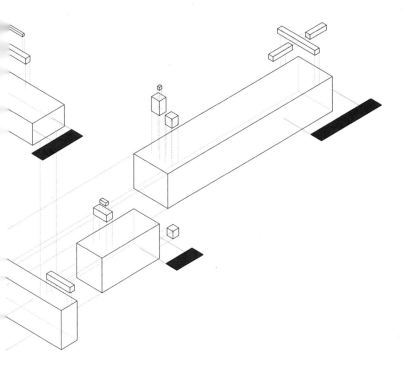

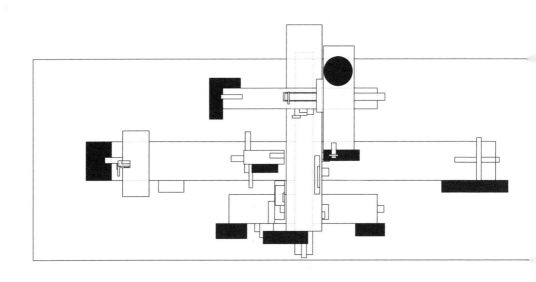

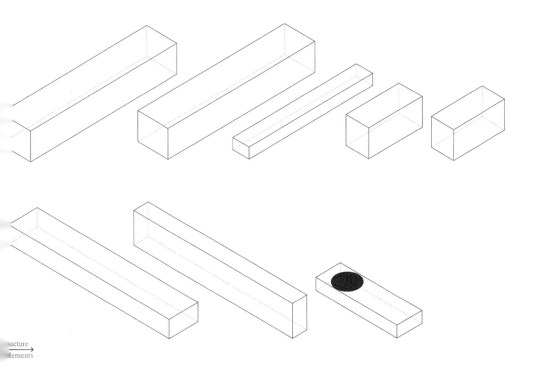

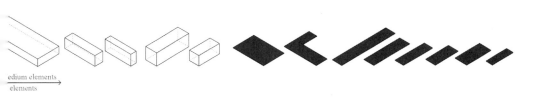

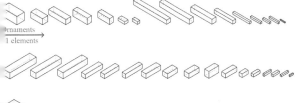

Arkhitekton A7
State 1
In this drawing: 62 elements

Scale 1:10

Arkhitekton A8 (date unknown)

This arkhitekton is characterized by its single structural body surrounded by smaller groupings. The smaller groupings are remarkable in having horizontal elements that could be initially identified as eaves. In fact, this is the only arkhitekton with flat elements apparently made in plaster, which are superimposed on top of other larger volumes, extending beyond them like eaves and creating a kind of cantilever-looking effect. At the same time, these flat elements are attached to the objects by the weight of smaller elements on top.

Called Arkhitekton A8 in Troels Andersen's and Jean-Hubert Martin's catalogues, it is known from a single original photograph, showing three of the five sides of the object. Due to the strong contrast of the light that illuminates the object, it becomes difficult to distinguish the different elements. It is the photograph with the fewest reproductions in publications. This arkhitekton was not preserved and there are no known reproductions.

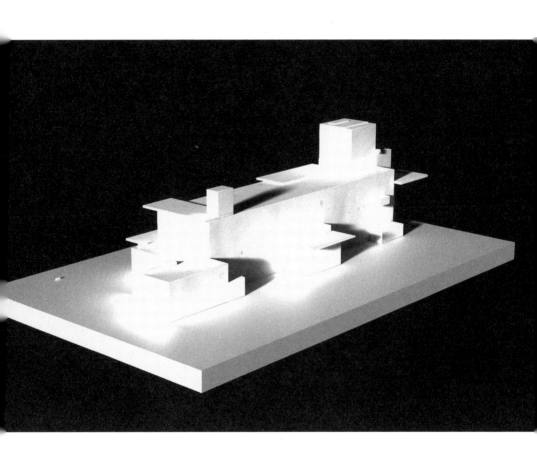

this and following pages:
Arkhitekton A8 (date unknown). Rendering © Paulina Bitrán.

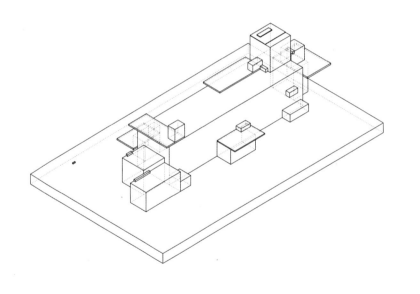

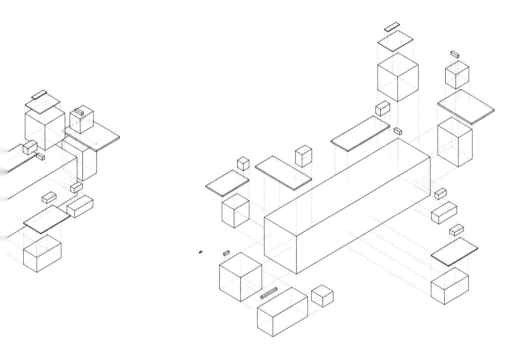

Arkhitekton A8

In this drawing: 27 elements; length 58 cm,
width 19.3 cm, height 16.4 cm

Scale 1:10

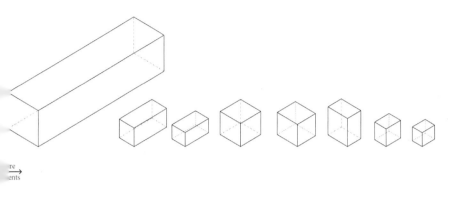

re
ents

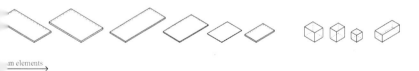

m elements
nents

ents
nents

Arkhitekton A8
In this drawing: 27 elements

Scale 1:10

Arkhitekton and planit A10 (1923)

This is the arkhitekton with the fewest volumetric elements, only twelve in all, to which however are added five black eaves and seven tonal planes inscribed in the volumes. It is also the only arkhitekton made in white carboard (not in plaster). It can be characterized by its lack of ornaments. Big and medium-size elements are attached to its main body. The two compounds on top are notable for being large and equivalent.

Called Arkhitekton A10 in Troels Andersen's and Jean-Hubert Martin's catalogues, it is one of the two arkhitektons that are also planits (together with A11). As arkhitekton it is named "the second phase of Suprematism's development line" (Malevich's original text in *Praesens*, 1926), or Form C (*Stepá architektura*, 1927). Its planit version is titled Two Studies of Suprematist Planits (together with planit X1, Spokoj) as published in *Blok* magazine (1925), and elsewhere is called Suprematist Composition (1926), and Suprematist Arkhitekton Beta (1927). Together with A11, A10 was the most published form in the 1920s and 1930s.

The original photograph of this arkhitekton is the only one that presents a figurative element. In the background of the image there are some treetops, as if the arkhitekton were "flying" or was positioned high up. This background was later replaced by Malevich with a black plane. It is also the only arkhitekton that is supported on a mirror base, reflecting the object.[5] In this it hints at Malevich's investigations into the best way of producing diverse effects in the photos. According to the studies of the team led by Troels Andersen and Poul Pedersen, who in the 1970s made two attempts at reconstructing A10 in plaster by analyzing the photo, it was one of the first arkhitektons produced by Malevich.

The planit version of A10 is an axonometric which is drawn from the back side (compared with the photo of the plaster version), thus presenting the rear flank as the front face and making visible the elements on this face that are unknown in the photo. However, a whole side of it is still unavailable. In the planit, the form has fifteen volumes, eleven eaves, and ten tonal planes attached to the volumes. Between these two versions, shifts are visible in the quantity, the shape, the and position of the elements, as well as in the proportions between them.

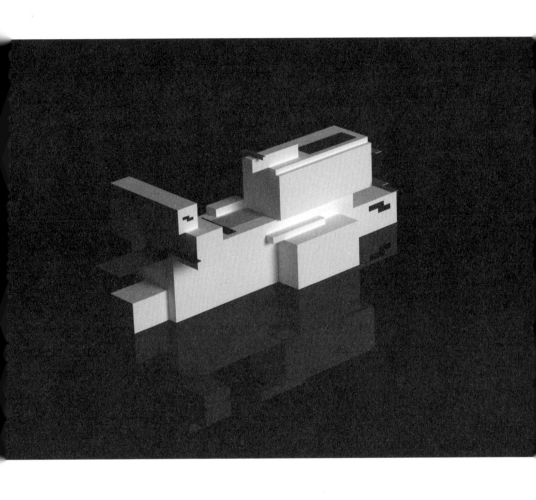

this and following pages:
Arkhitekton A10 (1923). © Paulina Bitrán.

Arkhitekton A10

In this drawing: 18 elements (12 volumes, 6 eaves), and 7 tonal planes on the surfaces of volumes; length 54 cm, width 19.1 cm, height 18.3 cm

Scale 1:10

	State 1 Arkhitekton	State 2 Planit
Side A		
Side B		

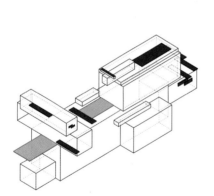

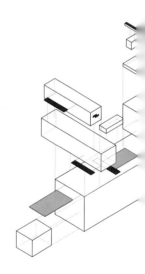

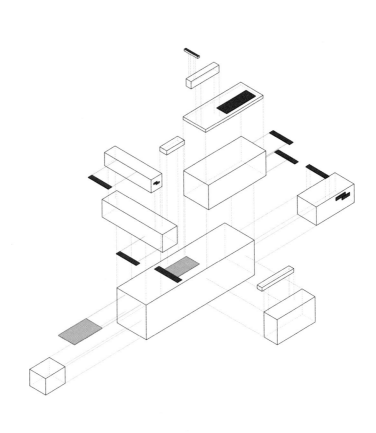

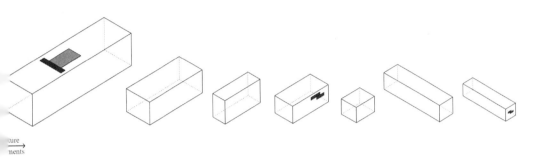

Arkhitekton A10
In this drawing: 18 elements

Scale 1:10

A11 is one of the arkhitektons with the smallest number of elements. Its main body is surrounded by minor and major groupings on top or adjacent. Two of these groupings, on top, are perpendicular to each other, and they look like smaller versions of the same form. It also has four black eaves.

Called A11 in Troels Andersen's and Jean-Hubert Martin's catalogues, it is one of the two arkhitektons that is also a planit (together with A10). Malevich also rotated this planit and used it to create a photomontage called *Suprematist Building among the American Skyscrapers* (1925–1926). In our study, this rotated version is considered as the third state of A11. The arkhitekton's photograph has the original title Form C (1926), and the planit is variously named Dynamic Construction (1924) and Blind Architecture (1926). Both the arkhitekton and the planit of A11 are the objects most often published during the 1920s and 1930s.

Arkhitekton A11 as a plaster model is composed of thirty-two elements corresponding to twenty-eight prismatic volumes and four eaves. The arkhitekton's original photograph was altered to eliminate the background and leave it white. It was then reproduced and published in this rather unique way. In the making of the photo, the base that supports the arkhitekton looks, as it were, like a Suprematist plane, especially in a case like this, where the white of the table is used to allow for reworking the image, replacing the base with a general white background.[6]

The planit version of A11 is created through two representation techniques: axonometry and perspectival axonometry. Both present the object from the same angle and with the same number and type of elements. However, the planit uses the opposite angle to the one from which the plaster model was photographed. Consequently, two previously unknown faces are visible, providing the observer with full understanding of the object. The planit of A11 is made up of forty-four elements: twenty-three prismatic volumes and twenty-one eaves. Oscillating between the axonometry and the perspectival axonometry, shifts can be identified in the quantity as well as in the shape and position of the elements.

The third state of A11 corresponds to a vertically rotated axonometry in the New York photomontage. Here there are alterations to the form that allow it to blend with the background context: a

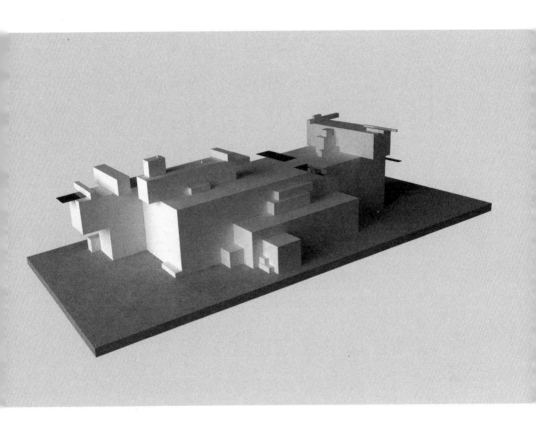

this and following pages:
Arkhitekton A11 (1923). Rendering © Paulina Bitrán.

Arkhitekton A11

In this drawing: 32 elements (28 volumes, 4 eaves); length 56 cm, width 26.6 cm, height 17 cm

Scale 1:10

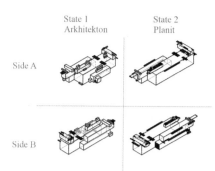

State 1
Arkhitekton

State 2
Planit

Side A

Side B

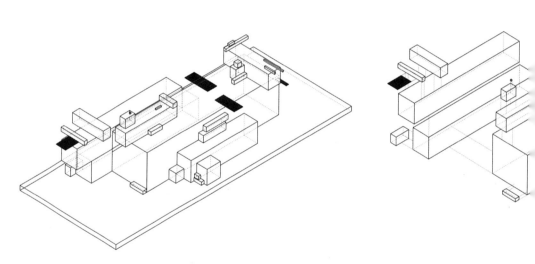

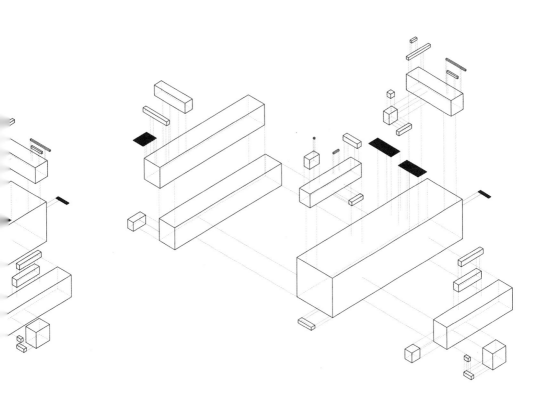

Structure
6 elements

Medium elements
10 elements

Ornaments
16 elements

Arkhitekton A11
In this drawing: 32 elements

Scale 1:10

black eave added to the bottom right, and a black rhomboid roof of a New York skyscraper, which has dimensions and angles apparently equal to the black square in A11.

Arkhitektons A12 and A13

These are not presented in this study because they belong to Malevich's ornaments and monuments. Consequently, they are not considered arkhitektons in the strict sense.

Arkhitekton A14—Lukos (1928)

Called Lukos by Malevich, it corresponds to A14 in Troels Andersen's catalogue and is one of the four vertical arkhitektons. It is also the one closest in appearance to a Suprematist column, composed as it is by a square plinth, base, shaft, and capital, with the sections diminishing with height. All sides are surrounded by extruded medium-sized elements and ornaments, forming groupings of vertical lines all along.

It is the tallest of all arkhitektons (the original plaster model was 1.8 meters high). Despite its apparent symmetry, Lukos is decentered at its base, surrounded by several elements that seem to come from other arkhitektons, such as Gota's emblematic white cube with black circle. It is as if other arkhitektons were dissolved, their parts flowing into this configuration. There is one photo of Lukos where it is possible to recognize the basal volume composed by four groups in its corners. This was reused by Suetin to create a different version crowned by a cubic capital, which was then staged in the setting of Malevich's funerary ceremony. It was also the formal theme of the USSR pavilion at the 1937 Exposition Internationale des Arts et Techniques dans la Vie Moderne in Paris. Therefore Lukos is considered to have two states. This arkhitekton was not preserved and there are no known reproductions.

following pages:
Arkhitekton A14—Lukos (1928). © Paulina Bitrán.

The Additional Element in Architecture

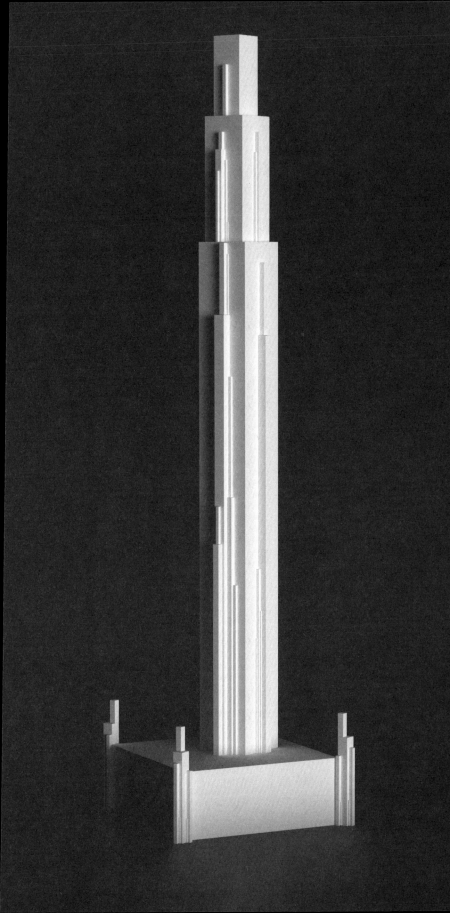

Arkhitekton Lukos
State 1

In this drawing: 61 elements; length 29.7 cm,
width 29.7 cm, height 89.6 cm

Scale 1:10

State 1 State 2

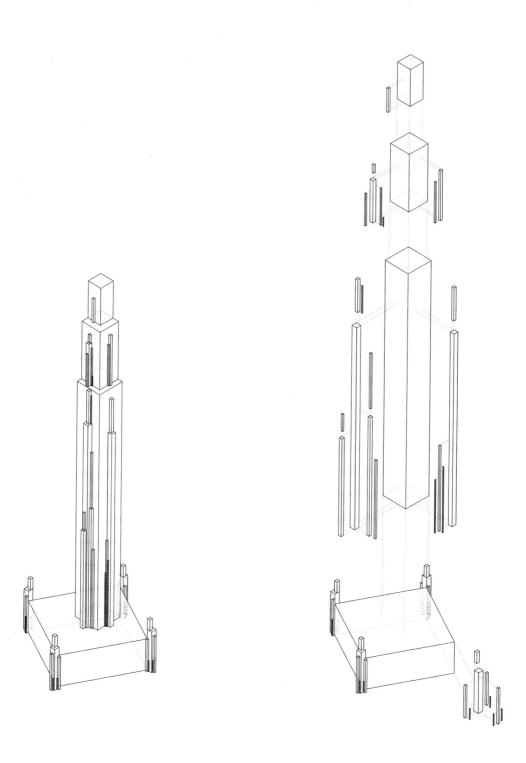

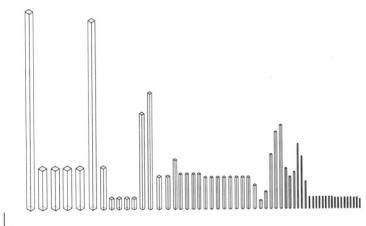

Arkhitekto
In this drawing: 61 e

Sc

Arkhitekton A15 (c. 1929)[7]

This is a particularly conspicuous arkhitekton, having a number of elements that are not found in any other forms. It is the only arkhitekton that includes circular elements (thereafter common in Malevich's Suprematist monuments), featuring two semicircles and one cylinder. And it is the only one that maintains a regular rhythm in the alignment of cubic volumes, giving A15 a rather static character.

Called A15 in Troels Andersen's and Jean-Hubert Martin's catalogues, it is, like A18, an arkhitekton of which Malevich's authorship is contested. According to Andrei Nakov, the author would have been Ilia Chashnik. In 1931 Kobro and Strzemiński titled it "arkhitekton Z, 1929." A15 is presented in two original photos, taken from opposing angles, allowing the observer to have a rather comprehensive understanding of its overall form. But because of an excess of light in the concave corners, as well as in its frontal and upper sides, it is difficult to grasp the quantity and shape of elements. In any case, the elements seem unchanged between the two photos, and consequently it is believed to have only one state.

Because of this lack of formal dynamism and its distribution of elements, A15 is considered by Christina Lodder to relate to a specific program: "A low circular volume, which might be an auditorium, dominates one end of the long low building, and is overlooked by a low tower. Another tower is situated towards the centre of the building, and a horizontal structure crosses it towards the other end. The combination of large circular and cuboid structures suggests a public building of some kind, and it is possible that this architecton was conceived in relation to a project like the Palace of Soviets competition, or even as a house of culture."[8] This arkhitekton was not preserved and there are no known reproductions.

Arkhitektons A16 and A17

These are not presented in this study because they belong to Malevich's ornaments and monuments. Consequently, they are not considered arkhitektons in the strict sense.

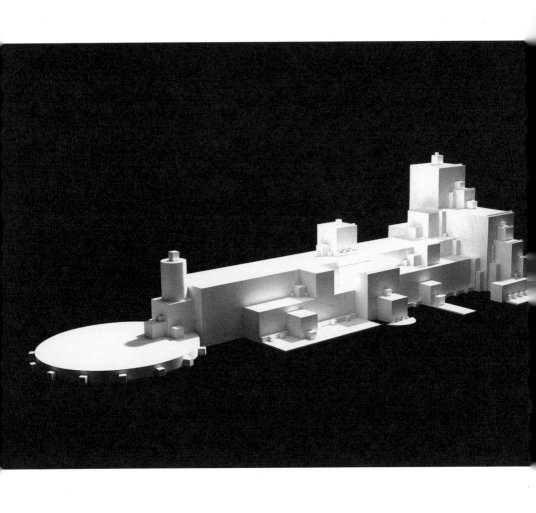

this and following pages:
Arkhitekton A15 (c. 1929). © Paulina Bitrán.

on A15

awing: 165 elements; length 110 cm,
5 cm, height 27 cm

0

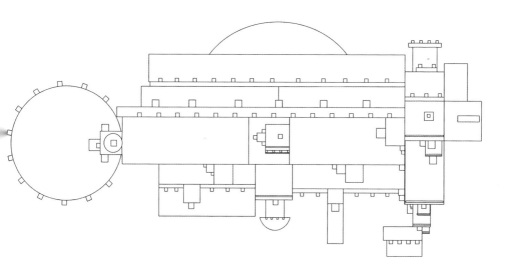

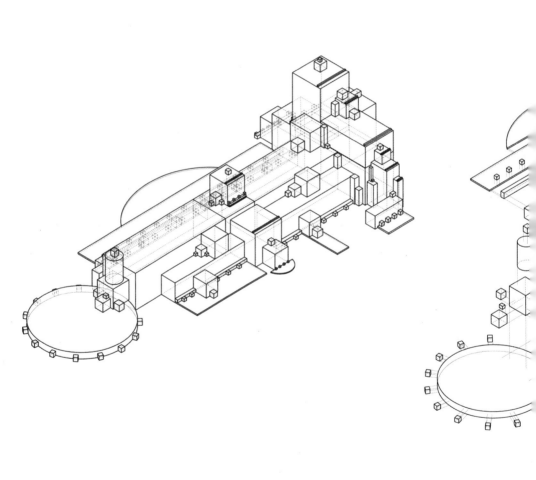

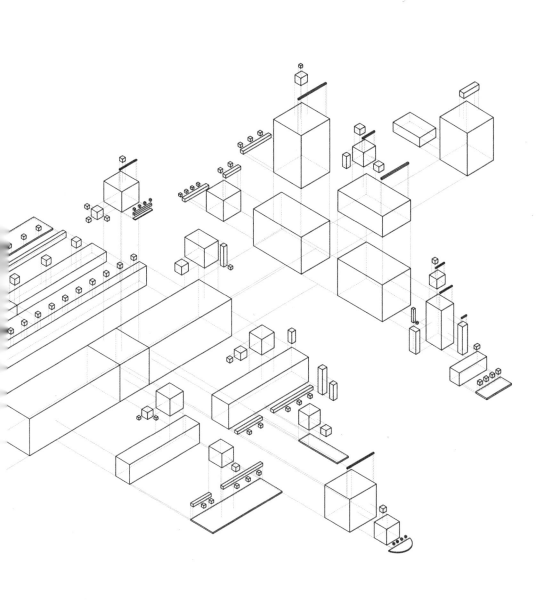

Structure
21 elements

Medium elements
12 elements

Ornaments
29 elements

Ornaments
103 elements

Arkhitekton A15
In this drawing: 165 elements

Scale 1:10

Arkhitekton A18 (date unknown)

With a cruciform central body, this is formed by a large longitudi-
nal element, together with prismatic elements square in plan. It
sustains four independent groupings, which might be five (there
is no information on one of its sides). Jean-Hubert Martin provides
one previously unrecorded photo of an arkhitekton that he names
A18 following Troels Andersen's numbering outline. Together with
A15, A18 is an arkhitekton of which Malevich's authorship has been
questioned. According to Nakov, the author would have been Ilia
Chashnik, who worked on a planit that is very similar to the plaster
model. But we know that all arkhitektons were the result of team-
work, including by Punin, Suetin, Chashnik, and Eslanova. A18 is
considered to have a single state.

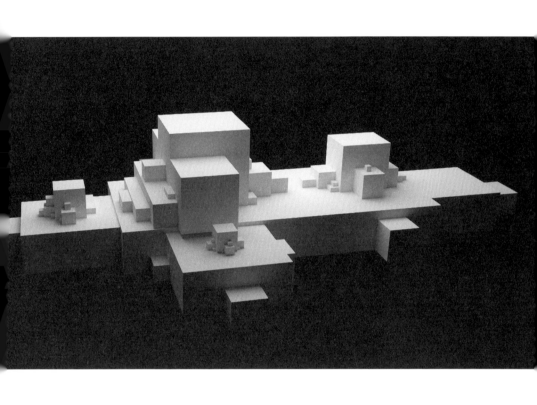

this and following pages:
Arkhitekton A18 (date unknown). © Paulina Bitrán.

Arkhitekton A18

In this drawing: 53 elements; length 94.5 cm,
width 54.5 cm, height 19.9 cm

Scale 1:10

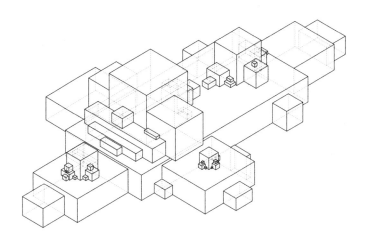

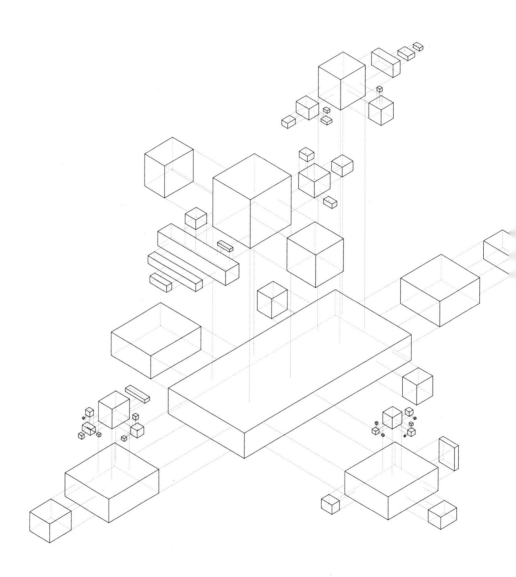

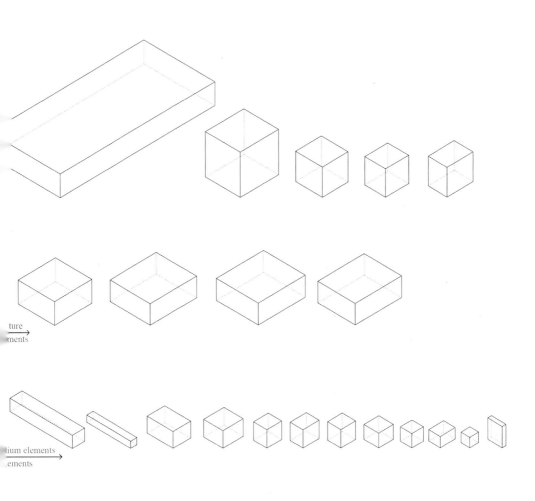

ture
ments

ium elements
ements

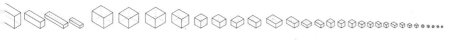

aments
lements

Arkhitekton A18
In this drawing: 53 elements

Scale 1:10

Arkhitekton A19 (c. 1922)

Despite having a cruciform structure, this cannot be described as symmetrical in any sense. In fact, it is noticeable for its deliberate lack of symmetry. Its main two features are the twelve black elements on top of it as well as its three independent satellites. The black elements form an independent and cohesive grouping that has, in turn, a single structural element surrounded by medium-sized and ornamental volumes. The rest of the white elements are characterized by the existence of eleven groupings adjacent to, or on top of, the main structural volumes.

Nakov provides one previously unrecorded photo of this arkhitekton, which he refers to as Arkhitekton Type Form Beta. Following Troels Andersen, and for the sake of clarity and consistency, we call it A19. Together with A24, this is one of two arkhitektons that are composed of black and white elements. In the photo provided by Nakov, arkhitekton Alpha is in the background. Due to the high contrast of light and shadow in the image, it is hard to identity the quantity, shape, and position of the black volumes. They look like a single black mass that is lost in the darkness of the platform. This single photograph gives the most accentuated aerial view of all arkhitektons, showing the upper face as if it were the main face.

The Additional Element in Architecture

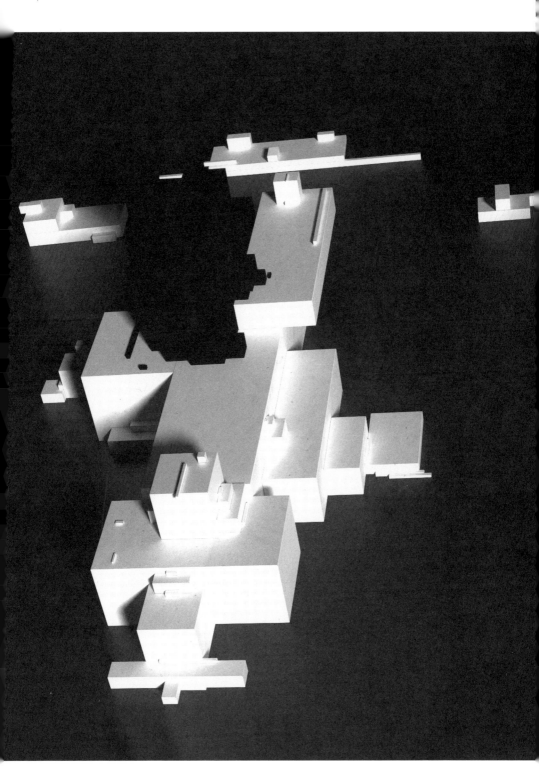

this and following pages:
Arkhitekton A19 (c. 1922). © Paulina Bitrán.

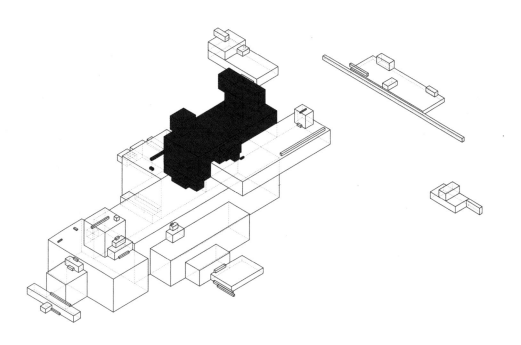

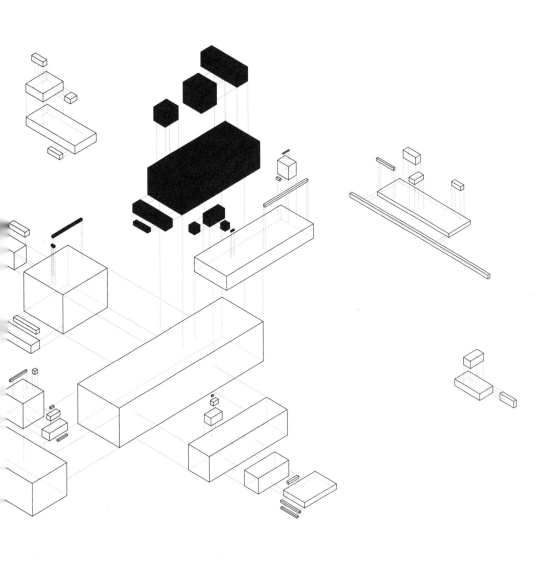

Arkhitekton A19 (1923)

In this drawing: 67 elements (12 black volumes,
41 white volumes, and three satellites with
14 volumes); length 120 cm, width 87.3 cm,
height 23.8 cm

Scale 1:10

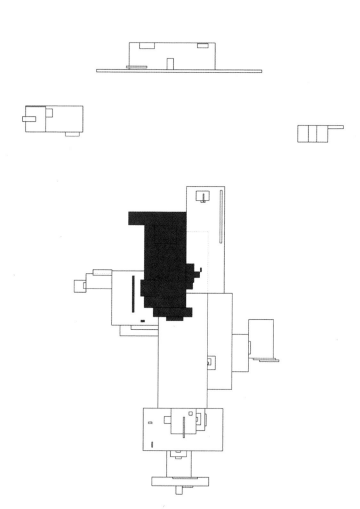

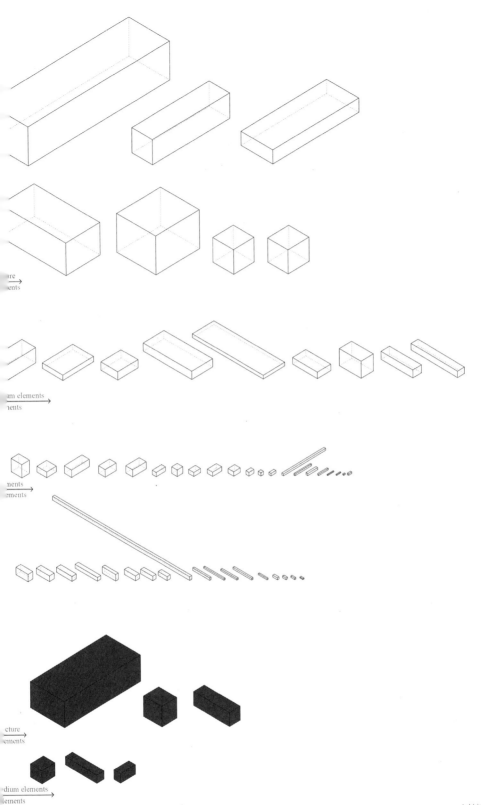

are
ents

am elements
ents

nents
ements

cture
ements

dium elements
ements

naments
lements

Arkhitekton A19
In this drawing: 67 elements

Scale 1:10

Arkhitekton A20 (c. 1920s)

An arkhitekton not identified in previous investigations or catalogues on Kazimir Malevich. We have called it A20 following Troels Andersen's numbering system. It is recognizable in photographs of the 1926 GINKhUK exhibition, in which A20 is located in the frontal plane, so its structural and ornamental elements can be easily identified. The position of the camera is nonetheless quite low, hampering the possibility of a more aerial and complete view of the object. From a careful examination of the image, it is possible to presume that the elements are in a fairly symmetrical dynamic equilibrium, so we conclude that the presence of mass must be very similar on both sides of the longitudinal axis.

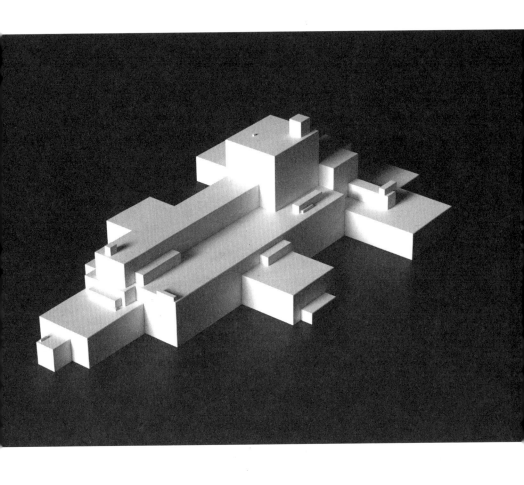

this and following pages:
Arkhitekton A20 (c. 1920s). © Paulina Bitrán.

Arkhitekton A20

In this drawing: 25 elements; length 72.5 cm,
width 45.9 cm, height 19.8 cm

Scale 1:10

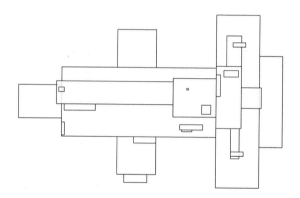

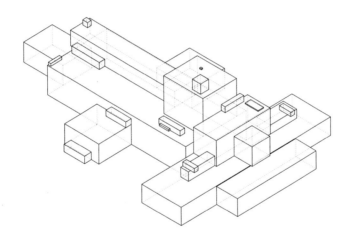

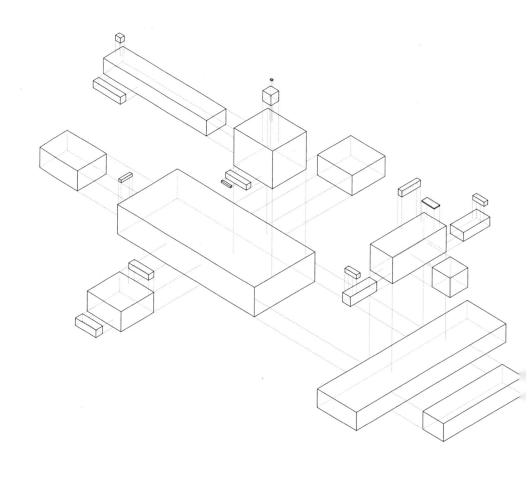

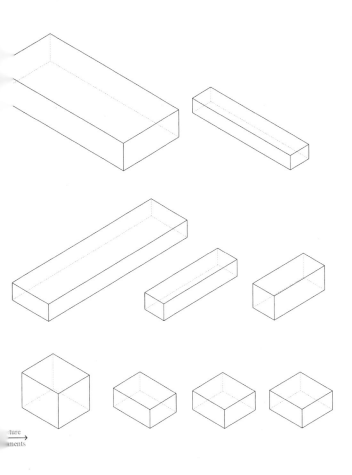

ture
ments

lium elements
ements

naments
lements

Arkhitekton A20
In this drawing: 25 elements

Scale 1:10

Arkhitekton A21

An arkhitekton not identified in previous investigations or cata-
logues on Kazimir Malevich. It is a rather longitudinal arkhitekton,
with a T-shaped base element that sustains, on top, yet another
cross-shaped grouping. Arkhitekton A21 is similar to planit X,
given its similar structural elements. Therefore, both could be con-
sidered states of a single form. However, there are enough differ-
ences to treat them as different objects.

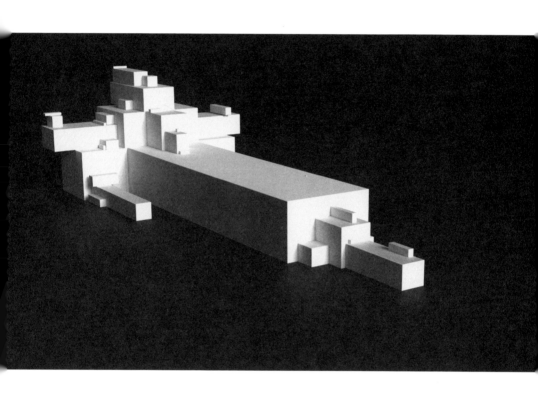

this and following pages:
Arkhitekton A21. © Paulina Bitrán.

Arkhitekton A21

In this drawing: 36 elements; length 86 cm,
width 36 cm, height 21.4 cm

Scale 1:10

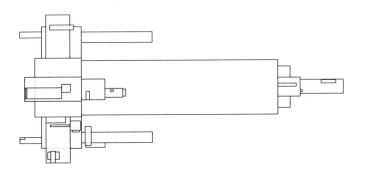

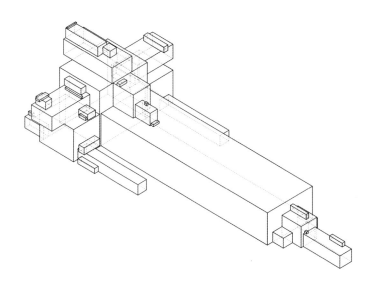

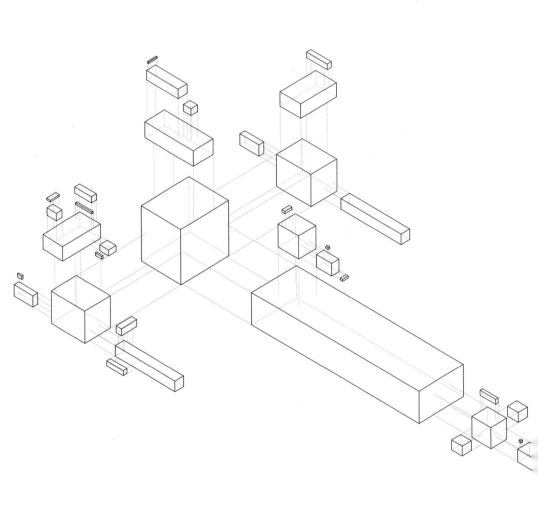

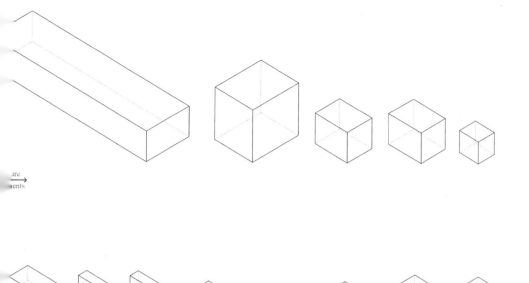

ıre
ents

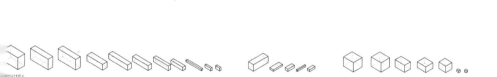

ım elements
ıents

ments
ements

Arkhitekton A21
In this drawing: 36 elements

Scale 1:10

Arkhitekton A22

An arkhitekton not identified in previous investigations or catalogues on Kazimir Malevich. Looked at from one side, it is very similar to A19, so it might be a variant state of that arkhitekton. It has a longitudinal main base body, cross-shaped in the front. On its back side it presents a different formal operation than A19, in that the displacement of the top volume is parallel to the base body instead of perpendicular.

this and following pages:
Arkhitekton A22. © Paulina Bitrán.

Arkhitekton A22

In this drawing: 29 elements; length
89.7 cm, width 42.1 cm, height 24.1 cm

Scale 1:10

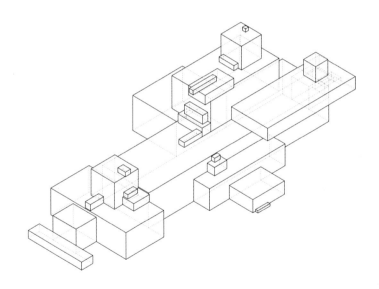

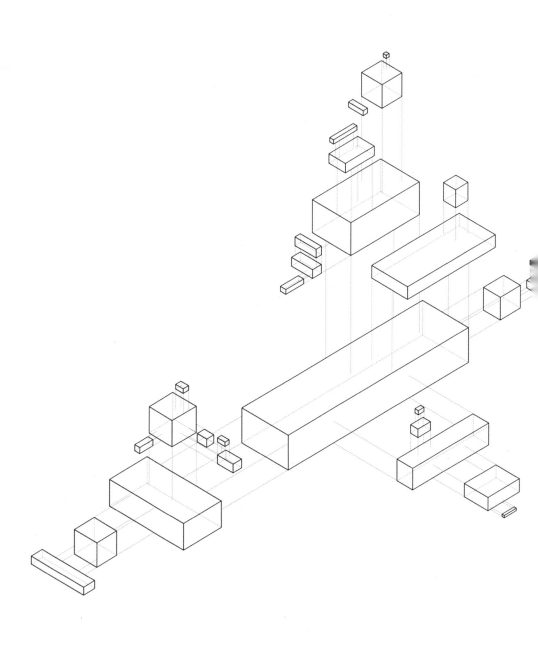

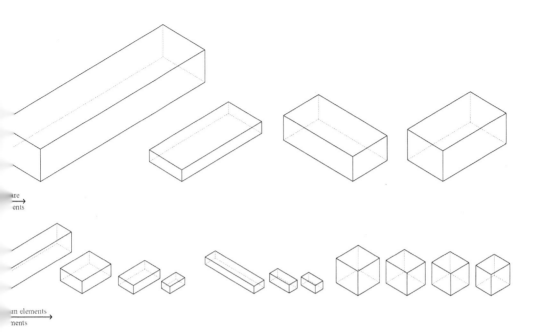

Arkhitekton A22
In this drawing: 29 elements

Scale 1:10

Arkhitekton A23

An arkhitekton not identified in previous investigations or catalogues on Kazimir Malevich. Its range of deformation makes it closer to A10 or A11, but it has a very small number of elements. This form is quite compact, having very few ornamental elements.

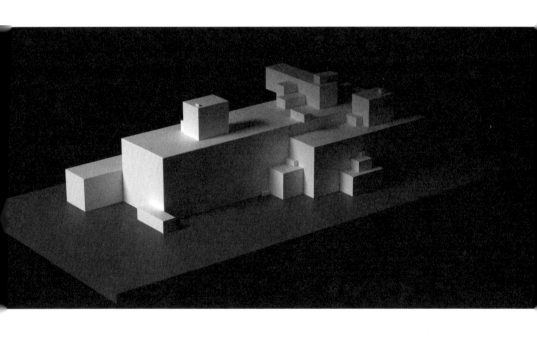

this and following pages:
Arkhitekton A23. © Paulina Bitrán.

Arkhitekton A23

In this drawing: 14 elements; length 64.4 cm,
width 27.7 cm, height 18.7 cm

Scale 1:10

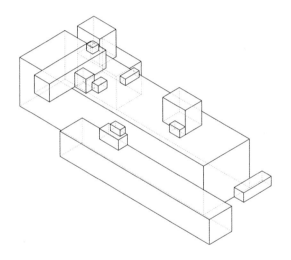

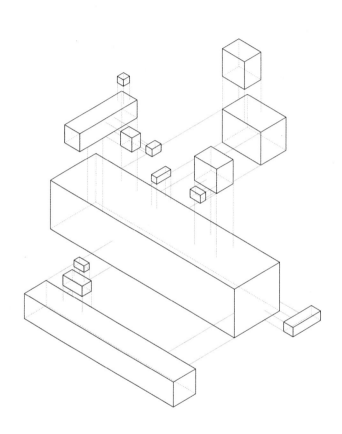

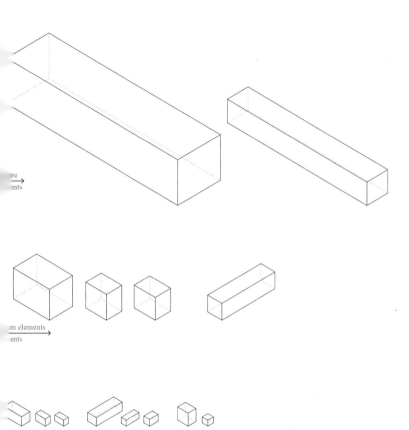

re
ents

m elements
ents

nents
nents

Arkhitekton A23
In this drawing: 14 elements

Scale 1:10

Arkhitekton A24

An arkhitekton not identified in previous investigations or catalogues on Kazimir Malevich. It is one of two arkhitektons with black volumes. One of them is a large element on top, perpendicular, and thus forming a cross with the base structural element. Either adjacent to or placed on top of these structural volumes, it has four groupings made out of medium and small objects.

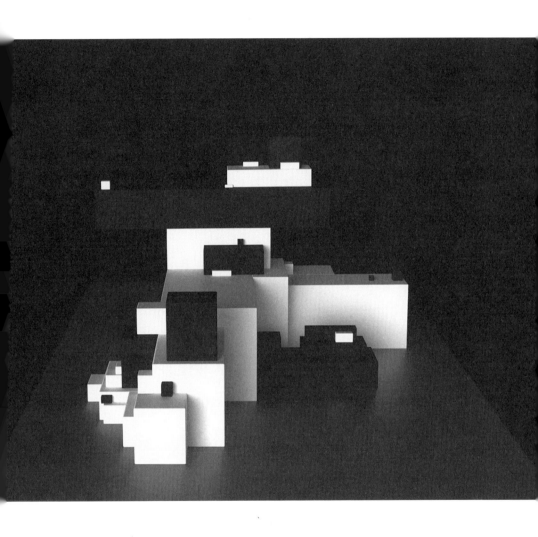

this and following pages:
Arkhitekton A24. © Paulina Bitrán.

Arkhitekton A24

In this drawing: 34 elements; length 67 cm,
width 40.3 cm, height 27 cm

Scale 1:10

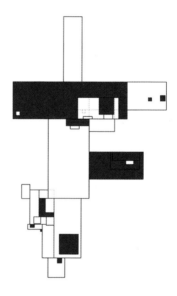

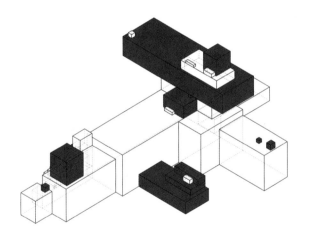

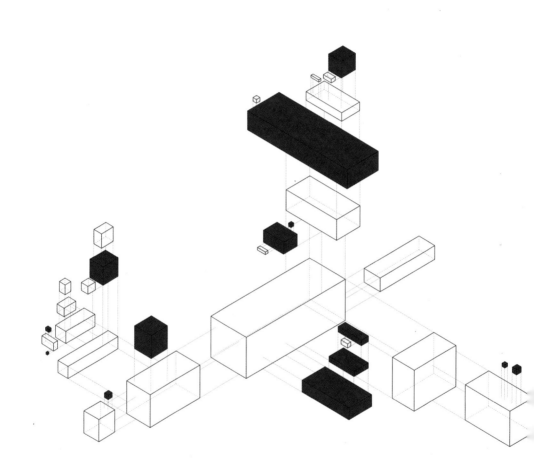

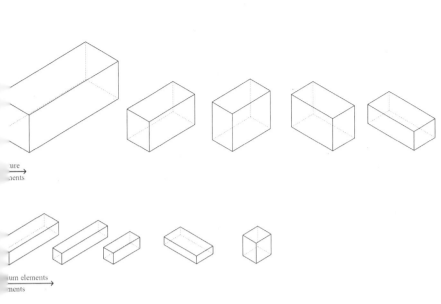

ure
nents

ium elements
ments

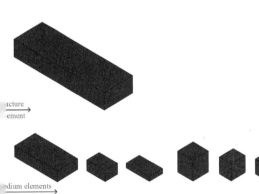

aments
ements

acture
ement

dium elements
lements

naments
elements

Arkhitekton A24
In this drawing: 34 elements

Scale 1:10

Arkhitekton A25

An arkhitekton not identified in previous investigations or catalogues on Kazimir Malevich. The two photographs available of this form, both taken at the GINKhUK exhibition, are consistent in characterizing it as a piling up of elements in such a way that it looks like an ascending pyramid, which nonetheless ends up in a crossed-shaped form. This is complemented by an additional structure that is attached to its base, giving it a longitudinal look.

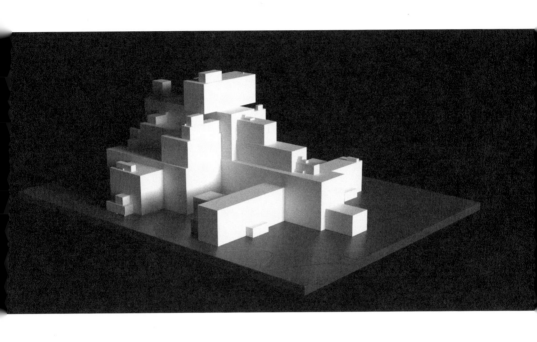

this and following pages:
Arkhitekton A25. © Paulina Bitrán.

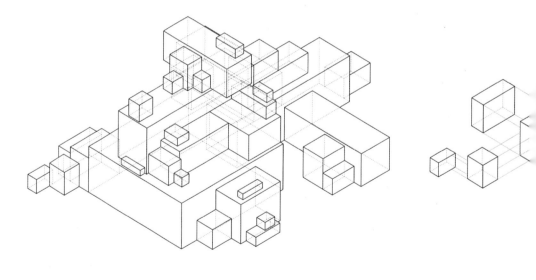

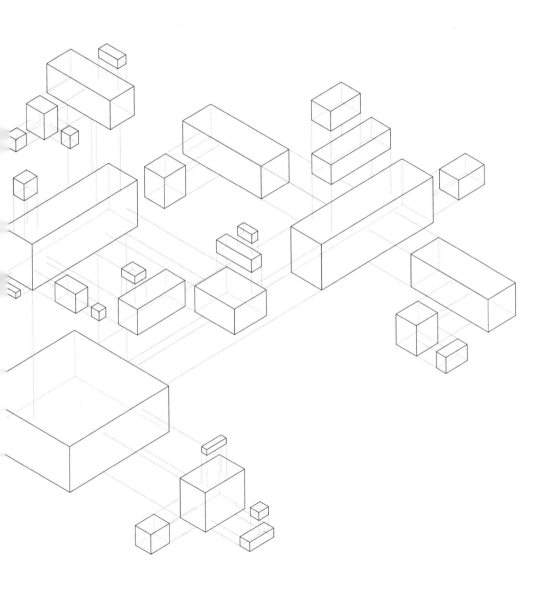

Arkhitekton A25

In this drawing: 34 elements; length 85 cm,
width 60 cm, height 35.3 cm

Scale 1:10

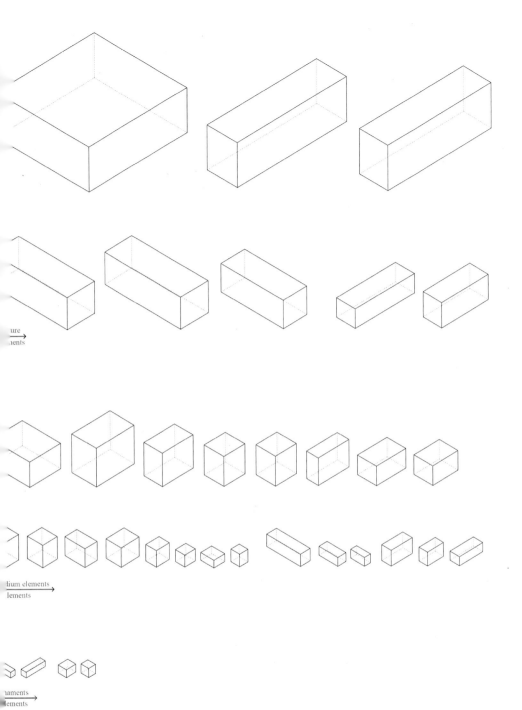

ure
ients

lium elements
lements

iaments
ements

Arkhitekton A25
In this drawing: 34 elements

Scale 1:10

Arkhitekton A26

An arkhitekton not identified in previous investigations or catalogues on Kazimir Malevich. A rather long and longitudinal arkhitekton, divided into front, middle, and back, that gradually increases in height as it grows toward its back. It has a T-shaped base element that sustains a cross-shaped compound on top, and that is rather unique for having two symmetrical arms.

The Additional Element in Architecture

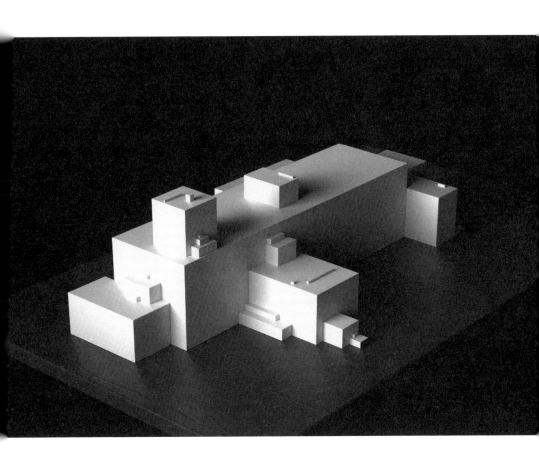

this and following pages:
Arkhitekton A26. © Paulina Bitrán.

Arkhitekton A26

In this drawing: 13 elements; length 60.4 cm,
width 35.5 cm, height 20.5 cm

Scale 1:10

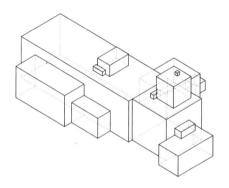

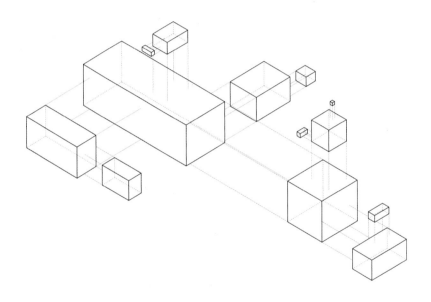

Arkhitekton A26
In this drawing: 13 elements

Scale: 1:10

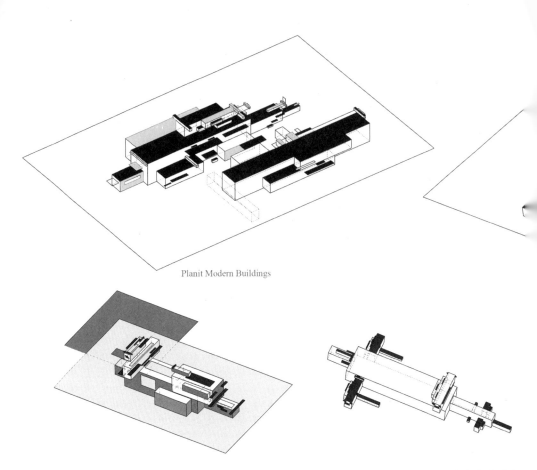

Planit Modern Buildings

Planit A10

Planit X1, Spokoj

this and following pages:
Eight planits. © Paulina Bitrán.

Planit Suprematist Composition

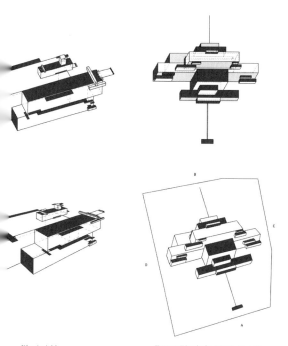

Planit A11

Future Planit for Earth Dwellers

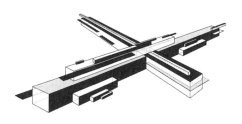

Planit Dynamic Nonutilitarian Suprematist Architecture

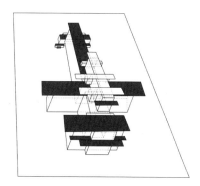

Future Planit for Leningrad: The Pilot's House

Planit A10 (1923)

A

1

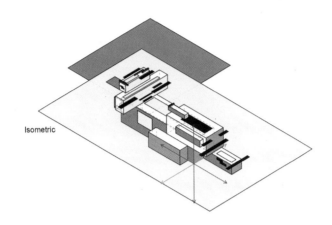

Isometric

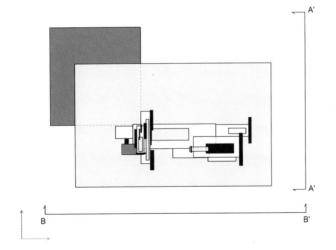

Elevation A-A'

Plan view

Elevation B-B'

Planit A10.

PLAN VIEW

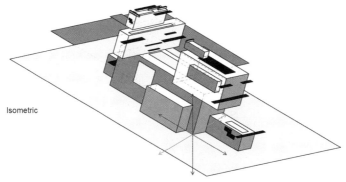
Isometric

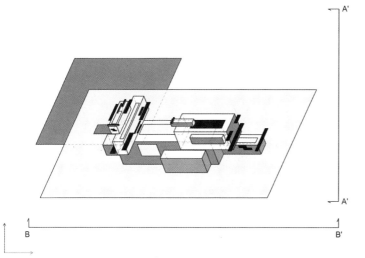

A'

A'

B

B'

Plan view

Elevation A-A'

Elevation B-B'

C

3

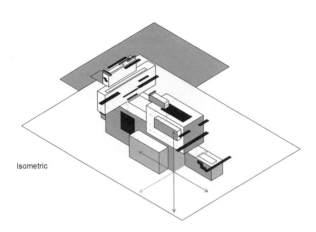

Isometric

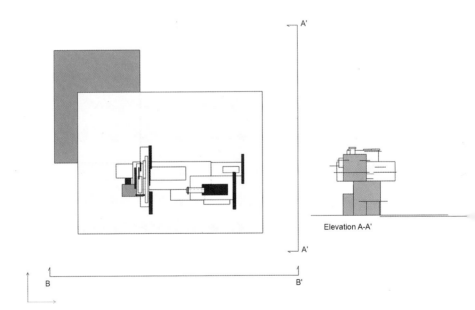

Plan view

Elevation A-A'

Elevation B-B'

Planit A11 (1923)

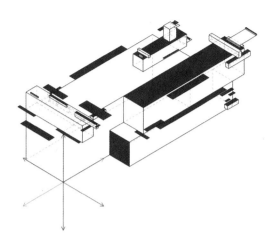

A'

A'

B B'

vation A-A' Plan view

Elevation B-B'

Planit A11.

B

2

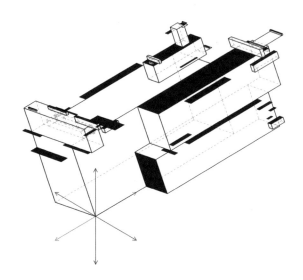

Elevation A-A'

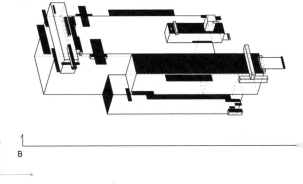

B

Plan view

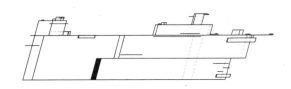

Elevation B-B'

3

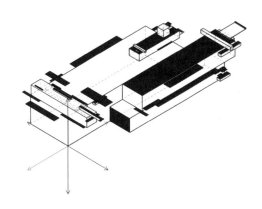

A'

A'

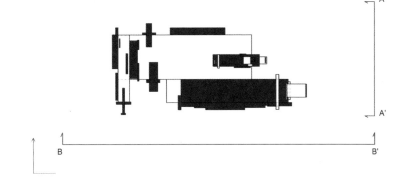

B B'

Elevation A-A' Plan view

Elevation B-B'

Planit X1, Spokoj (1925)

This planit, and planit A10, are together titled Two Studies of Suprematist Planits (1925). It is drawn as an axonometric, and is one of the three planits exhibited together with the arkhitektons at the GINKhUK exhibition in Leningrad 1926. This form has an appearance of symmetrical balance with respect to the distribution of volumes and elements in relation to the central longitudinal axis, and the differences between the two sides are very slight.

The planit is represented in a highly accentuated aerial view, so that the upper plane is almost represented in plan. The inclined position of the object with respect to the projection plane is so slight that the axonometry technique is at the visual limit with the oblique projection technique, with a sensation of forced depth. Finally, the shape seems to cast a shadow on the base plane, an ethereal shadow that does not correspond to the projection of the proportions of the volumes.

PLAN VIEW

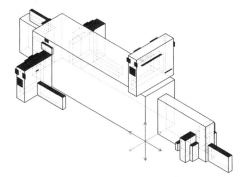

Isometric

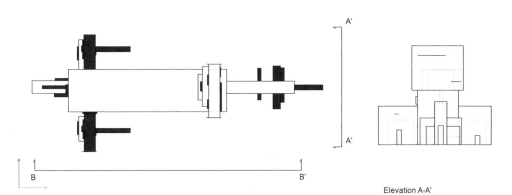

Plan view

B B'

A'

A'

Elevation A-A'

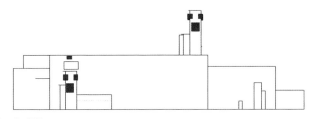

Elevation B-B'

this and following pages:
Planit X1, Spokoj (1925). © Paulina Bitrán.

B

2

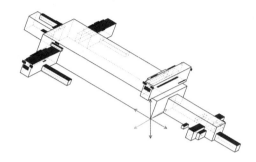

Isometric

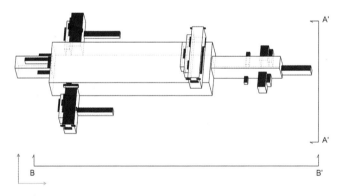

A'

A'

B B'

Plan view

Elevation B-B'

Elevation C-C'

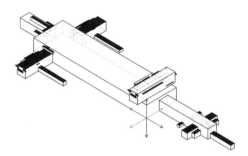

Isometric

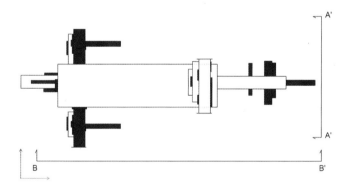

A'

A'

B

B'

Plan view

Elevation A-A'

Elevation B-B'

Future Planit for Leningrad: The Pilot's House (1924)

Also known as Airplane-Shaped Spatial Planit (the title given by *Praesens*, 1926), this has three versions. One of them, presented as a tapestry, was exhibited in the GINKhUK exhibition of 1926. In all three formats, the axonometric perspective technique is the same, and the object retains the same number and types of elements. Therefore, this form is considered to have only one state. This drawing was exhibited together with five other planits at the Venice Biennale in 1924. Similar to the Future Planit for Earth Dwellers (1923–1924), also presented at the Biennale, this planit has the written inscription "aF, second group of planits" on top.

This designation "aF" is also present in a drawing by Malevich labeled "Form aF" (1919–1920). Patrick Vérité suggests that "Form aF" may refer to "aeroform,"[9] but there is no clarification from the artist as to what "Form aF" means. Later on, he uses this nomenclature in the title of the series of six planits presented at the 1924 Biennale.

Regarding the drawing technique, this planit is represented as an axonometric perspective in aerial view, with the three depth axes altered with different techniques. The first axis is subject to perspective, vanishing toward three points located at the top of the object. The second axis of lateral depth of the object is represented in axonometry and also with a fourth vanishing point very far from the right side of the object; therefore some volumes are deformed by perspective and others are not. The third axis of depth that corresponds to the vertical (height of the object) is represented only in axonometry, so all the volumes are subject to orthogonality in the vertical axis, yet this vertical line is not at 90° but at 67°. In summary, the object is represented both in axonometry and in perspective, but has four different vanishing points, with elements that are represented without deformation and others with deformation in the lateral depth axis. As a consequence, the virtual volumetric reproduction of this object can have innumerable formal variations, depending on which vanishing point is taken as a reference to abstract the object, and consequently the elements subject to axonometry would be deformed and not orthogonal. Or vice versa, the volumes in axonometry may be considered as an orthogonal reference, and the perspectival elements with several vanishing points would be not orthogonal.

following pages:
Future Planit for Leningrad: The Pilot's House (1924). © Paulina Bitrán. There are two versions of this planit, one at the Museum of Modern Art in New York (graphite on paper, 31 × 44.1 cm); the other at the Stedelijk Museum, Amsterdam (graphite on paper, 30.5 × 45 cm).

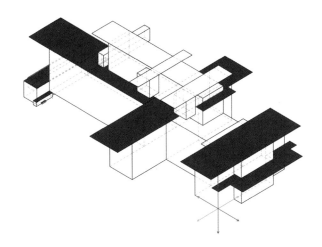

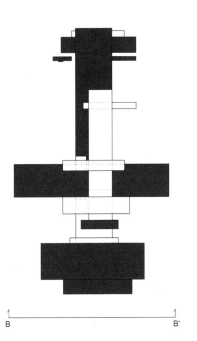

B B'

view

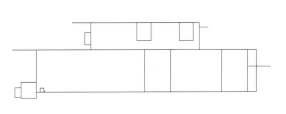

Elevation A-A'

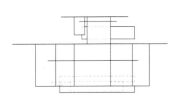

Elevation B-B'

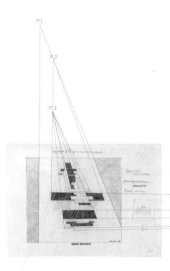

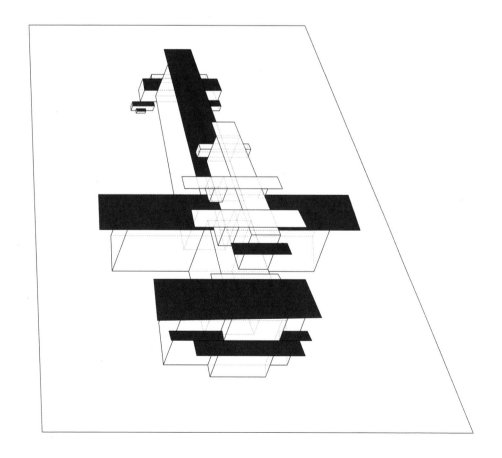

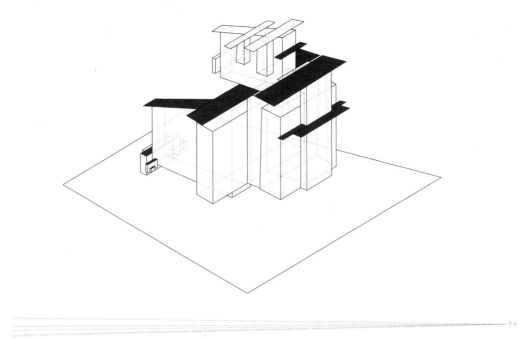

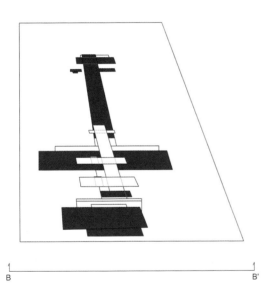

B ———————————————————————————— B'

Future Planit for Earth Dwellers (1923–1924)

Future Planit for Earth Dwellers has two drawings, each with a different representational technique: the first in a perspectival axonometric, and the second in an oblique representation. In both, the forms preserve the same quantity and type of elements and have the conspicuous feature of having the left side of the structural volume with two elements; a volume belonging to a plane of depth merges with another volume of a different depth, through the union of their respective edges on one side. The first drawing, dated by Malevich "1913–1924," was exhibited together with Future Planit for Leningrad: The Pilot's House and four other planits at the Venice Biennale in 1924. It is one of two known planits that include a human figure (the other being the planit Modern Buildings), and this is the only one presenting a tree, a basement, and so the earth as a context. These are figurative elements that provide a scale and a resemblance to a project of architecture settled on the ground. If we scale the planit to the human figure, the dimensions depicted would be about 23 m long, 11 m wide, and 7 m high. It is also the only planit with three elevations, A, B, and D, each having a general relation to the planit, but they cannot be related to one another. Each one shows differences in the quantity, proportions, tonalities, and positions of the elements, so the planit does not have a singular shape, but different states of the same form. The drawing is complemented with a technical description:

> Suprematism in buildings. The Suprematist forms AF of the second group of planits 1913–1924. I am now thinking about the materials. Opaque white glass, concrete, tarred roofing felt, and electric heating without chimneys. The colours of the residences are predominantly black and white. Sometimes, in exceptional circumstances, it could be red, black and white. But that depends on the tension of the state's powers and its weakness. In terms of dynamism. Earthlings must be able to reach a planit from every side; they can be inside it or outside. The planit is simple, like a tiny atom, and all of it is within the reach of the Earthling who lives in it. In fine weather, he could sit or even live in the surface. Thanks to its construction, and its system, the planit is self-supporting, and it will be possible to keep it hygienically clean. It can be washed every day without

The Additional Element in Architecture

the least difficulty, and owing to its low shape, it is not dangerous.[10]

This first drawing shows the form in an aerial view through the axonometric perspective technique, but, as the drawing looks like a draft with neither finished lines nor conclusive edges, it is impossible to figure out a clear orthogonality for the volume. Nevertheless, the perspective, presented in one of the three edges of depth, can be clearly recognized on the far right of the object. There are two possibilities for making a digital version of this planit from this drawing. We can establish an orthogonality on two of the three axes of depth, abstracting the volumes from non-regular shapes toward perfect prisms, and then create a two-point perspectival drawing. The second way is by providing an arbitrary unit of measurement on the three orthogonal axes, and excluding the presence of perspective.

The second drawing of this planit was published in *Blok* magazine in 1926 with two other planits, with the title Planits (Houses) of the Future. This planit is represented with the oblique technique, which means that the top faces of the volumes are presented on 90° as a plan view, so the sides are only visible as if in a forced (artificial) depth. To make a digital version, there are two possibilities: we can either take the shape of the object as it is presented, which means that the top faces of the volume remain parallel to the plane of projection and the edges of the lateral faces are inclined, giving as a result prisms with nonorthogonal corners; or we can provide an arbitrary unit of measurement on the three orthogonal axes.

following pages:
Future Planit for Earth Dwellers (1923–1924). Rendering © Paulina Bitrán. Original drawing, pencil on paper, 17¼ × 12⅛ in. (44 × 30.8 cm), State Russian Museum, Saint Petersburg.

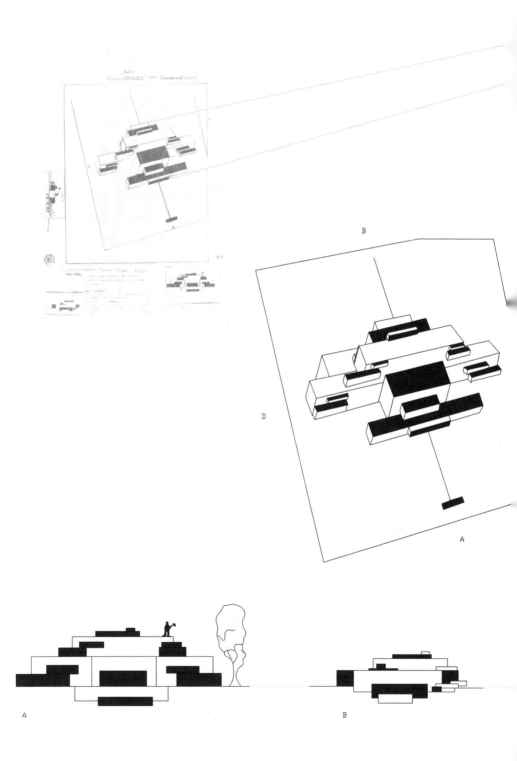

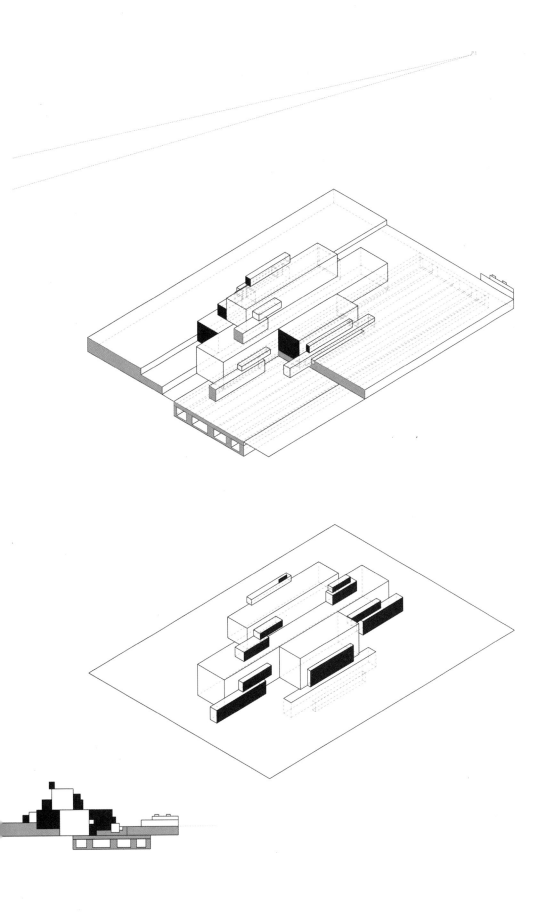

B

1

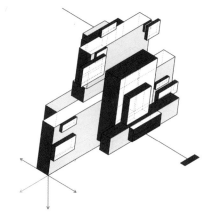

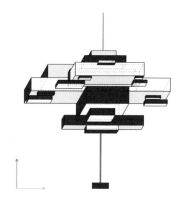

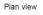

Plan view

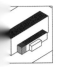

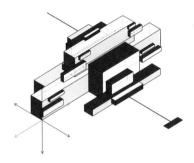

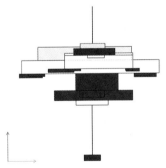

Plan view

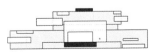

Planit Dynamic Nonutilitarian Suprematist
Architecture (1925)

This planit was published on the front page of *Blok* magazine in Poland, in 1925, with the title Dynamic Nonutilitarian Suprematist Architecture. It is represented with the axonometric perspective technique, with the two horizontal axes of depth in perspective, and the vertical axis in axonometric. The perspective is inverted due to the many vanishing points (at least eleven), with some of them running against the depth sought by the overall drawing. These vanishing points act in a few elements of the objects, or sometimes just in one of them.

The object has a clear cruciform shape, with elongated elements along the two main bodies, and a total of fifteen volumes and six eaves. The white elongated prism on the top appears to be resting on the highest surface of the main volume of the planit, but it is actually separated, providing space for another perpendicular longitudinal white volume. To make a digital reproduction of this planit, the technique is to create a two-point perspectival axonometric, choosing the two main vanishing points for the axes of depth, and keeping the axonometric on the vertical axis. All the volumes and eaves that had their own vanishing points are interpreted as deformed nonorthogonal elements.

The Additional Element in Architecture

...e the shape of this planit in a 3D model, it is
... to choose two vanishing points, in this case P.4
...which correspond to the main two crossed volumes.
...of the planes with their own vanishing points are
...ed as deformed planes, with a nonorthogonal shape.

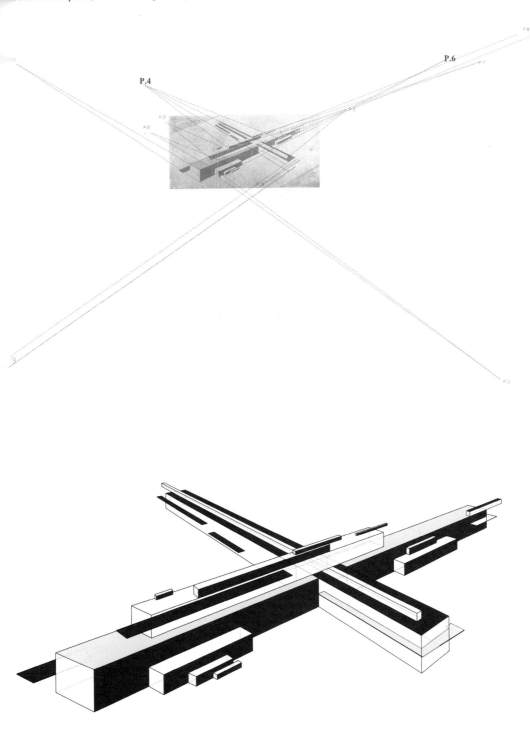

this and following page:
Planit Dynamic Nonutilitarian Suprematist Architecture (1925). © Paulina Bitrán.

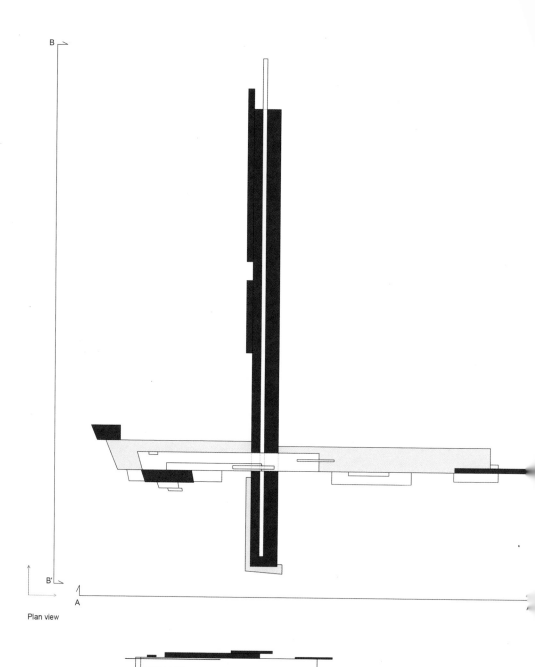

B

B'

A

A

Plan view

Elevation A-A'

Elevation A-A'

Planit Modern Buildings (1923–1924)

There are no known original publications of this planit. It is one of two planits (with Future Planit for Earth Dwellers) that include human figures, which provide a sense of scale. If we fit the planit to the scale of the human figure, the dimensions depicted are around 60 m width, 110 m length, and 20 m height. Malevich's axonometries are trimetric, that is to say, their three orthogonal axes are at different scales. This makes it impossible to know the unitary proportion between the different sides of the object. Therefore, in order reconstruct the object using digital tools, three different hypotheses can be tested, leading to three different outcomes: (1) We can provide an arbitrary unit of measurement to the three spatial axes in order to generate a proportional relationship between them. This means, for example, that we agree that the section of a volume of cubic appearance is a square. (2) We can build the object orthogonally, and with the exact inclined position of the drawing in a virtual space, taking the upper plane as a reference. The depth of the object is the result of its position according to the projection plane. Or (3) we can consider the image a direct vision, perpendicular to the plane of projection, resulting in the exclusion of an orthogonal appreciation of the representation. The shape is then deformed in such a way that the visible sides are actually inclined planes.

following pages:
Planit Modern Buildings (1923–1924). © Paulina Bitrán.

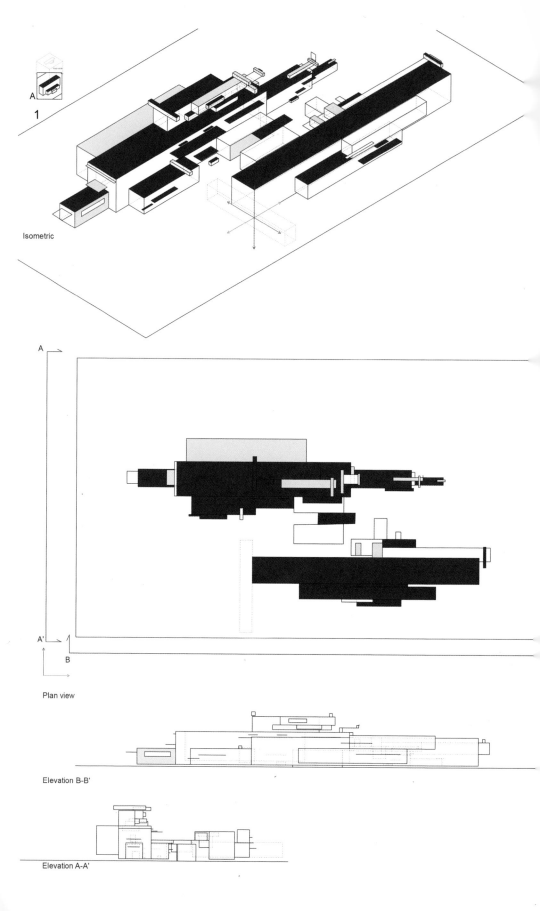

A

1

Isometric

A

A'

B

Plan view

Elevation B-B'

Elevation A-A'

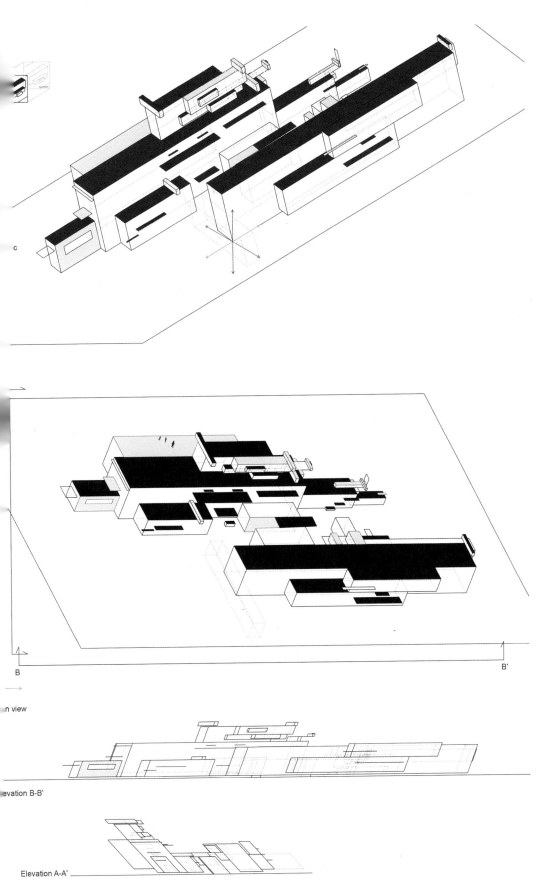

c

B B'

n view

evation B-B'

Elevation A-A'

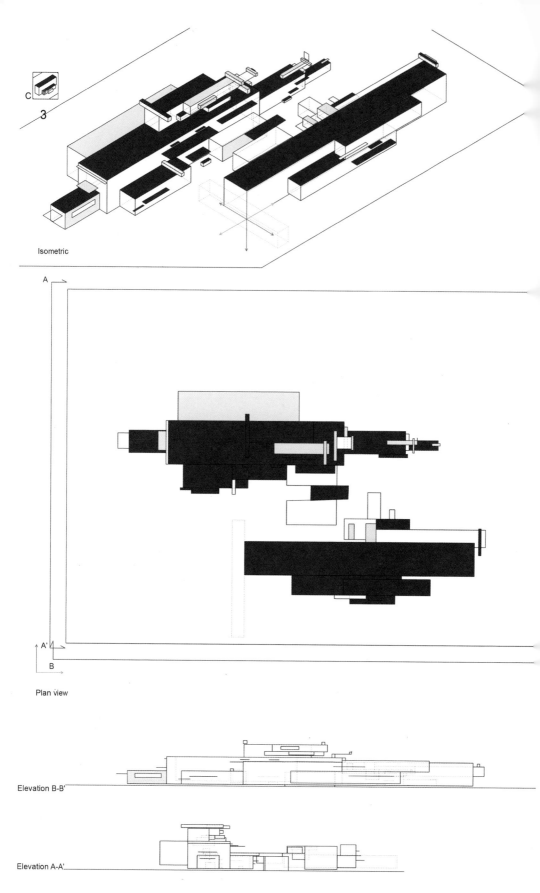

C

3

Isometric

A

A'

B

Plan view

Elevation B-B'

Elevation A-A'

Planit (no known name)

This planit has never been published before. It was found on the art sale website Artnet. In disposition and type of elements it is very similar to the planit Modern Buildings. It is drawn with the trimetric axonometric technique, and it presents various unfinished lines, open volumes, and some planes that belong to different depths, but ultimately they merge on a single plane. There are also some edges of volumes that look parallel but are not. It is not possible to virtually recreate this form, because of all the merged planes and unfinished volumes. However, we provide a draft containing the more significant features of the object.

following pages:
Planit (no known name); we call it Modern Buildings 2. Rendering © Paulina Bitrán.
Original drawing, pencil, 21 × 29.8 cm.

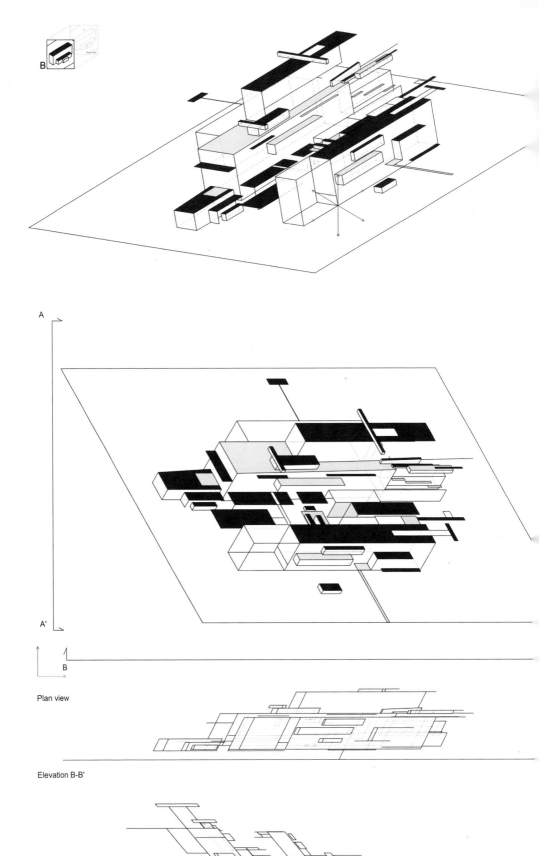

B

A

A'

B

Plan view

Elevation B-B'

Elevation A-A'

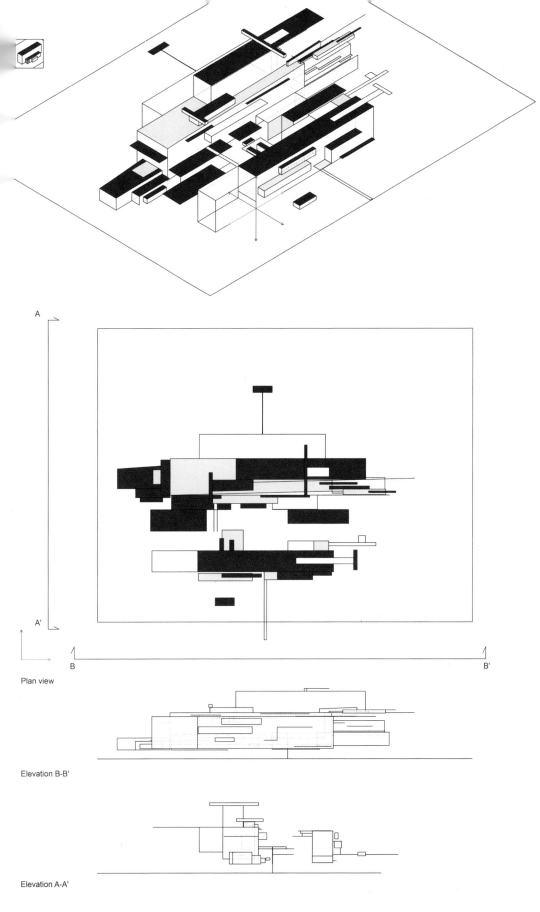

Plan view

Elevation B-B'

Elevation A-A'

7 *Positionings*

D escribed by himself as a window into the desert of nonobjectivity, Kazimir Malevich's *Black Square* should not be considered in a conceptual, pictorial, or geometrical sense only, or as an attempt to destroy or reduce all concrete content. Its relationship with the past and its rejection of all figuration also incorporated quite a radical operation—one that we would call an operation of "positioning"—when, in the "Last Futurist Exhibition of Paintings 0.10" in Petrograd (now Saint Petersburg) from 19 December 1915 to 17 January 1916, he placed the *Black Square* in the so-called "red corner," or "icon corner," a place in a Russian room traditionally reserved for religious symbols, usually for an image of the Virgin and Child. By doing this, Malevich carried out an act of misappropriation. He replaced the images of previous icons and, at the same time, reasserted the most profound meaning of this sacred corner, seizing it for himself. It could be said that Malevich appropriates a whole lot of meanings and historical and symbolic references when taking over somebody else's place.

This operation, physical and aesthetic in character, was somehow determined by political ends. The "enemies," or simply the "others" (to Malevich, the religious images placed in the "icon corner"), must be acknowledged and then internalized in order to surpass them. This acknowledgment, this control of previous icons, "must be real and material,"[1] for instance in the effective

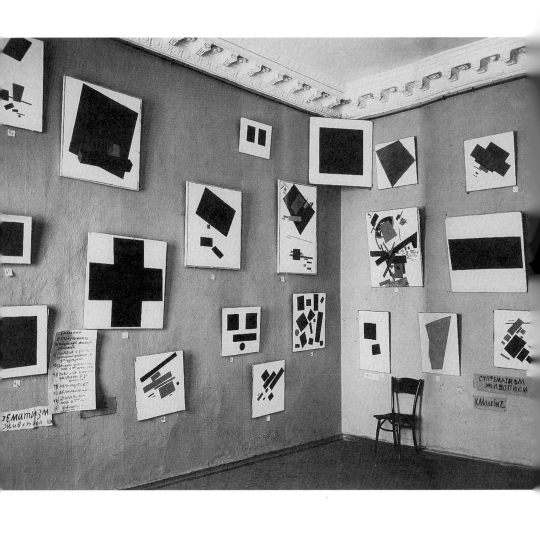

The *Black Square* at the "Last Futurist Exhibition of Paintings 0.10," Saint Petersburg (then Petrograd), 19 December 1915 to 17 January 1916.

installation of the *Black Square* by its positioning in the traditional sacred corner. Thus, by adopting this place, Malevich decided to actively absorb its entire symbolic load, while at the same time the *Black Square* would make it blank. Laura González has summarized this problem in the concept of "absorption," understood as "the destruction of an idea from within itself."[2]

The operative (or we can say the projective) sense of this absorption is as radical as it is elegant, because it does not require the physical destruction of the wanted object (which is, by definition, inaccessible). What Malevich does is, rather, to create an abstract double that allows him to redefine the enemy while absorbing and thus replacing it. In doing this, however, he does not betray the original, but instead presents his own translation, *as the original*. Logically speaking, to Malevich, icons are always already there, within the *Black Square*. He creates a double that is pure and perfect, in the nonobjective state that is previous to its objectification by means of faith, necessity, or, in architectural terms, program.

This sense of effective duplication corresponds with the idea of the "double" and the "ominous" so famously described by Otto Rank and Sigmund Freud. In their terms, what Malevich does is to create a double—the *Black Square* in the icon corner—destined to challenge the apparent unity and singularity of the object it lurks behind. Paradoxically, this operation threatens the destruction of tradition by appropriating it, while simultaneously providing the means to save it from extinction, connecting the fear of death with the narcissistic attitude of remaining young forever.

But, pertinent to our argument on Malevich's positionings, putting the *Black Square* in the icon corner is certainly not the only time Malevich formalized this type of operation. In 1924, he produced a famous photomontage (the only one he is known to have made) in which he usurped the image of the most emblematic skyscrapers of the New York skyline of the first decades of the twentieth century—14 Wall Street, Trinity Building, Equitable Building, Bankers Trust Tower, and Trinity Church—replacing them with his Suprematist arkhitekton A11. This photomontage, with the axonometric of the arkhitekton vertically rotated, was published in *Praesens* in 1926. The "Suprematist arkhitekton," catalogued in 1980 by Jean-Hubert Martin as A11, was elaborated by Malevich in four different versions: as a perspectival drawing (1923), as an axonometric drawing (1923–1925), as the New York photomontage of this axonometric (1924), and as a plaster model of the arkhitekton,

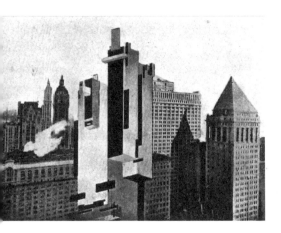

Analysis of Malevich's photomontage of A11 with 14 Wall Street, Trinity Building, Equitable Building, Bankers Trust Tower, and Trinity Church, New York.

of which only a photograph remains (1923–1926). The Suprematist arkhitekton A11 is therefore multiple, or has been multiplied, existing in four states, which actually translate into five different representational registers: an axonometric drawing, a perspective drawing, a photomontage, a plaster model, and a photograph of the plaster model. But this is not quite all. To Malevich, it still needed to be positioned, in Manhattan, in order to absorb the city from within, appropriating it.

Also in 1926, Malevich repeated this path when he transformed the drawing of his Future Planit for Leningrad: The Pilot's House (1924) into a large hanging tapestry that he placed at the end of the hall in the GINKhUK exhibition. Although the tradition of hanging tapestries was less transcendent than the meaning of the icon corner, Malevich is seen, once again, to be subverting the eminently symbolic, traditional, and ornamental effect of placing carpets on walls by replacing their decorative patterns with his Suprematist nonobjectivity. Clearly, Malevich's intention was to carefully disseminate his work, appropriating all means and formats by way of positioning.

In the series of plaster models that he produced in the 1920s, we again witness this procedure, when he claims for himself nothing less than the place of architecture. In fact, despite his own claims, the arkhitektons are not just an architectural endeavor to progress from the two dimensions of painting to the three-dimensionality of space. Without "any sentimental attachment to

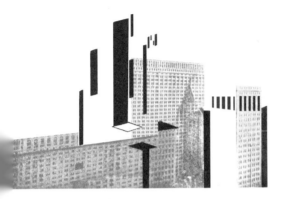
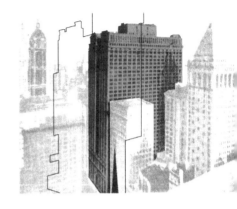

Kazimir Malevich, Future Planit for Leningrad: The Pilot's House (1924). Hanging tapestry placed at the end of the hall in the GINKhUK exhibition, 1926.

the culture of the past,"[3] and having already absorbed traditional painting by means of the *Black Square*, Malevich decided that his next objective was to absorb architecture "from within," taking its place, creating a nonfigurative double that is logically previous to figuration. What makes a building architectonic is not use, but

the plastic sensations stirred by the actual relationships between objects that Malevich fixed, casting them into photographic framings. As Boris Groys points out, in its deepest revolutionary meaning, that is to say, in the destruction of the existing society through the destruction of its paintings and its architecture, these strategies of duplication and positioning were conveyed through very concrete operations. The arkhitektons, in this sense, do not offer a new, more or less abstract, way to stabilize an avant-garde image in the context of permanent historical transformations. On the contrary, what they do is to provide an image of the process of destruction they refer to. Following Groys's understanding, this explains why the arkhitektons do not define closed or finished forms, but only states, objects open to "disfiguration, dissolution and disappearance in the flow of material forces and uncontrollable material processes."[4] Malevich, the creator of nonobjective doubles, accepts this historical violence, appropriating it.

There is no evidence that the arkhitektons ever moved from place to place in the form shown in photographs. The literature would agree that they were transported as scattered arrays of prismatic volumes. They were not finished or stable objects, but provisional "states" susceptible to disappearance and reappearance according to a certain grouping plan. Strictly speaking, they were not objects but assemblages defined by formal operations in the concurrence of "additional elements" that, in Malevich's terms, become "compositions of stereometric figures that transmit plastic sensations only."[5] These sensations might be "of ecstasy or dynamism, and the diffusion or concentration of weight."[6] The arkhitektons do not have a form in a stable sense, but instead comprise an unstable image of sensations achieved through the interplay of light and shadow, inevitably condemned to prompt dissolution.

This instability is evident in arkhitekton Alpha or A1,[7] which is not one but at least three Alphas, differentiated by the number of elements and their relationships of size, according to "thresholds of proportionality."[8] As convincingly argued by Harold Rojas, Alpha state 1 (1920–1923) has one hundred elements, state 2 (1923–1924) has ninety-seven, and state 3 (called Form D) has only fifty-one.[9] It should be recalled that Malevich's Tektonik, the famed reference to arkhitekton Alpha made by Zaha Hadid in 1976–1977, has only twenty-eight elements, and does not correspond to any of the states assembled by Malevich.[10] In making it, Hadid had

The Additional Element in Architecture

in fact created her own state for Alpha, also infecting the arkhi-
tekton with program (the proposed hotel on Hungerford Bridge).
The arkhitektons do not offer a new (more or less abstract) way to
stabilize an avant-garde image in the context of permanent his-
torical transformations. They are objects open to "disfiguration,
dissolution and disappearance in the flow of material forces and
uncontrollable material processes."[11] Malevich, accepts this his-
torical violence, appropriating it. And with the same violence he
appropriates the icon corner, the hanging tapestries, and the sky-
line of New York City.

Hadid's project is relevant for our argument. In a brief essay on
consumerism, Chilean sociologist Tomás Moulian elaborates some
of Freud's observations to explain that objects cannot be possessed
when they lack an interior. "You can only possess that which has
it. . . . Possession has to do with the control of the interior."[12]

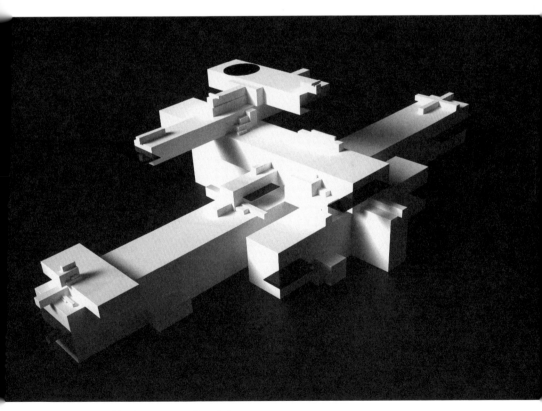

Dynamic arkhitekton A7. © Paulina Bitrán.

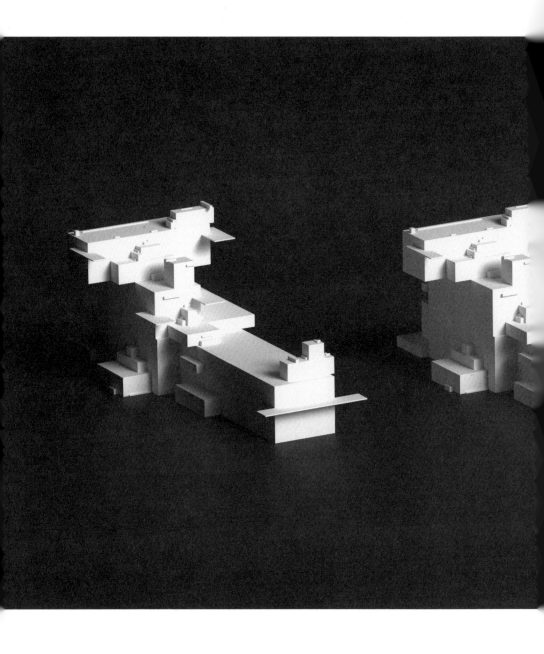

The three states of arkhitekton Alpha. © Paulina Bitrán.

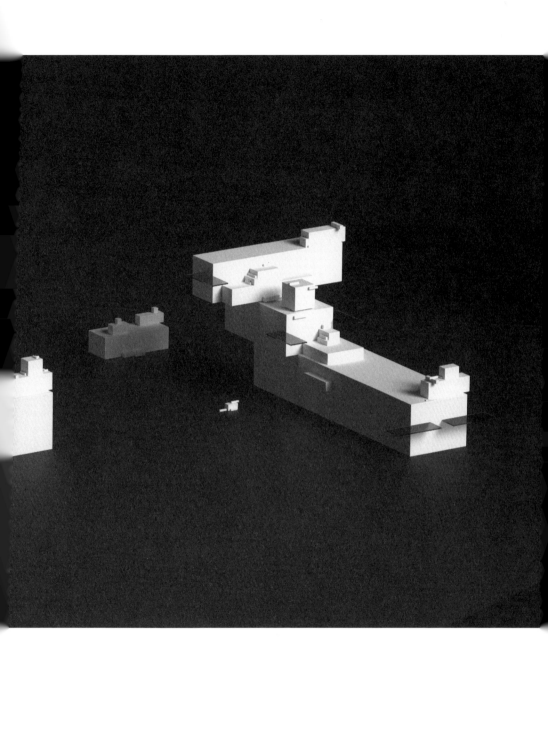

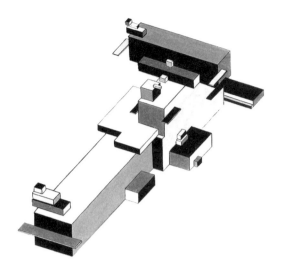

Zaha Hadid's version of arkhitekton Alpha with twenty-eight elements. © Paulina Bitrán.

Therefore, not providing an object with an interior would prevent it from being possessed or conquered. It then follows that in order to possess an object, one must first give it an interior. This operation would require design. And that is what Hadid—inspiringly taught by Rem Koolhaas and Elia Zenghelis at the AA—performed. This action entails, at some level, an erotic impulse of penetrating the object. Perhaps for this reason, Malevich deliberately devised his arkhitektons as pure exteriorities. According to Freud, "Many symbols represent the womb of the mother . . . as wardrobes, stoves, and primarily a room. The room-symbolism is related to the house-symbol, doors and entrances again become symbolic of the genital opening." All of those objects "share its peculiarity of enclosing a space capable of being filled by something."[13] Perhaps this notion explains why Malevich called these objects arkhitektons, transforming the Russian female for architecture—Архитектура—into the masculine neologism Архитектоны. A male with no "womb" to be filled: architecture conceived and displayed as pure exteriority.

A more plausible—if related—reason for this name relates to Malevich's understanding of the difference between architecture and architectonics. In his book on Malevich, Serge Fauchereau refers to a report by Polish writer Tadeusz Peiper on the 1927 meeting at the Bauhaus between the Russian artist and Walter

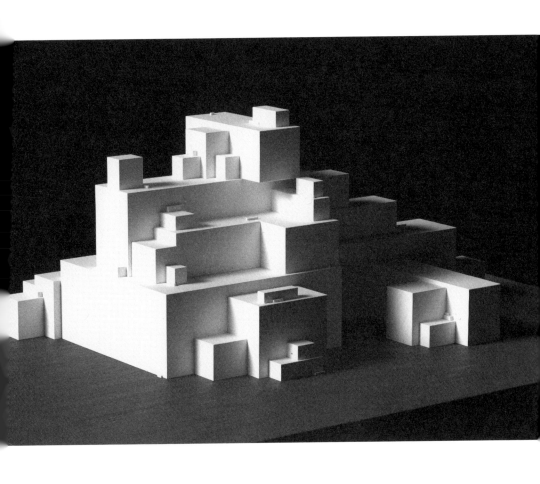

A25. © Paulina Bitrán.

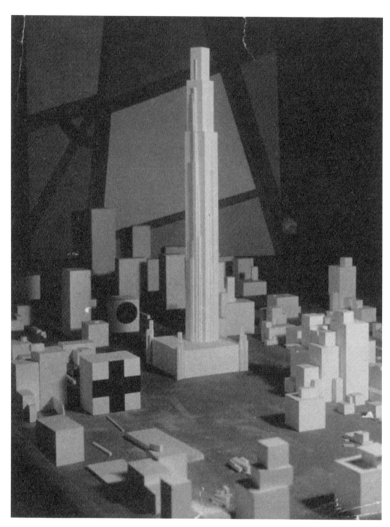

A14—arkhitekton Lukos, 1928.

Gropius, where Malevich differentiated between architecture and architectonics: "The former has a utilitarian aim whereas the latter is strictly artistic. Architectonics produces work which only describes the artistic relationship of spatial form; it does not take into consideration the fact that people will inhabit the form. . . . Gropius, who unlike the plastician Malevich is an architect by training, proposes another aim. For him, the method of construction depends with the greatest precision on the ultimate use of the building."[14] By depriving buildings of their interiority,

The Additional Element in Architecture

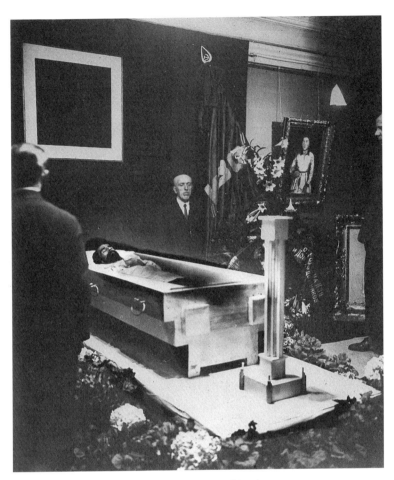

A different state of Lukos at Kazimir Malevich's funeral (1935).

"architectonics" renders "architecture" useless, reinserting it into the realm of pure art (architecture as an art form). This understanding brings us back to the idea of "the additional element" in architecture, which, paradoxically, is like a virus that rather takes away instead of adding. It takes away function and its postmodern relaunch as program.

During the meeting with Gropius, Malevich discarded any interest he might have had in architecture's self-indulgent functionalist claims, reinforcing the belief that for him, the only thing that matters is art. And art—living art—must be always ready to dissolve or disintegrate. For Malevich, nothing could be more decadent than creating forms only justified by a discourse on necessity.

Radically, he wanted to avoid the possibility that the arkhitektons could be possessed, or become useful, necessary, or, ultimately, important to preserve. Malevich aimed at preserving architectonics from preservation itself. Only when buildings enter the world of pure, absolute, living art do they achieve the calm acceptance of their own fate, destruction and disfiguration in the flows of time. And in order to do this, he performed the ultimate act of positioning, radically placing us, the subjects, outside the arkhitektons.

8 Sensation

In his writings, Kazimir Malevich turns time and again to discuss the notion of "sensation." In particular, he addresses the term in a text devoted to Paul Cézanne, titled "An Analysis of New and Imitative Art" (1928). For Malevich, what is important in Cézanne's paintings is how the color elements are woven to create the new painterly structure from which various sensations are strongly revealed. This is what he calls New Art, in opposition to Imitative Art. The new artist seriously studies "sensation itself," Malevich explains, as the formative basis of painting. This new art can thus communicate the conception of painterly sensation "as such" without reference to external reality, or to imitation. And Malevich credits Cézanne with having both conceptualized and realized this. To him, Cubists, Futurists, and Suprematists are, in truth, "Cézanne's followers."[1]

About six decades after Malevich's text, Cézanne's work and insights were still matters of interest and debate, including his approach to sensation.[2] In the late 1970s Lawrence Gowing published "The Logic of Organized Sensations," a text that was soon followed by Éric Michaud's essay "Cézanne's Sensations" (in critical response to Gowing's arguments),[3] as well as Gilles Deleuze's *Logic of Sensation*, the rather Cézannean subtitle of his book on Francis Bacon,[4] all published between 1978 and 1981.

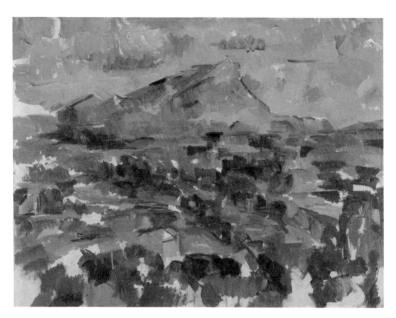

Paul Cézanne, *Sainte-Victoire, vue des Lauves*, 1904–1906. Oil on canvas, 63 × 83 cm. Kunsthaus Zürich.

But what is sensation really about? And how does it work in the arkhitektons, planits, and by extension in Malevich's approach to architecture?

Malevich would respond to this question as follows: sensation is what holds our attention: "We can say that our attention is arrested by the structure, by the apportionment of the mass of colour in its contrasts, by the texture and its general tone, and by the purely painterly sensation." In praise of Cézanne, then, the "content" of the new art is, to Malevich, "a purely painterly perception of phenomena." Painting, he would conclude, is not the expression "in painting" of some tree, "but a new, independent, real body, which acts upon us directly."[5] Gilles Deleuze's account of Cézanne repeats Malevich's assertions about the corporeality of sensation. Sensation is in the body, he says, "and not in the air. Sensation is what is painted. What is painted on the canvas is the body, not insofar as it is represented as an object, but insofar as it is experienced as sustaining this sensation."[6] Éric Michaud goes even further. Cézanne does not paint the effect, "he paints the conditions for the production of the effect, preparing the conditions for its possible emergence in others' eyes."[7] In all

The Additional Element in Architecture

cases, Michaud's, Deleuze's, and indeed Malevich's insights start to unfold two different, if complementary, threads: on the one hand, the independence of sensation from the figurative (famously grasped by Malevich as the nonobjective); on the other, the actual painterly strategies associated with the achievement of such independence, swiftly listed by Malevich as dealing with the structure, the relations between elements, the distribution of color in its contrasts, texture, and tone. What Malevich had already conceptualized as nonobjectivity is close to what Deleuze would later reelaborate as the "pathic" (or nonrepresentative) "moment of the sensation."[8]

Therefore, when Malevich states that the arkhitektons represent a move from two-dimensional painting to three-dimensional space, a question immediately arises on the manner in which sensation is transferred from one to the other. The obvious answer to this question should start by considering that the arkhitektons involve a purely "architectonic" perception of phenomena,[9] associated with the structure of the object and its related plastic relationships of size, scale, and equilibrium, as well as width, length, height, horizontality, verticality or else longitudinality, parallelism, mass, volume, density, orthogonality, repetition, adjacency, all in tandem with the distribution of color in its contrasts, texture, and tone.

But while this is not untrue, the arkhitektons simultaneously remain within the realm of a two-dimensional sensation, bouncing back from the volumetric to the photographic. We are arrested by the plaster volumes as they are lit by Malevich in order to create the effect of glowing objects sharply contrasting against the dark background. Our attention is grasped by the manner in which the structures work in the photographs. As Yve-Alain Bois points out, for Cézanne, the opposition between figure and ground is "the foundation of our human perception."[10] To Cezanne, in fact, "There is no line, there is no modelling, there are only contrasts."[11] The chiaroscuro is in the lighting, in the image, not in an object that will promptly dissolve into the nothingness of bigger or smaller prisms. One of Maurice Merleau-Ponty's assertions on Cézanne fully applies to the nonobjective sensation pursued by the arkhitektons thanks to the properties of plaster when lit. The object, Merleau-Ponty says, seems subtly illuminated from within, light emanates from it, and the result is an impression of solidity and material substance.[12] We know that this illumination is not

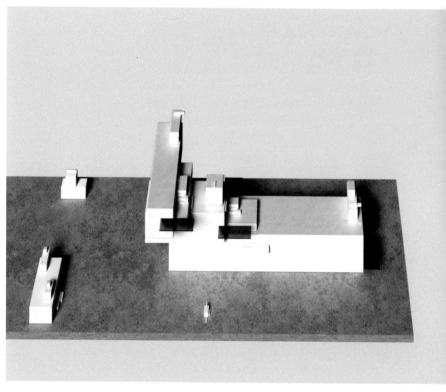

Arkhitekton Alpha state 3 (Form D) and Paul Cézanne's *Still Life with Milk Jug and Fruit*, 1888–1890. Nasjonalgalleriet, Oslo.

in Malevich's objects, but in the effect of lighting the plaster and in the photos.

Consequently, in order for sensation to move from painting to photography, physical models were needed. We would contend that the actual making of plaster models was an intermediate stage in moving from the pictorial, to the volumetric, to the photographic (as the new positioning of sensation). Malevich treats the arkhitektons' photographs and the planits in a painterly way. This is all too clear when we see that his planits are, in all senses, reverse perspectives. The photographs of arkhitektons and the drawings of planits are not the representation of buildings, but independent bodies, acting upon us directly. The image of the arkhitektons affects us by means of the real aspect of painterly content. Malevich thus considers that he is creating a new reality that replaces the illusions of imitative art.[13]

The Additional Element in Architecture

Of course, our analysis is based on transferring arguments about Cézanne provided by Gowing, Michaud, Merleau-Ponty, Deleuze, and Bois into the Cézannean aspects of Malevich's sensation. This exchange could be extended indefinitely. For instance when Bois remarks the "molecular surface" of Cézanne's watercolors, which he considers "a process which is not simply additive, but multiplying," this certainly fits a description of the arkhitektons, as they are made of "skeins of molecules more or less loose."[14] According to Bois, Cézanne is very careful that his colors don't mix, and *that the atoms must remain identifiable as such*,[15] unintendedly describing the big and small plaster elements at work in Malevich's work. This is why the flat surface of the *Black Square* (and its extruded transference into volumetric prisms) have no value in themselves. Rather, like Cézannean brushstrokes, they are the elemental and neutral components of nonobjective sensations.

Paul Cézanne, *Houses in Provence: The Riaux Valley near L'Estaque*, c. 1883. Oil on canvas, 65 × 81.3 cm. National Gallery of Art, Washington, DC, Collection of Mr. and Mrs. Paul Mellon.

In his Cézannean analysis of Francis Bacon's paintings, Gilles Deleuze also hints at Malevich when saying that "each sensation would thus be a term in a sequence or a series."[16] For Deleuze, each figure is itself a shifting sequence that exists at diverse levels, in different orders, or in different domains. This means that there are not sensations of different orders, "but different orders of one and the same sensation."[17] Every sensation, he concludes, is already an "accumulated" sensation. As we have seen, the arkhitektons are a collective that cannot be assessed by looking at each form in isolation. This shifting sequence of different orders would only be attained through a series of forms in a persisting process of deformation. Malevich is quite explicit about the sense of this process, saying that "deformation does not mean that the artist deforms the form of the object for the sake of a new form, but alters the form for the sake of perceiving painterly elements in the object."[18] The changing forms are thus directly linked to perception, and deformation is integral to sensation. What we experience as different arkhitektons is rather a single—if expanded—sensation, explored through a process of deformation. Malevich sought to achieve sensation through the temporary stillness of different "states" while moving into the next level. This is what Deleuze would later call "a movement-in-place."[19] The painterly stroke of the plaster volumes makes up their sense of unity among different states and through the whole series. The formal differences between arkhitektons, in terms of equilibrium, size, length, height, or density, are thus expedients for exploring the extent to which sensation accumulates. Malevich does not create this or that form. He explores deformation to seek different painterly elements in the object. Paraphrasing Paul Virilio, the pursuit of forms is only the pursuit of time, but if there are no stable forms, there are no forms at all.[20] What the arkhitektons show is not formal diversity but the "concept of diversity" as such. Malevich provides an image of change itself, showcasing the impossibility of stabilizing form. He recognizes the failure of form to remain unchanged. It is in these permanent processes of individualization and deindividualization of specific forms that the numbering and naming of arkhitektons gets into a muddle, despite Malevich's naming a few using letters from the Greek alphabet.

Yet, despite these associations between Malevich and Deleuze's appraisal of Cézanne, it is notable that the French philosopher moves from Cézanne into Francis Bacon. True, Deleuze's study is

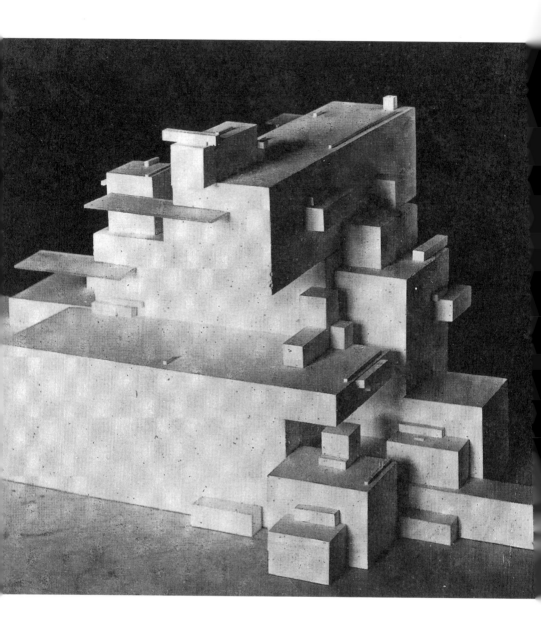

Arkhitekton Alpha (detail).

devoted to Bacon, not Malevich, but Malevich represents an obsta-
cle to his argument. According to Deleuze, there are two ways of
going beyond figuration, "either toward abstract form or toward
the Figure," but only one leads to sensation. To him, the Figure is
the sensible form related to a sensation, which acts immediately
upon the nervous system, "whereas abstract form is addressed to
the head, and acts through the intermediary of the brain."[21] In
other words, according to Deleuze, abstract painting, by passing
through the brain, does not act directly upon the nervous system,
and therefore does not attain the sensation.[22] For Deleuze abstrac-
tion and sensation oppose one another. Malevich, of course, thinks
differently, and concentrates his efforts on creating artworks that
would foretell the pitfalls of Deleuze's dichotomy. Malevich is con-
cerned with creating a new, abstract sensuousness. More, to Male-
vich, sensation can only be achieved through abstraction—that
is to say, by neutralizing figuration through plaster prisms repre-
senting no-thing.

If, in Cézanne, sensation relates to a process of detachment
between painting and the figurative, in Malevich's photos the sub-
ject matter (the arkhitektons) from which the image is gaining
pictorial independence is already a nonfigurative, nonobjective
reality. What Malevich does is to look for the emergence of dif-
ferent painterly effects through a deformation process that is, in
reality, the permanent flow of elemental components. In this way,
each arkhitekton is nothing but a temporal modulation of sensa-
tion. It is all about flux: big or small plaster prisms flowing in the
changing repertoire of the same.

In architecture, this connects with modernist discourses on
variation, in something that was imagined as becoming some kind
of universal and "fluid transition of things."[23] It also connects with
the older notion of "unity in diversity," so relevant for someone
like Walter Gropius, that prevailed through the nineteenth cen-
tury in debates about beauty and style in the theoretical scope of
authors ranging from Gottfried Semper to Hendrik Petrus Berlage.
A notion that, in relation to art, comes from Hegel's *Lectures on Fine
Art*, who in turn was referring to Schiller's *Letters on Aesthetic Educa-
tion* (1800), to propose the essence of art as the unity of freedom
and necessity, spirit and nature, and the universal and particular.[24]
Within this principle, art, style, and nature are internally related.
Pieter Singelenberg points out that Hegel is doubtless at the base
of Berlage's understanding, for whom the artist, by bringing unity

to plurality, has created a work of art that has style.[25] Only true and essential works of art are both eternal like nature and universal: the combining of the diverse into a unity by means of style. Malevich's work has been rightly credited with seeking to absorb (and so to supersede) classical architecture, much in the way his painting aimed at absorbing art. But more than a debate on classicism, it was about style, at both discursive and plastic levels. The category of "style" might have been gradually removed, but not the theoretical conditions for it, like the idea that art, as well as nature, brings unity to an infinity of varying forms, with no recourse to a discourse on use or necessity. In modernist architecture, therefore, unity in plurality is the translation of a wider aesthetic quest. And it was Malevich, throughout his arkhitektons and planits, who led the way for a plurality of changing forms to be tied together by the unity of painterly sensation.

Acknowledgments

This book began while I was undertaking research at Princeton University's Marquand Art Library as a Princeton University Mellon Fellow. Marquand's complete collection of Kazimir Malevich's publications and the many scholarly works on the artist, as well as those on Russian Constructivism more generally, invited a more sustained investigation into the foundations of a body of work that had always intrigued not just me but many others, namely his so-called arkhitektons and planits. Back in Chile, I explored the idea further through a design studio titled "On Reading Malevich" in the Master's Program in Architecture—MARQ—at the Pontificia Universidad Católica de Chile, taught in collaboration with Nicolás Stutzin. Paulina Bitrán, Francisca Cortínez, Micaela Costa, Laura González, Harold Rojas, and Cristóbal Ugarte were our students. Over the years that followed, the project benefited hugely from the collaboration and coauthorship of Paulina, as well as from the advice and support of scholars and colleagues to whom we are deeply indebted: Petr Antonov, Edward Bottoms, Luis Eduardo Bresciani, Dasha Cheremisina, Jean-Louis Cohen, Samuel Gonçalves, Boris Groys, Germán Hidalgo, Catherine Howe, Hugo Palmarola, Jane Pavitt, Elvira Pérez, Rodrigo Pérez de Arce, Javier Ruiz, and Thomas Weaver. We are also thankful to the many friends and loved ones who have followed the various steps of the process of writing and illustrating this book: Carmen Gloria de las Heras, Ricardo Bitrán, Lucia del Carmen de Pablo, Leonardo Bitrán, Cecilia Zúñiga Desgroux, Pamela Prado, Martín and Adrián Alonso. We dedicate this book to the memory of Carlos Alonso Camus (1935–2023).— *Pedro Ignacio Alonso*

Notes

Chapter 1

1. The number of arkhitektons would increase if we included the ones of disputed authorship, made by Malevich's collaborators like Suetin, Punin, Chashnik, or Eslanova, and not only those that the literature agrees were made by Malevich himself. The numbers would also differ if we included the Suprematist ornaments also produced in plaster.

2. Patrick Vérité, "Sur la mise en place du système architectural de Malevič," *Revue des Études Slaves* 72, no. 1–2 (2000), 201.

3. Andréi Nakov, *Malevich: Painting the Absolute*, vol. 3 (London: Lund Humphries, 2010), 59.

4. Jean-Hubert Martin, ed., *Malévitch: architectones, peintures, dessins*, exh. cat. (Paris: Centre Georges Pompidou, 1980). The title page reads: "Malévitch: œuvres de Casimir Severinovitch Malévitch (1878–1935). Avec en appendice les œuvres de Nicolaï Mikhaïlovitch Souiétine (1897–1954). Catalogue établi par Jean-Hubert Martin, reconstitution des modèles par Poul Pedersen."

5. Kazimir Malevich, "God Is Not Cast Down" (1922), in Malevich, *Essays on Art*, vol. 1, *1915–1928*, ed. Troels Andersen, trans. Xenia Glowacki-Prus and Arnold McMillin (Copenhagen: Borgen, 1968), 194–195.

6. El Lissitzky, "New Russian Art: A Lecture, 1922," typescript from the Lissitzky archive, Moscow; translated in *El Lissitzky: Life, Letters, Texts*, ed. Sophie Lissitzky-Küppers (Greenwich, CT: New York Graphic Society, 1968), 337.

7. Kazimir Malevich, "Art and the Problems of Architecture: The Emergence of a New Plastic System of Architecture," script for an artistic-scientific film, in Malevich, *The White Rectangle: Writings on Film*, ed. Oksana Bulgakowa (Berlin: Potemkin Press, 2003).

8. Paulina Bitrán and José Hernández, *Kazimir Malevich's Artistic-Scientific Film: Art and the Problems of Architecture. The Emergence of a New Plastic System of Architecture* (2018), animated film realized from Malevich's script in *The White Rectangle: Writings on Film*.

9. Kazimir Malevich, "On New Systems in Art" (1921), in Malevich, *Essays on Art*, vol. 1, 97.

10. Kazimir Malevich, "An Introduction to the Theory of the Additional Element in Painting" (1926), in Malevich, *Essays on Art*, vol. 3, *The World as Non-Objectivity: Unpublished Writings 1922–25*, ed. Troels Andersen, trans. Xenia Glowacki-Prus and Edmund T. Little (Copenhagen: Borgen, 1976), 167.

11. Tarcisio Cardoso, "Suprematism-as-Architecture: Opening the Way to K. Malevich's Work," MARCH thesis (McGill University School of Architecture, 1993), 84.

12. In philosophical terms, the notion of "pilotage" has been discussed by Catherine Larrère in her book *Technique et nature* (Paris: Fondation Calouste Gulbenkian, 2013).

13. Maria Gough, "Architecture as Such," in Achim Borchardt-Hume, ed., *Malevich* (London: Tate Modern, 2014), 160.

14. Kazimir Malevich, "An Analysis of New and Imitative Art (Paul Cezanne)," in Malevich, *Essays on Art*, vol. 2, *1928–1933*, ed. Troels Andersen, trans. Xenia Glowacki-Prus and Arnold McMillin (Copenhagen: Borgen, 1968), 21.

15. Zygmunt Bauman, *Liquid Modernity* (Cambridge: Polity Press, 2000), 2–3.

16. Kazimir Malevich, "The Question of Imitative Art" (1920), in Malevich, *Essays on Art*, vol. 2, 181.

17. See The Architectural Association, Event List 4, Autumn term, 27–31 October 1975.

18. Kazimir Malevich, *The Non-Objective World*, trans. Sarah Trenker (1927; Zurich: Lars Müller, 2020), 7.

19. About this debate, see Serge Fauchereau, "Architektons and GINKHUK," in Fauchereau, *Malevich* (New York: Rizzoli, 1992), 30.

20. Gilles Deleuze, "Renverser le platonisme (les simulacres)," *Revue de Métaphysique et de Morale* 71, no. 4 (1966), 426–438.

21. See Linda Dalrymple Henderson, "Malevich, the Fourth Dimension, and the Ether of Space in Malevich One Hundred Years Later," in Christina Lodder, ed., *Celebrating Suprematism: New Approaches to the Art of Kazimir Malevich* (Leiden: Brill, 2019), 44–80.

22. See Regina Khidekel, "Lazar Khidekel and Suprematism as an Embodiment of the Infinite," in Lodder, *Celebrating Suprematism*, 161–186.

Chapter 2

1. Maria Gough, "Architecture as Such," in Achim Borchardt-Hume, ed., *Malevich* (London: Tate Modern, 2014), 162.

2. Kazimir Malevich, "Suprematism. 34 Drawings," in Malevich, *Essays on Art*, vol. 1, *1915–1928*, ed. Troels Andersen, trans. Xenia Glowacki-Prus and Arnold McMillin (Copenhagen: Borgen, 1968), 123.

3. Malevich, "Suprematism. 34 Drawings," 124.

4. However, A18 has been attributed to Chashnik. According to Jean-Claude Marcadé, Malevich did not write much to explain this way of naming, except for a 1923 text dedicated to Khlebnikov where he talks about Alpha and Beta, saying that Alpha designates the origin of things and Beta their accomplishment. Kazimir Malevich, "Vélimir, Victor, Khlebnikov Zanguézi," in Jean-Claude Marcadé, *À Rebours III* (Paris, 1981–1982), 42 (manuscript facsimile by Malevich).

5. Troels Andersen, *Malevich: Catalogue Raisonné of the Berlin Exhibition 1927* (Amsterdam: Stedelijk Museum, 1970).

6. Work conducted by Poul Pedersen and his team between 1978 and 1980, for an exhibition at the Centre Pompidou in Paris. They reconstructed five arkhitektons from remaining original plaster elements: Alpha, Beta, Zeta, Gota, and Gota 2-a.

7. In this context, quite naturally, there are errors on how to cite the arkhitektons in various catalogues, websites,

and even exhibitions, partly due to lack of rigor, and partly because Malevich intentionally used to name different forms with the same names, or the same form with different names. While we are not exempt from mistakes, this study seeks to provide as much clarity as possible about such naming.

8. Jean-Louis Cohen, *Building a new New World: Amerikanizm in Russian Architecture* (Montreal: Canadian Centre for Architecture, 2020), 200.

Chapter 3

1. The album *Kazimierz Malewicz, 1876–1935* was produced in 1936 in Łódź by Strzemiński and his students in honor of Malevich. This album contains lithographs of thirty-four drawings and ten photographs by Malevich, including one photograph of Suprematist ornaments and nine of arkhitektons that allowed the study of Malevich's architectural work. Malevich had given the negatives of these photographs to Strzemiński in 1930–1931. The album was acquired by the Museum of Modern Art in 2012.

2. In an interview with Rem Koolhaas and Hans-Ulrich Obrist, Ungers recalls that this visit to Häring was in 1948 or 1949. See Rem Koolhaas and Hans-Ulrich Obrist, "An Interview with O. M. Ungers," *Log* 16 (2009), 59.

3. Koolhaas and Obrist, "An Interview with O. M. Ungers," 59.

4. "Leon Krier in Conversation with Christopher Pierce and Thomas Weaver," in

Thomas Weaver, ed., *AA Files Conversations* (London: Architectural Association, 2013), 93.

5. Kazimir Malevich, *Essays on Art*, vol. 1, *1915–1928*, ed. Troels Andersen, trans. Xenia Glowacki-Prus and Arnold McMillin (Copenhagen: Borgen, 1968); vol. 2, *1928–1933*, ed. Troels Andersen, trans. Xenia Glowacki-Prus and Arnold McMillin (Copenhagen: Borgen, 1968); vol. 3, *The World as Non-Objectivity: Unpublished Writings 1922–25*, ed. Troels Andersen, trans. Xenia Glowacki-Prus and Edmund T. Little (Copenhagen: Borgen, 1976).

6. Troels Andersen, *Malevich: Catalogue Raisonné of the Berlin Exhibition 1927*, including the collections of the Stedelijk Museum Amsterdam; with a general introduction to his work (Amsterdam: Stedelijk Museum, 1970).

7. Jean-Claude Marcadé, ed., *Malévitch: Colloque International Kazimir Malévitch, Musée National d'Art Moderne Centre Pompidou, 4 et 5 mai 1978* (Lausanne: L'Âge d'Homme, 1979).

8. Jean-Hubert Martin, ed., *Malévitch: architectones, peintures, dessins*, exh. cat. (Paris: Centre Georges Pompidou, 1980).

9. Larissa A. Zhadova, *Malevich: Suprematism and Revolution in Russian Art 1910–1930* (London: Thames and Hudson, 1982).

10. Troels Andersen, *K. S. Malevich: The Leporskaya Archive* (Aarhus: Aarhus University Press, 2011), 6.

11. Andersen, *K. S. Malevich: The Leporskaya Archive*, 7–10.

12. They had reconstructed Arkhitektons Gota 2-a and

A10, with unsatisfactory results, because later in 1979 they discover that the original model's elements were much smaller, thinner, and more delicate than they had deduced through the photography study.

13. Martin, *Malévitch: architectones, peintures, dessins.*

14. Exhibited from 26 February to 18 April 1971.

15. Rodrigo Pérez de Arce interviewed by Pedro Ignacio Alonso, Santiago, 14 December 2022.

16. The Architectural Association, Events List 4, Autumn term, 27–31 October 1975.

17. The Architectural Association, Events List 4, Autumn term, 27–31 October 1975.

18. The Architectural Association, Events List 4, Autumn term, 27–31 October 1975.

19. See Elia Zenghelis and Rem Koolhaas, "*Malevich's Tektonik,* London, 1976/77," introduction to Zaha M. Hadid, "Planetary Architecture, Projects 77–81," in *Pamphlet Architecture 8* (New York: Princeton Architectural Press, 1981), 1.

20. Steven Holl interviewed by Joseph Masheck, *Bomb Magazine,* 1 April 2002, https://bombmagazine.org /articles/steven-holl/.

21. Steven Holl interviewed by Joseph Masheck.

22. See *Pamphlet Architecture 1–10* (New York: Princeton Architectural Press, 1998).

23. Pier Vittorio Aureli, *The Possibility of an Absolute Architecture* (Cambridge, MA: MIT Press, 2011), 23.

24. "OMA," *Architectural Design* 47, no. 5 (1977).

25. Other projects featured in the City of the Captive Globe include El Lissitzky's Lenin Tribune (1924), a couple of towers from Le Corbusier's Plan Voisin (1925), and Salvador Dalí's *Millet's Architectonic Angelus* (1933).

26. "OMA," 333.

27. "OMA," 341–347.

28. "OMA," 341.

29. "OMA," 341.

30. *Flashback: Carrilho da Graça,* exh. cat. (Porto: Casa da Arquitectura, 2022), 178.

31. *Flashback: Carrilho da Graça,* 170.

32. Kazimir Malevich, *The Non-Objective World,* trans. Sarah Trenker (1927; Zurich: Lars Müller, 2020), 96.

Chapter 4

1. Roland Barthes, *Camera Lucida,* trans. Richard Howard (1980; New York: Hill and Wang, 2010), 4.

2. There is no evidence that Malevich and Florensky ever met, or that Malevich read Florensky's text, but as pointed out by Jean-Claude Marcadé, "let us not forget that Malevich's treatise is strictly contemporary with father Pavel Florensky's book." Kazimir Malévitch, *Écrits,* ed. and trans. Jean-Claude Marcadé (Paris : Éditions Allia, 2015), 313.

3. Pavel Florensky, "Reverse Perspective" (1920), in Florensky, *Beyond Vision: Essays on the Perception of Art,* ed. Nicoletta Misler, trans. Wendy Salmond (London: Reaktion Books, 2002), 201–202.

4. Kazimir Malevich, "An Analysis of New and Imitative Art (Paul Cezanne)," in Malevich, *Essays on Art,* vol. 2, *1928–1933,* ed. Troels Andersen,

trans. Xenia Glowacki-Prus and Arnold McMillin (Copenhagen: Borgen, 1968), 24.

5. Raoul-Jean Moulin, *Cézanne, Bodegones,* trans. Juan-Eduardo Cirlot (Barcelona: Gustavo Gili, 1964), 2.

6. Florensky, "Reverse Perspective," 206.

7. Florensky, "Reverse Perspective," 230.

8. Florensky, "Reverse Perspective," 229.

9. Florensky, "Reverse Perspective," 209.

10. Kazimir Malevich, *Suprematism: 34 Drawings* (1920), ed. with an essay by Patricia Railing (East Sussex: Artists Bookworks, 2014), 2.

11. Florensky, "Reverse Perspective," 206.

12. Florensky, "Reverse Perspective," 242.

13. Florensky, "Reverse Perspective," 250.

14. Florensky, "Reverse Perspective," 229.

15. Florensky, "Reverse Perspective," 204.

16. Malevich, *Suprematism: 34 Drawings,* 2.

17. Jonathan Crary, *Techniques of the Observer: On Vision and Modernity in the Nineteenth Century* (Cambridge, MA: MIT Press, 1992), 97–98.

18. Patricia Railing, "Reading the 34 Drawings," in Malevich, *Suprematism: 34 Drawings,* 47.

19. Railing, "Reading the 34 Drawings," 46.

20. Crary, *Techniques of the Observer,* 98.

21. Railing, "Reading the 34 Drawings," 47.

22. Crary, *Techniques of the Observer,* 98.

23. Florensky, "Reverse Perspective," 202.

24. Florensky, "Reverse Perspective," 204.

25. Florensky, "Reverse Perspective," 208–209.

26. Florensky, "Reverse Perspective," 218.

27. Kazimir Malevich, "An Attempt to Determine the Relation between Colour and Form in Painting" (1928), in Malevich, *Essays on Art*, vol. 2, 129.

28. Malevich, "An Attempt to Determine the Relation between Colour and Form in Painting," 138.

Chapter 5

1. Troels Andersen, "De R2 à R3," in Jean-Hubert Martin, ed., *Malévitch: architectones, peintures, dessins*, exh. cat. (Paris: Centre Georges Pompidou, 1980), 12.

2. Georges Cuvier, "Discours préliminaire," in *Recherches sur les ossemens fossiles* (1812), trans. R. Kerr as *Essay on the Theory of the Earth* (1813).

3. Thomas Henry Huxley, "On the Method of Zadig: Retrospective Prophecy as a Function of Science" (1880), in Huxley, *Collected Essays* (Cambridge: Cambridge University Press, 2011), 1–23.

4. Georges Cuvier, "Discours sur les révolutions de la surface du globe," in *Recherches sur les ossemens fossiles*, iv, tôme i, p. 185.

5. Huxley, "On the Method of Zadig," 3.

6. Huxley, "On the Method of Zadig," 22.

7. Huxley, "On the Method of Zadig," 9.

8. Huxley, "On the Method of Zadig," 23.

9. Francisca Cortínez Albarracín, "La ciudad como elemento adicional para los arquitectones de Kazimir Malevich suprematista," MA thesis (Pontificia Universidad Católica de Chile, 2016), 15.

Chapter 6

1. *Sovremennaia Arkhitektura* (Moscow, 1928, no. 5), trans. Jean-Claude Marcadé in K. S. Malévitch, *Écrits II, Le miroir suprématiste* (Lausanne, 1977), 112–113.

2. Kazimir Malevich, "La peinture dans le problème de l'architecture," *Nova Guénératsiya* (Kharkiv, 1928, no. 2), 116–132, quoted in Malevich, *Écrits*, ed. and trans. Jean-Claude Marcadé (Paris : Éditions Allia, 2015), 404.

3. Malevich, "La peinture dans le problème de l'architecture."

4. There are four vertical arkhitektons: Gota, Gota 2-a, Zeta and Lukos. There are other vertical models, but they correspond to Suprematist monuments.

5. A10 is said to be the first arkhitekton made by Malevich, because it is recognized as being made of cardboard and not plaster. It was photographed on a mirror-glass base and against a background of trees. This photo was first published in 1926, by the magazine *Praesens*. The trees in the original photograph were later replaced with a black background; this is the way it appeared in the 1936 album by artist Władysław Strzemiński.

6. Malevich used two techniques for photographing an arkhitekton. In the first, the arkhitekton was photographed on a table, in a dark room where some other arkhitektons or elements can be distinguished in the background. The second was to place the arkhitekton on a white base (probably a wooden plane painted white), eliminating the background. In this second technique, the arkhitekton is always presented with this white base. In either case, the base plane of the arkhitekton is always present, whether a table or a piece of wood painted in white.

7. A12, A13, and A14 are not considered in the present study because they are not arkhitektons in the strict sense, but rather Suprematist ornaments or monuments.

8. Christina Lodder, "Living in Space: Kazimir Malevich Suprematist Architecture and the Philosophy of Nikolai Fedorov," in Charlotte Douglas and Christina Lodder, eds., *Rethinking Malevich* (London: Pindar Press, 2007), 187.

9. Patrick Vérité, "Sur la mise en place du système architectural de Malevič," *Revue des Études Slaves* 72, no. 1–2 (2000), 202.

10. Kazimir Malevich, quoted in Lodder, "Living in Space," 195–196.

Chapter 7

1. Boris Groys, *The Communist Postscript* (London: Verso, 2009), 35.

2. Laura González, "La práctica del 'lenguaje suprematista' a través de la obra de Kazimir Malevich: ¿una experiencia que libera u oprime?," MA thesis (Pontificia Universidad Católica de Chile, 2016), 1.

3. Boris Groys, *Kazimir Malevich* (Moscow: Ad Marginem, 2014), 36.

4. Groys, *The Communist Postscript*, 39.

5. Tatiana Mikhienko, "The Suprematist Column—A Monument to Nonobjective Art," in Matthew Drutt, ed., *Kazimir Malevich: Suprematism* (New York: Guggenheim Museum, 2003), 80.

6. Mikhienko, "The Suprematist Column—A Monument to Nonobjective Art," 81.

7. This is arkhitekton A1 in the classification provided by Troels Andersen in *Malevich: Catalogue Raisonné of the Berlin Exhibition 1927* (Amsterdam: Stedelijk Museum, 1970).

8. Harold Rojas, "Architecton Alpha y los umbrales de proporción. El papel del elemento formativo y adicional en el volumen suprematista," MA thesis (Pontificia Universidad Católica de Chile, 2016), 67.

9. Rojas, "Architecton Alpha y los umbrales de proporción."

10. See Elia Zenghelis and Rem Koolhaas, "*Malevich's Tektonik*, London, 1976/77," introduction to Zaha M. Hadid, "Planetary Architecture, Projects 77–81," in *Pamphlet Architecture 8* (New York: Princeton Architectural Press, 1981), 1.

11. Groys, *The Communist Postscript*, 39.

12. Tomás Moulian, *El consumo me consume* (Santiago: LOM, 1998), 20.

13. Sigmund Freud, *A General Introduction to Psychoanalysis*, trans. G. Stanley Hall (New York: Boni and Liveright, 1920), 18.

14. Serge Fauchereau, "Architektons and GINKhUK," in *Kazimir Malevich* (New York: Rizzoli, 1992), 30.

Chapter 8

1. Kazimir Malevich, "An Analysis of New and Imitative Art (Paul Cezanne)," in Malevich, *Essays on Art*, vol. 2, *1928–1933*, ed. Troels Andersen, trans. Xenia Glowacki-Prus and Arnold McMillin (Copenhagen: Borgen, 1968), 20–21.

2. Paul Cézanne's ideas have been compiled in a number of books published from conversations with the artist by authors such as Emile Bernard, Joachim Gasquet, Gustave Geffroy and others. See Lawrence Gowing, "Cézanne: La logique des sensations organisés," *Macula* (Paris, 1978); Éric Michaud, "Les sensations de Cézanne," *Critique*, no. 390 (November 1979); Gilles Deleuze, *Francis Bacon: The Logic of Sensation*, trans. Daniel W. Smith (1981; London: Continuum, 2003).

3. Michaud, "Les sensations de Cézanne"; trans. Bridget Alsdorf as "Cézanne's Sensations," *Nonsite*, no. 39, https://nonsite.org. This remains an essential essay on Cézanne that deserves a broader anglophone readership. It was written in response to the recent publication in French of Lawrence Gowing's "Cézanne: La logique des sensations organisés," the new edition of Cézanne's correspondence edited by John Rewald (*Paul Cézanne: Correspondance* [Paris: Grasset, 1978]), and an anthology of primary sources on the artist edited by P. Michael Doran (*Conversations avec Cézanne* [Paris: Macula, 1978]).

4. See Deleuze, *Francis Bacon: The Logic of Sensation*.

5. Malevich, "An Analysis of New and Imitative Art (Paul Cezanne)," 24, 26.

6. Deleuze, *Francis Bacon: The Logic of Sensation*, 35.

7. Michaud, "Cézanne's Sensations."

8. Deleuze, *Francis Bacon: The Logic of Sensation*, 42.

9. Tatiana Mikhienko, "The Suprematist Column—A Monument to Nonobjective Art," in Matthew Drutt, ed., *Kazimir Malevich: Suprematism* (New York: Guggenheim Museum, 2003), 81.

10. Yve-Alain Bois, "Cézanne: Words and Deeds," trans. Rosalind Krauss, *October* 84 (Spring 1998), 43.

11. In Julia Kerninon, "Cezanne: The Logic of Organised Sensations According to Lawrence Gowing," http://www.diptyqueparis -memento.com/en/the-logic -of-organised-sensations-of -cezanne/.

12. Maurice Merleau-Ponty, "Cézanne's Doubt," in Merleau-Ponty, *Sense and Nonsense* (Evanston: Northwestern University Press, 1964), 3.

13. Malevich, "An Analysis of New and Imitative Art (Paul Cezanne)," 25–26.

14. Bois, "Cézanne: Words and Deeds," 39.

15. Bois, "Cézanne: Words and Deeds," 39.

16. Deleuze, *Francis Bacon: The Logic of Sensation*, 36.

17. Deleuze, *Francis Bacon: The Logic of Sensation*, 37.

18. Malevich, "An Analysis of New and Imitative Art (Paul Cezanne)," 22.

19. Deleuze, *Francis Bacon: The Logic of Sensation*, 41.

20. Paul Virilio, *The Aesthetics of Disappearance*, trans. Philip Beitchman (1980; Los Angeles: Semiotexte (e), 2009), 27.

21. Deleuze, *Francis Bacon: The Logic of Sensation*, 34.

22. Deleuze, *Francis Bacon: The Logic of Sensation*, 36.

23. Sigfried Giedion, *Building in France, Building in Iron, Building in Ferro-concrete*, trans. J. Duncan Berry (1928; Los Angeles: Getty Center for the History of Art and the Humanities, 1995), 91.

24. G. W. F. Hegel, *Hegel's Aesthetics: Lectures on Fine Art*, trans. T. M. Knox (1835; Oxford: Clarendon Press, 1975), 62–63.

25. Pieter Singelenberg, *H. P. Berlage, Idea and Style: The Quest for Modern Architecture* (Utrecht: Haentjens Dekker & Gumbert, 1972), 184.

The MIT Press
Massachusetts Institute of Technology
77 Massachusetts Avenue, Cambridge, MA 02139
mitpress.mit.edu

The MIT Press would like to thank the anonymous peer reviewers who provided comments on drafts of this book. The generous work of academic experts is essential for establishing the authority and quality of our publications. We acknowledge with gratitude the contributions of these otherwise uncredited readers.

This book was set in Haultin Normal by New Best-set Typesetters Ltd. Printed and bound in Canada.

Library of Congress Cataloging-in-Publication Data is available.

ISBN: 978-0-262-54890-8

10 9 8 7 6 5 4 3 2 1

EU product safety and compliance information contact is: mitp-eu -gpsr@mit.edu